BOOKS PRODUCED FOR THE MEYER PROJECT:

The Facsimile

An exact reproduction of Meyer's 1570 treatise (using all the same materials and construction) based primarily on the painted copy in the Leipzig University Library, supplemented by pages from several other copies containing annotations and other use marks.

The Prestige Edition

A copy of REBECCA L. R. GARBER's translation constructed using the same materials and methods as the facsimile, with restored artwork and the English text laid out and formatted to match the original book as closely as possible, including historical typefaces.

The Reference Edition

A two-volume set: volume 1 contains REBECCA L. R. GARBER's translation laid out side-by-side with MICHAEL CHIDESTER's transcription of the 1570 German, with an introduction by CHRISTOPHER VANSLAMBROUCK and an appendix summarizing the Meyer Census; volume 2 contains a complete set of painted Figures at 150% size, black and white Figures (with the backgrounds removed) at 100% size, indexes of all references to each Figure, and appendixes containing the illustrations from the München, Lund, and Rostock manuscripts.

The Reading Edition

A copy of REBECCA L. R. GARBER's translation with the Figures separated into individual pairs of fencers and placed inline in the text whenever they are referenced, with an introduction by ROGER NORLING.

FOUNDATIONAL DESCRIPTION OF THE ART OF FENCING

The 1570 Treatise of Joachim Meyer

Illustrated by Hans Christoph Stimmer

with introduction by MICHAEL CHIDESTER

HEMA Bookshelf

Published by HEMA Bookshelf, LLC.
47 High St #433
Medford, MA, 02144
www.hemabookshelf.com

Designed and edited by MICHAEL CHIDESTER.

Version 1.0 (2023)

ISBN 978-1-953683-37-3 (hardcover collection)
ISBN 978-1-953683-38-0 (softcover collection)
ISBN 978-1-953683-30-4 (volume 1 hardcover)
ISBN 978-1-953683-32-8 (volume 2 hardcover)
ISBN 978-1-953683-31-1 (volume 1 softcover)
ISBN 978-1-953683-33-5 (volume 2 softcover)

Library of Congress Control Number: 2023947301

Typeset in Libertinus Serif Display and Libertinus Sans, which are used under the Open Font License
http://libertine-fonts.org/
German text typeset in Humboldt Fraktur, used under the 1001Fonts Free For Commercial Use License
https://www.1001fonts.com/licenses/ffc.html

Printed by Amazon.

TABLE OF CONTENTS – VOLUME 2

TABLE OF CONTENTS – VOLUME 1

For MIKE CARTIER *(1966-2019),*

first Captain of the Meyer Freifechter Guild, whose example
continues to drive our generational pursuit of martial knowledge
and research, with sword in one hand and book in the other.

And for everyone who loves Meyer in their heart.

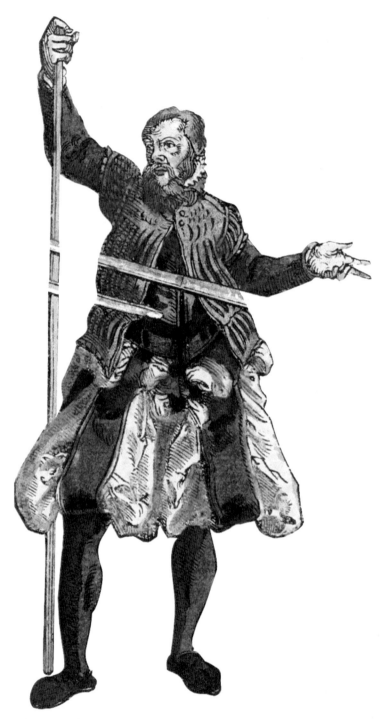

Fig 1: A fencing master from Sword Figure A of the 1570 treatise of Joachim Meyer, which may be a representation of Meyer himself. By Hans Christoph Stimmer, 1560s (printed by Thiebolt Berger). Painted by an unknown artist in c. 1574 (from copy 1.14).

Introduction: The Treatise of Joachim Meyer

Michael Chidester

In his short life,[1] Joachim Meyer († 1571) produced at least three books—two manuscripts and one in print—detailing his art of fencing, and notes for at least one more book survive in a third manuscript.

Meyer's first known written work is the *von Veldenz Fight Book* (JMM), dedicated to Georg Johan von Veldenz, a scion of the Wittelsbach dynasty, and dated 1561. It is a manuscript and is currently kept at the Bayerisches Nationalmuseum in München, Germany, and cataloged as Bibl. 2465. Meyer's works are often described in terms of which weapons they cover, and this first manuscript's 115 folia include the full range: sword,[2] dusack, rapier, dagger, short staff, halberd, and pike. It's also unique among Meyer's works in covering fencing in armor.[3]

Meyer's second written work, the *von Solms Fight Book* (JML), was created some time in the early 1560s for Otto von Solms-Laubach. Another manuscript, it's currently kept at the Lunds Universitets Bibliotek in Lund, Sweden. This manuscript's 89 folia repeat some introductory material from JMM, but it's largely a new composition limited to teachings on the sword (framed as explanations of a teaching poem not unlike 15th century texts in the tradition of Johannes Liechtenauer), the dusack, and the rapier.[4]

Meyer's third book was published in Strasbourg in 1570 and dedicated to Johann Kasimir von Simmern, another Wittelsbach prince. Meyer's only printed book, there are at least 40 copies of the first edition known to survive in libraries around the world.[5] It's titled *Gründtliche Beschreibung, der freyen Ritterlichen unnd Adelichen kunst des Fechtens, in allerley gebreuchlichen Wehren* ("Foundational Description of the Free, Knightly, and Noble Art of Fencing, with All Commonly-used Weapons"). Its 456 pages again cover sword, dusack, rapier, dagger, staff, halberd, and pike (the full range except for armor), following a similar plan to JMM but expanding it enormously. It also includes the sword teachings of JML almost verbatim.[6]

Finally, in the months before his death at the beginning of 1571, Meyer seems to have been gathering notes for another book. These are found in a manuscript called *Fechtbuch zu Ross und zu Fuss* (JMR) currently kept at the Universitätsbibliothek Rostock in Rostock, Germany, and cataloged as Ms. var. 82. The bulk of this manuscript is a compilation of the writings of earlier fencing masters, primarily from the 15th century. Meyer seems to have added five folia to the beginning of this manuscript and 18 folia to the end. All of these additions (apart from an index for a previous segment) treat the rapier, and they include notes on a theory of fencing that Meyer had learned from Stephan Heinrich von Eberstein.[7]

In this introduction, I'll explain a bit more about how Meyer's book came together.

Background

Let's start at the beginning.

The *codex book* was invented during the Imperial period of Roman history by combining the two most common writing media: the *papyrus scroll* and the *wooden tablet*. Scrolls, which were already often written on only one side and then folded 'accordion style' rather than rolled, were stitched on one edge and then sandwiched between wooden tablets.[8]

...What? Too far back? Okay.

[1] For a detailed account of the life of Joachim Meyer, see Christopher VanSlambrouck's introduction to Volume 1.

[2] The term "longsword" is commonly used in discussions of historical fencing to describe a sword with a grip long enough to hold comfortably in both hands but somewhat shorter than the height of the fencer using it. This is a thoroughly modern term based on misunderstanding Johannes Liechtenauer's terminology for ways to hold the sword, and it will not be used in this book. Meyer simply terms this a "sword", whereas the dusack and rapier are never called swords.

[3] For a full description of this manuscript, see Dupuis 2021a; its illustrations are found in Appendix 1.

[4] For a full description and translation of this manuscript, see Forgeng 2016; its illustrations are found in Appendix 2.

[5] A complete catalog of all known copies is found in the Appendix to Volume 1.

[6] Good news: you're reading Volume 2 of a full description and translation of this treatise *right now*.

[7] No detailed description of this manuscript has been published to date, but a translation of the fencing notes from Eberstein is included in Forgeng 2016; its illustrations are found in Appendix 3.

[8] For a very accessible overview of this development, see Petroski 1999: 29–31.

In the early Medieval period, papyrus, which was only about as durable as modern paper, was replaced by *parchment*, basically a weird kind of leather that is very thin and ideal for writing on. It's also fairly waterproof (though the ink used on it wasn't) and very difficult to burn. The process of making parchment involved stretching wet animal skin to flatten it, meaning that, if left alone, the finished parchment would naturally shrink and curl again, so parchment books would typically have metal clasps or leather ties to close the covers tightly and keep the parchment flat. Sandwiched between leather-covered wooden boards, held shut with metal clasps on leather straps, sometimes with further metal fixtures to protect the corners and raise the material off whatever surface it rested on, the Medieval book could be a virtually indestructible vehicle for information.

Still too far? Fine, but this next part is important.

The invention of the *moveable type* printing press in the mid-15th century didn't signify the invention of the book. It didn't even really mark the beginning of a new *kind* of book (at least not to people at the time).

Ever since *paper*, fashioned from discarded linen rags, began to be cheaply mass-produced in the latter part of the 14th century, the cost of books had plummeted (needing to slaughter one sheep or goat for every eight pages in a book can apparently get expensive). Even though paper wasn't nearly as durable as parchment, you can't beat it in terms of price and the prospect of building a library for the cost of a handful of parchment books—or the prospect of being able to afford a book *at all* for the first time—made paper books very popular very quickly.[9]

Until this point in European history, every book that existed was a *manuscript*, meaning it was written or copied by hand.[10] The professional hand-writers who performed this craft were called *scribes* (the stereotype is that they were primarily monks and nuns, but professional secular scribes came to dominate the trade by the late Middle Ages). This sudden increase in demand for books quickly became more than the community of scribes could handle, though—even

after they adopted assembly line-style organization to make the process as fast as possible.

These were the conditions when movable type entered the scene, and in the beginning, it was seen as merely a labor-saving device. The first typefaces were designed to be indistinguishable from the hand-written letters of scribes; the printer provided the black-inked words and picture outlines for a book, but then it would be handed off to scribes to add the colored letters, and to other craftsmen to draw the decorative capital letters, paint the illustrations, illuminate with gilding, and perform all the other decorative flourishes that characterized a Medieval book. In fact, the first books to come off the press in the 1450s were hard to distinguish from the manuscripts they were imitating—some were even printed on parchment.

PREPARING A BOOK[11]

As mentioned before, Joachim Meyer was responsible for the creation of lavish manuscripts for two of his noble students. It strikes many people as odd that, over a century into the "age of print", Meyer would be ordering manuscripts at all. The princely manuscripts created for his contemporary Paul Hektor Mayr might easily be explained by his antiquarian inclinations,[12] but Meyer was quite willing and able to print his teachings in 1570, so why didn't he do so earlier?

It's important to remember that even though the technologies of printing sped up the mass production of books, it was really a rather slow process. All of the apparent speed of printing came from matters of scale—printing a thousand copies of a page took only moderately longer than printing a single one, but printing a *single* book start to finish was slower and more expensive than hiring a scribe to write it. Any book intended for only one recipient would still be created by scribes for centuries after Gutenberg.

In fact, a book could not be printed without a *copytext* that the printer could refer to in order to set the type. This could be a previous edition of the book, but

[9] See KWAKKEL 2018: 8–9.

[10] "Manuscript" comes directly from Latin: *manu* means "by hand", and *scriptus* is the past participle of *scribere*, meaning "to write". Anything handwritten is technically a manuscript, though the term has become more expansive in today's world and is often used to mean anything that isn't *published* (e.g., the 'manuscript' that an author submits to an editor in 2023 is probably a digital file created on a computer). The term "typescript", referring to a unique type-written work to distinguish it from hand-written, was common in the era of typewriters but has more or less fallen into disuse today.

[11] The information presented here about 16th century printing technology is primarily derived from DANE 2012: 47–140.

[12] For an overview of Mayr's life and works, see FORGENG 2017 as well as the edition he plans to release in 2024 (no title announced yet).

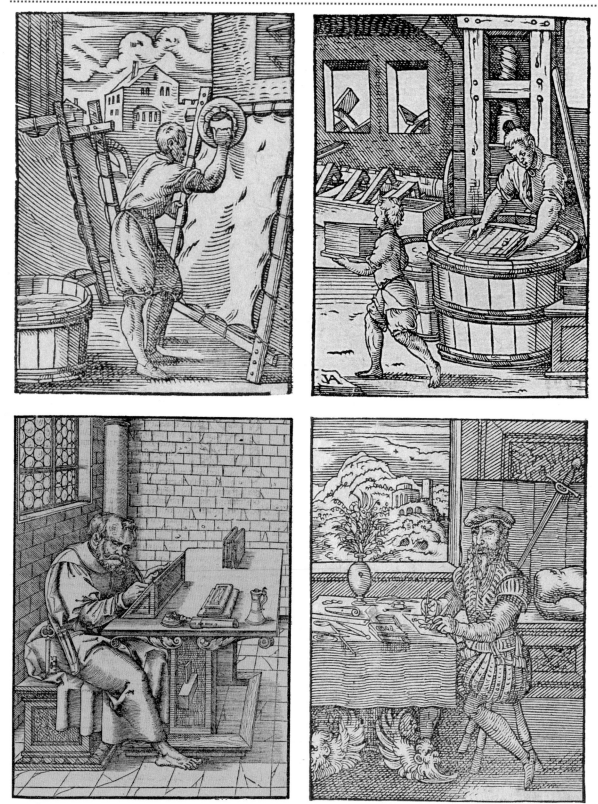

Fig. 2: Artisans preparing materials for a book. Top left: Membranarius. Der Bermenter. *("Parchmenter"); top right:* Chartarius. Der Papyrer. *("Papermaker"); bottom right:* Adumbrator. Der Reisser. *("Draftsman"); all by Jost Amman, 1568 (printed by Sigismund Feyrabendt). Bottom left: illustration of St. Peter at a writing desk by Lucas Cranach the Younger, 1541 (printed by Nicolaus Wolrab), filling in for a scribe here since Amman doesn't include one in his* Book of Trades.

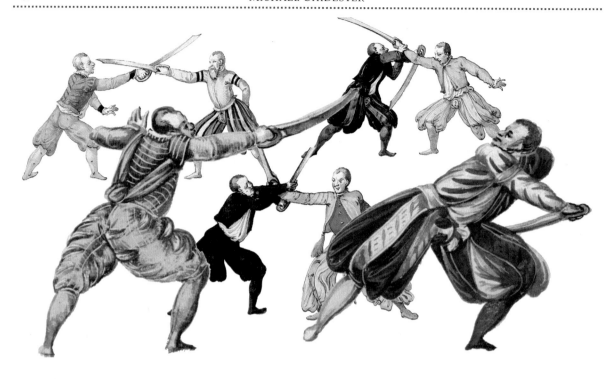

Fig. 3: Dusack Figure C recreated using pairs of fencers clipped from JMM: 26ᴿ, 28ᴿ, & 40ⱽ and JML: 55ᴿ.

in case of a new work (or a work that had never been printed before), it was… a manuscript (either a preexisting one or one created specifically for this purpose). Such a manuscript wouldn't necessarily be a beautiful text like those Meyer produced for his students—the author might personally hand-write the copytext or hire a scribe to take dictation. But prior to the advent of mechanical typewriters in the 19th century, hand-writing was ubiquitous.

Joachim Meyer obviously drew heavily on his prior manuscripts—probably the drafts that he used to create them, since the manuscripts themselves had long since been carried off by their dedicatees—when creating the copytext for his book, but also extensively rewrote and expanded that material. It's unclear how long this process took him—he might easily have devoted most of the 1560s to this project.

If a book was to be illustrated, that would also often require advance preparation. A printer would have a supply of elaborate capital letters for the beginnings of sections and decorative elements to occupy unused page space, and typically also an assortment of generic illustrations that could be repurposed for many kinds of books. But for something original, the client would need to hire artists to create it for them.

Creating printed art was a multi-part process. First, a draftsman would design the print, then an engraver would turn the design into a printing plate; some artists practiced both trades. Meyer's book uses *relief* prints, in which the "white" portion of the picture would be carved out (usually of a wooden block) and then black ink spread over the remaining ridges.[13]

To create the Figures for his book, Joachim Meyer contracted with the Stimmer workshop in Strasbourg. They specialized in the Mannerist style popularized by Nürnberg engravers Virgil Solis (1514–1562) and Jost Amman (1539–1591), and would likely have been contracted for a year and a day's work.

The illustrations are based in part on Meyer's prior works and on the popular treatise of Achille Marozzo; out of 198 pairs (or individuals in cases where there's no counterpart) in the 62 elaborate woodcuts, 46 were based on JMM, 28 were based on JML, 14 were based on Marozzo, and 123 were apparently newly created

[13] The other technique used at the time is *intaglio*, in which the "black" portions of a picture would be carved out, usually of a copper plate, and then ink poured into the gaps to press into the paper.

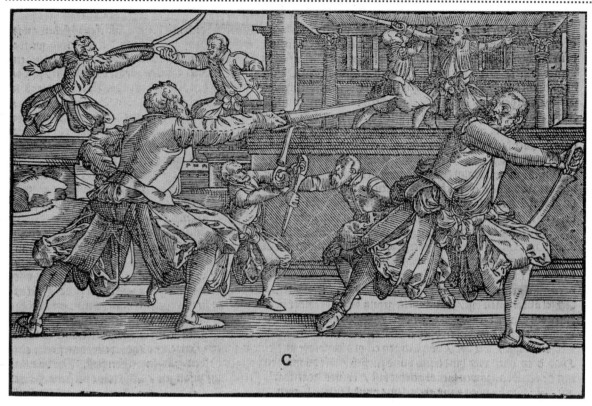

Fig. 4: Dusack Figure C as it appears in the completed book (from copy 1.33; described on pp. 60–61).

for this project. These illustrations were likely drawn from life based on local fencers acting as models, though it's hard to be certain without finding more records of the project.

This process seems to have begun when the writing was in its early stages, since the Figures frequently combine techniques from far-flung parts of the eventual text. Indeed, many of the pairs portrayed in the Figures aren't referenced in the text at all.

Unusually, each block was given small "window" in which a single piece of type could be inserted to give the block a label.

Guild regulations required the use of monograms to identify the artisans who participated in a project

and certify that they were guild members in good standing. Meyer's book shows five such monograms: HCS (Hans Christoph Stimmer, 1549–1578), FO, GW, MB (Michael Bocksberger), and CW (C. Wunderdinger). [14] Stimmer's monogram on the very first Figure is fitting for the master of the shop, though it's unclear why the first two prints—the title page and frontispiece—are unmonogrammed. The other monogramists are recognizable as engravers working in the Strasbourg area in this period (though their names are unknown). Conspicuously absent is the TS monogram of Christoph's bother, Tobias Stimmer (1539–1584), who is commonly credited with the art in the book despite little or no evidence of his involvement. [15]

[14] The monograms appear, respectively, on Sword Figure A (pp. 8–9), Sword Figure K (pp. 26–27), Rapier Figure G (pp. 80–81), the portrait of Rapier and Cloak (pp. 92–93), and Dagger Figure B (pp. 98–99). For information about the artists involved, see CHRISTOPHER VANSLAMBROUCK's introduction to Volume 1, pp. xxxviii–xlviii.

[15] Authors from FORGENG 2006 to KIEFFER 2022 have committed to this error, but as VANSLAMBROUCK points out, Tobias Stimmer wouldn't even settle in Strasbourg until after the book was finished—he spent 1568–70 in Como, a city in the Duchy of Milano, working on a massive cataloging project. If he contributed anything, it was probably limited to drafting designs that wouldn't require him to observe fencers in person, such as the unmonogrammed title page and frontispiece. His brother was the one active in Strasbourg as an engraver at this time, and their styles are virtually indistinguishable, even to most art historians. Many of the engravers listed above would go on to work closely with Tobias in the 1570s, but those relationships develop in the years after the work on Meyer's book.

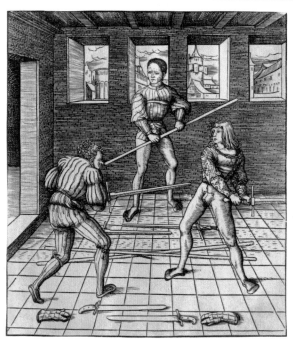

Fig. 5: Wie der junge weiße König das Fechten mit Schwertern und anderen Waffen erlernte. *("How the young White King learned to fence with swords and other weapons") by Leonhard Beck (draftsman) and Alexius Lindt (engraver), 1514–16. Left: Original woodblock (Albertina HO2006/342); right: 16ᵗʰ century proof print from the block, printer unknown.*

PRINTING A BOOK

To print his *magnum* opus, Meyer contracted the services of Thiebolt Berger (fl. 1551–1584), who operated a small print shop in the Trübel house in Strasbourg's Wine Market district.

Once the copytext and woodblocks were complete, Berger and his apprentices would've then carefully begun building pages, letter by letter and line by line. The type was held in large cases[16] and would be assembled on *type-sticks* and transferred to trays called *galleys* before being used to lay out complete pages.

Printing would typically be done on large rectangular sheets that varied from 45–85 cm (16–33 ½ in.) on the long side and 30–60 cm (12–23 ½ in.) on the short side. The sheet would be printed with anywhere from two to sixteen pages on each side, which would then be folded up into a booklet and cut along the folds.[17] This booklet is known as a *quire* or *signature*, and most books are built from many—Meyer's has 57.

Printers often didn't own enough type to print all of the pages on a sheet at once, so they would plan out the text for each page of the sheet and then print a few at a time. If their guess about how much text would fit on each page was wrong, then they'd have to start either abbreviating words to shorten the text or arranging it in triangles and diamonds to use up more space.

Some printers didn't have presses large enough to hold an entire sheet, either, so when they could only get large sheets they would cut them into half-sheets before printing. Berger's printing presses seem to have been on the small end, since Meyer's book was printed on sheets roughly 40 × 50 cm in signatures of eight pages (rather than the usual sixteen).

The paper weight is also very inconsistent in surviving copies—two or three different thicknesses are used randomly throughout each copy, and sometimes the same signature (consisting of two folded sheets after the cutting) will have two different thicknesses of paper, indicating that the pages were cut and stored separately prior to binding.

Another anomaly in Meyer's book is the page numbering. It is *numbered in folio*, which means that only

[16] The organization of these *typecases* is the origin of the terms "upper-case" and "lower-case" letters.

[17] DANE 2012: 52–53. This system, based on the size of the sheet of parchment that can be rendered from one sheep, goat, or calf skin, carries forward all the way to the present day in the ISO standard 'A series' of paper sizes.

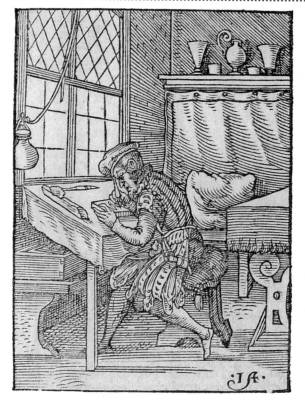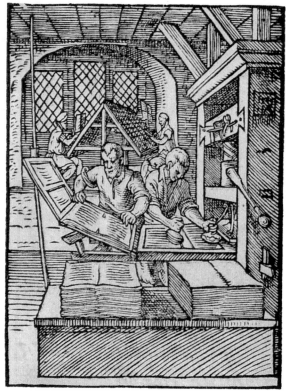

Fig. 6: Artisans involved in printing a book. Left: Sculptor. Der Formschneider. *("Engraver"); right:* Typographus. Der Buchdrucker. *("Printer"); by Jost Amman, 1568 (printed by Sigismund Feyrabendt).*

the front of each page is numbered (the back of the page is just referred to as the *verso* or 'reverse' side of that number). This was quite common, but much less common is the fact that the numbering restarts twice—at the beginnings of the Dusack and Dagger.

The reason for this is unclear. It might indicate an initial plan to sell it as a three-volume set rather than one large compendium. It might equally signify that the printing was done in stages (perhaps because Meyer couldn't afford it all at once) and the sword was not the first section completed, so correct numbering from start to finish couldn't be estimated.

When it came to printing illustrations, woodblocks were much easier to handle than copperplates. Since woodblocks are inked in the same way type is, they could be added directly into the page layout and have type set around them. This ensured that each picture would appear in the intended place every time.[18]

Once the type was set, then a proof would be printed to be sure it looked the way they expected.

Every attempt would be made to correct any errors at this point, but they still crept through. Any further errors that a printer noticed might be invisibly corrected in the middle of printing (usually with no effort made to correct the copies already printed).

Notably in Meyer's book, some copies have page II.96 misnumbered "XCVII", II.97 misnumbered "XCXVII", and II.97 misnumbered "XCXIX"; other copies have the numbers on II.96–97 corrected and II.98 changed to the equally-incorrect "XCXVIII". Page II.18, on the other hand, was misnumbered "XIX" and never corrected in any extant copy.

Figure D in the Sword Section also initially had a defect in which two small black rectangles are visible in some copies, but were removed at some point during printing (see Fig. 17).[19] Uncorrected block errors

[18] Conversely, copperplates were incompatible with type since they were inked the opposite way. Instead, the printer would have to leave gaps in the text the right size for the plate, and then do a second printing of the page that tried to position the plate in the gap. This often resulted in alignment errors—including having pictures overlap text.

[19] Figure D (pp. xi & 14–15) is also unique in that the portraits of the guards Key and Change are numbered '11' and '7' respectively, which matches their positions in Meyer's list of guards, and the upper right tenants are labeled 'd'. The

include placing the wrong letter into the block (G instead of H on I.32V) and forgetting to place a letter at all (on III.15, presumably meant to have an E).

There may well be other, less obvious corrected errors lurking in the text, but only manually checking many copies against each other will identify them.

Errors noticed after the printing was complete would be listed on an errata page at the back of the book; in Meyer's book, the errata only covers the Sword and Rapier Sections, so either no errors were found in the other sections or no one checked them for errors in the first place.

It's unclear how many copies of the book Berger printed, but it likely ranged from 450 to 1250 and took about four months to complete.[20]

The combination of errors corrected and uncorrected, as well as problems perfectly aligning sheets each time another portion is printed, start to differentiate each copy before it even leaves the print shop.

FINISHING A BOOK

Once the text was complete, the book would be sent to a bindery to be finished. Typically, the buyer would purchase the unbound sheets and send them to a binder of their own choosing.[21] This means that there was no 'standard' binding for a particular book and rather each one would end up unique.

To bind a book, all the signatures would be sewn through the middle to attach them to cords (usually three to five of them), and these cords would then be attached to the inside of the wooden boards (usually oak or beech). The back of the book where all the sewing happened is the *spine*, and the boards are the *covers*. For a cheaper binding, paperboard might be used instead of wood. Either way, the whole thing would be covered with leather (if the buyer could afford it) or parchment (if they couldn't or didn't want to) in order to protect the boards and the stitching.

Some books were instead covered in luxury fabrics like velvet, but such material was mostly too fragile to survive the succeeding centuries.

The cheapest binding of all would be a parchment cover without any boards (called a limp binding—the equivalent to a softcover book today).

Leather covers would often be decorated using metal tools like stamps or wheels with patterns on them (called "tooling"). These could be used to press foil into the leather to make gold or silver decorations, or just by themselves, which is called "blind" tooling and was especially popular among German book buyers in the early modern era. Books in this era might also still be protected with cornerpieces and centerpieces of brass, copper, or bronze, and with clasps or ties to hold them shut.

The page edges also might be painted red or blue or even gilded—or at the highest level of luxury, *gauffered*, meaning that a tooling wheel was heated up and then rolled down the gilded edge to melt a pattern into it.

With this focus on protecting the book, it might surprise some to learn that binding also sometimes involved cutting the margins (or even part of the text) off to make the book smaller, either to match other books on its destination shelf or for ease of carry.

Books would also be embellished on the inside. In Medieval thought, a book wasn't completed until the decorations and illustrations were painted, if not illuminated. This attitude persisted long into the 'age of print', and printed illustrations were generally viewed as incomplete until they'd likewise been painted.[22]

Those who could afford it would take their books to yet another artisan to add the finishing coloration. There were various crafts that included the skills and willingness to sometimes paint books. The cheapest were the 'card painters' (German: 𝕶𝖆𝖗𝖙𝖒𝖆𝖑𝖊𝖗) who would make a living coloring playing cards, handbills, and other small, disposable paper goods. More skilled (and therefore more expensive) were the 'letter painters' (German: 𝕭𝖗𝖎𝖊𝖋𝖒𝖆𝖑𝖊𝖗) who made their living primarily coloring larger prints like icons and posters. The most elite were the illuminators (German: 𝕴𝖑𝖑𝖚𝖒𝖎𝖓𝖎𝖘𝖙𝖊𝖓) who traditionally colored manuscripts and had the skills of applying gold leaf and metallic paints.[23]

placement of the two black rectangles suggests they were intended to be carved into additional labels as part of this aborted plan. During printing, someone apparently thought they were errors and carved them out of the block.

[20] See CHRISTOPHER VANSLAMBROUCK's introduction to Volume 1, p. xlvii.

[21] It does seem that occasionally a printer would make a deal with a local bindery to produce pre-bound books for less picky customers—in any case, it wasn't the printer's job to bind the book.

[22] The watershed study on the practice of painting prints in 14th–16th century Germany is DACKERMAN 2002. Also see OLTROGGE 2009 and HORSBATCH 2020.

[23] A few artists experimented with multicolor printing to address this need, in which several blocks or plates were created, each with only the parts intended to be a specific color, and they would then be printed onto the (Continued on p. x)

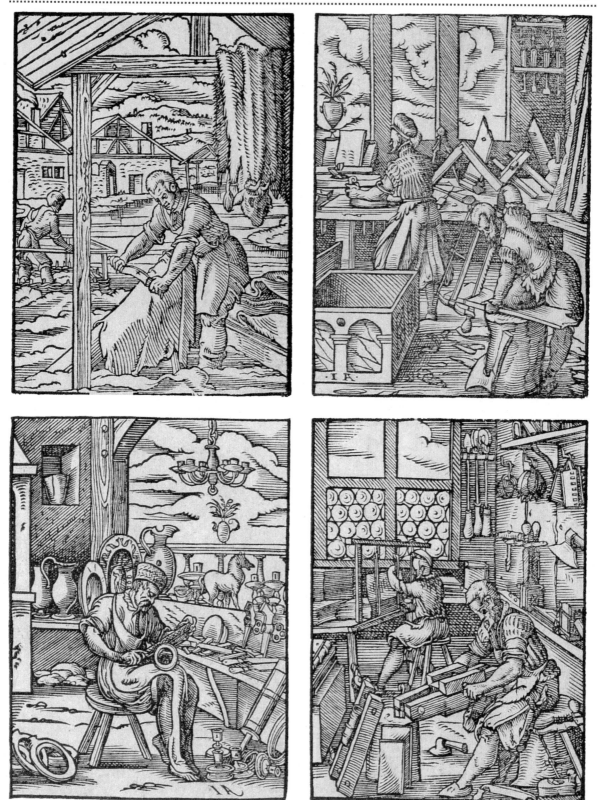

Fig. 7: Artisans involved in binding a book. Top left: Alutarius. Der Gerber. ("Tanner"); top right: Arcularius. Der Schreiner. ("Carpenter"); bottom left: Conflator orichalceus. Rotschmidt. ("Redsmith"); bottom right: Concinnator librorum. Buchbinder. ("Bookbinder"); by Jost Amman, 1568 (printed by Sigismund Feyrabendt).

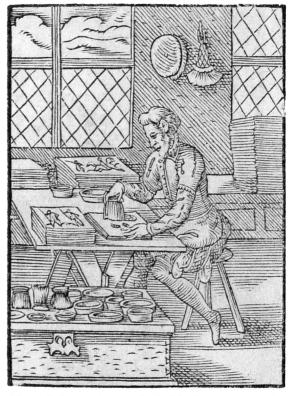 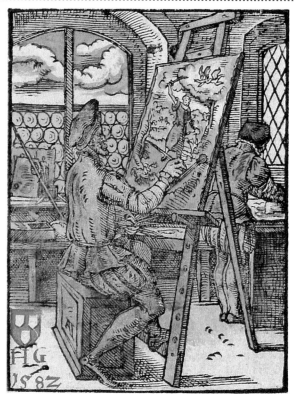

Fig. 8: Artisans painting a book; left: Illuminator imaginum. Brieffmaler. *("Illuminator"); right:* Pictor. Der Handmaler. *("Painter"); by Jost Amman, 1568 (printed by Sigismund Feyrabendt; 'painter' painted by an unknown artist).*

This is a major point at which some copies become distinguished from all the others, since no two painters will produce the same paint—and even the same painter won't be able to perfectly replicate the same paint job twice, even if they wanted to. There are at least ten extant copies of Meyer's book that have some amount of coloration: 1.02, 1.03, 1.07, 1.10, 1.11, 1.14, 1.17, 1.18, 1.24, and 1.29.[24]

Of these, 1.02, 1.03, 1.07, and 1.29 have only small amounts of incidental color that might have just been added by an owner at some point in the past 450 years. (1.02 also shows that one reader went on a quest to add blood fountains to all of the Rapier Figures and a few others.) 1.24 has not yet been digitized or had specific information about its prints published, so the degree of painting is currently unknown.

The remaining five run the gamut of quality and extent of painting.

1.17 is the worst of this group. There is paint on the title page, frontispiece, and Sword Figures B, C, and K are colored in an extremely uneven and haphazard fashion with the look of perhaps finger paints. Sword Figure A was torn out, but the remaining upper corner also shows the remains of paint. The artist in this case seems likely to have been a child.

1.11 has paint on Sword Figures A×2, B, C, D, F, H, & N, Dusack Figures B, C×2, K, L, M, & N, Rapier Figures B, C, & F, and Dagger Figure A. These are still not high-quality work, but mostly show some semblance of intentionality—some of the problems may have been due to using improper paints for the paper,

Fig. 9 (facing): Comparison of Sword Figure D from three painted copies and one unpainted; clockwise from the upper left: 1.12, 1.14, 1.18, & 1.11. Note the black marks under the feet of the upper left tenants and inside the arms of the central tenants, present in all but 1.18. See also footnote 19.

(Continuted from p. viii) same sheet in sequence. This was prone to alignment problems, though, and also only provided very flat and simple color. It never caught on.

[24] The copy numbers used in this article refer to the Meyer Census in the Appendix in Volume 1 and CHIDESTER 2024.

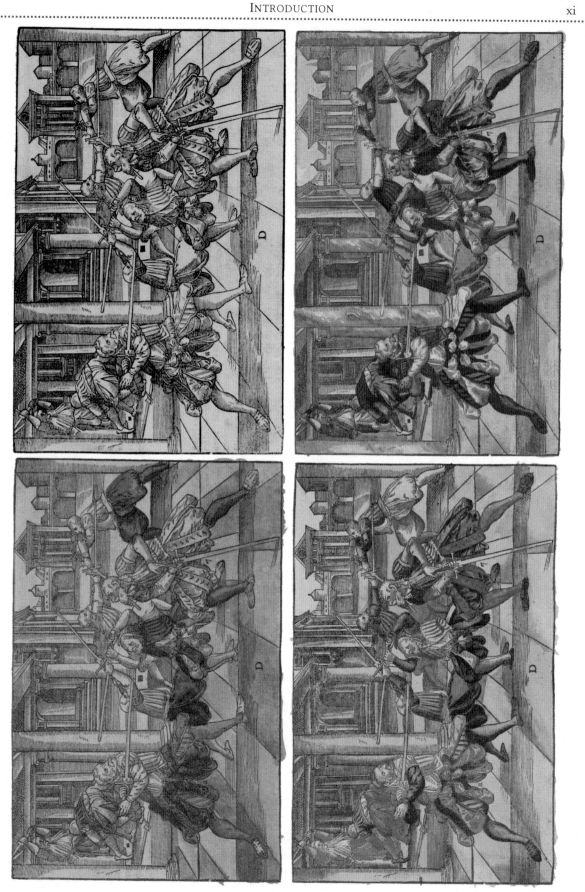

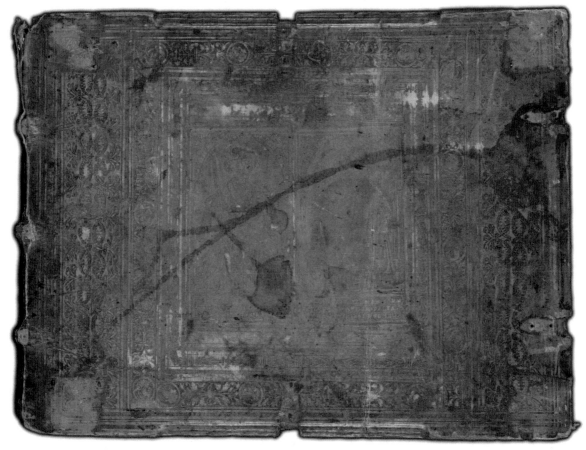

Fig. 10: The cover to Meyer copy 1.14. This is a pigskin leather cover that was blind-tooled using various wheels and stamped with depictions of Justice and Lucretia (now mostly worn almost flat). On the left side of the cover, you can see three sewing supports in the spine, and the cover also shows the imprints of the four clasps and four corner-pieces that once protected it.

which ran and bled considerably. Most of these prints are only partially painted, suggesting that the work was abandoned at an early stage.

1.18 has some amount of painting on the title page, frontispiece, Sword Figures A×2, B, C, D, F, G×2, K×2, & L, Rapier Figures C & G, and the portrait of rapier alone. Several of these seem to be largely complete, but others were again abandoned unfinished. Despite this, many of the Figures are painted quite skillfully (much more than the previous three). The disparity between the degree of skill shown in some of the Figures and the blotchy and incomplete nature of others may suggest that a professional painter was contracted to paint a selection of the Figures, and then an enthusiastic amateur later attempted to equal their work.

1.10 has six painted prints: the title page, frontispiece, Dusack Figure B, Rapier Figure G, Dagger Figure C, and the portrait of Rapier and Cloak. The title page and frontispiece received lavish attention from the artist, whereas the others are painted competently but unambitiously with a very limited color palate.

The most impressive of all the known copies—and the source of the painted prints found in the present Volume—is unquestionably 1.14. All 76 large prints are fully and lavishly painted (only the two small cutting diagrams in the Sword Section were left uncolored). The painting uses an enormous pallet of colors, delicately applied, and in many places the artist adds embellishment of their own devising such as textures on the columns and floor tiles and patterns on the fencers' clothing. This is a princely work, and a note inside the front cover indicates that it was done at a cost of 8 *Thaler* (presumably per page) by 1574.

A final note on the painting is that only 1.10 and 1.14 paint the background of the Cutlers' crest on the title page with the correct color (blue), and only 1.10 uses correct colors on the Wittelsbach heraldry. For these reasons, 1.10 is the best candidate for having been commissioned by Meyer himself.

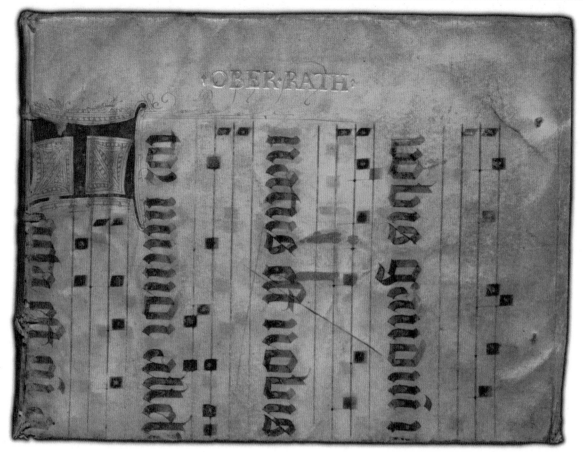

Fig. 11: The cover to Meyer copy 1.20. This is a limp binding made from parchment recycled from a Medieval choir book—about the cheapest binding material available. This also has three sewing supports on the left edge, and on the right there are the nubs of two ties that would hold the book closed. A later owner had 'OBER-RATH' stamped into the cover with gold foil.

USING A BOOK

Once a book left the printer, it took on a life of its own. We've already discussed how each owner would have their copy bound according to their tastes and needs, and also have it colored if they could afford it. But what did these owners do with their books once the parade of craftsmen shown across the previous pages had completed their labors?

When talking about the ways historical readers interacted with their books, scholars typically focus on 'use marks'.[25] This is a broad category that covers everything from fingerprints and food or liquid stains to marginal annotations and underlining to manual error correction or censorship of the text. The surviving copies of Meyer show a range of reader interactions and we'll summarize them here.[26]

One common and obvious reader intervention is correcting the text, and specifically implementing the errata on the last page. We see this in several copies, including 1.04, 1.10, 1.11, 1.15, and 1.17; in 1.11, the errata block was subsequently scribbled out.

Readers also show frequent interest in the Figures specifically. Apart from having them painted as described above, some or all of the guard positions are labeled either under the Figure or inside it in 1.08, 1.28, 1.33, and 2.14. In addition, paper tabs intended to make the Figures easy to find were added to 1.08 and 1.14, and tables listing the page number of each Figure appear at the beginning of 2.14 and 2.15.

[25] For an introduction to the study of use marks, see JACKSON 2001, SHERMAN 2008, and DANE 2012: 157–170. For specific discussion of ways owners used fencing treatises, see FORGENG 2012.

[26] A full review of the use marks identified in copies of Meyer can be found in the Appendix to Volume 1.

The fascination with Meyer's Figures also has its dark side: the practice of "bookbreaking", in which pages in a book that are deemed particularly interesting are cut out by a dealer and sold separately—sometimes they will even discard the rest of the book as worthless! 1.25, 1.38, 2.01, 2.07 have had many of their Figures cut out, whereas 1.32 and 1.34 consist only of pages cut from unknown copies that surfaced for sale with no information about their sources.

As we've already seen, writing in books was not a taboo in this era the way it often seems to be today. In fact, it was encouraged as a means of studying and grappling with a text. Many passages are underlined in 1.07, 1.17, 1.28, and 2.07, whereas 2.14 has a series of diagrams in the margin of page II.3 that replicate Meyer's four cutting lines and associate them to the descriptions on that page with interlinear numbers.

Some readers tried to make connections with other fencing teachings inside their books, such as the quotations from the 1579 treatise of Heinrich von Gunterrodt on the front flyleaf of 1.20 or the notes on fencing inside the covers of 1.07. The fencing print hand-copied into 2.03 might also fit into this category.

Other readers inserted other printed materials directly into their copies, such as the *Epithaphium* in 2.03 or the broadsheet containing the teachings of Balthasaro Cramonio Pomerano found in 1.03.

An example of a book that was used extensively in the more recent past is 2.07, which was owned by KARL WASSMANNSDORFF, the great wrestling historian in the late 19th century. He carefully studied the book and left notes and diagrams on virtually every page of the Sword Section and sporadically through the rest of the book. He also replaced the stolen pages by tracing Figures from copy 1.15 and copying the text over onto the other side.

The search for a book that was equally well-used by a 16th or 17th century reader continues.

ABOUT THIS BOOK

I hope this tour of book history helps in some way to contextualize the book you're now holding—and the book that it's based on, which was first printed 453 years ago.

Like Meyer's readers throughout the centuries, modern HEMA practitioners often fixate on the artwork that Stimmer and his workshop created for Meyer. It unlocks a lot of ideas about movement that are not explicit in the text and helps make the sometimes-complex technical descriptions more concrete.

But ensuring that the Figures were readily available to readers is a problem that Meyer never solved. Since the Figures often include techniques from far-flung parts of their section, placing a full-page print next to each reference is practically impossible. Historical readers tried to deal with this by adding page tabs and reference tables, as mentioned before.

For the Reading Edition of this translation, we took a cue from Meyer's later recensors Jakob Sutor (1612) and Theodori Verolini (1679) by separating the Figures into manageable pairs and individuals and placing them close to the text they describe.

In this, the Reference Edition, we're taking a different approach and separating the Figures from the text entirely.[27] The original German text and REBECCA L. R. GARBER's English translation can be found in Volume 1, whereas in this Volume 2, we're including the beautiful Figures from 1.14, digitally restored to something approaching their original colors and presented at 150% of their original size, as well as a black-and-white cutouts of just the fencers in each figure, presented at the original size, and reference tables that will help associate the Figures with the text in Volume 1 (and JEFFREY FORGENG's 2005 translation, if you prefer). It also includes plenty of space to add your own notes about how you think the pairs of fencers that are not referenced in the text relate to Meyer's teachings.

The appendixes at the end include all the illustrations from JMM, JML, and JMR, as well as some other pictures mentioned in Volume 1—the 1570's dedicatee, Johan Kasimir; maps of the current locations of known Meyer books; and some Fechtschule and training scenes that we couldn't include in CHRIS's introduction either due to space or because they were in color.

Enjoy!

MICHAEL CHIDESTER
Project Editor

[27] This Volume is based on CHIDESTER & Stimmer 2020, but fully revised and expanded with additional content.

PREFACE

Title Page

Artist: Anonymous

Prior work: None

Position: a i

References:

Meyer	Forgeng	Garber	Position	Description
III.40	267	370	Large scene	Low Guard (𝕌nderhut)

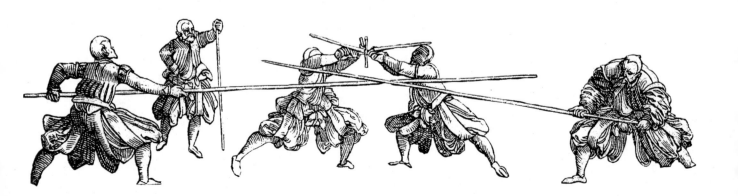

Frontispiece*

Artist: Anonymous

Prior work: None

Position: a iV

References:

Meyer	Forgeng	Garber	Position	Description
a ii	37	7	Center	Wittelsbach heraldry

* Note that this painted illustration is the only one that does not come from copy 1.14. It is taken instead from 1.10, because that's the only copy that uses the correct colors for Johan Kasimir's heraldry.

SWORD

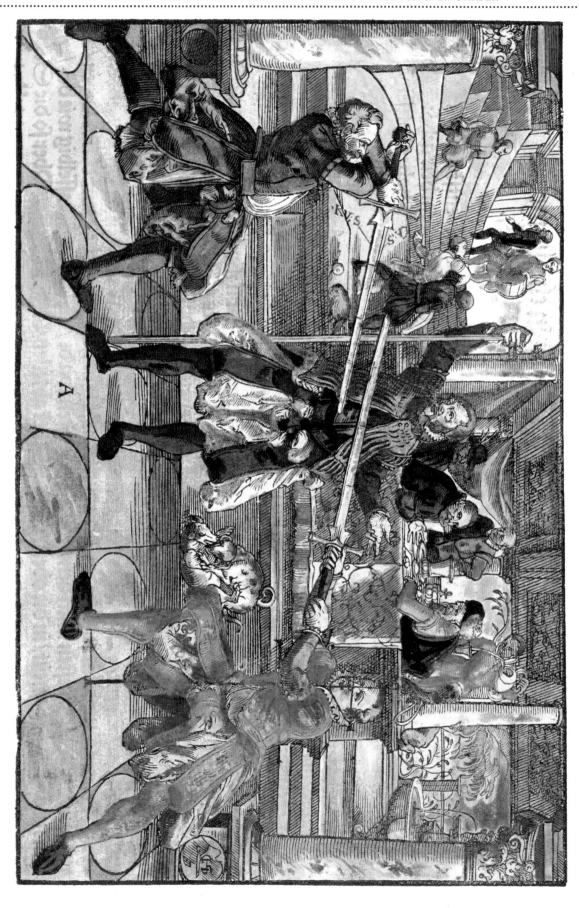

FIGURE A

Artist: Hans Christoph Stimmer

Prior work: None

Positions: I.3, I.27

References:

Meyer	Forgeng	Garber	Position	Description
I.3V	51	29	Large right portrait	Four parts of the opponent
I.5	52	31	Large left portrait	Long and short edge of the sword
I.5	52	31	Large scene	Four parts of the sword
I.7V	54	36	Large right portrait	Longpoint (𝕃angort)
I.35	79	80	Large right portrait*	"hit them with the inverted flat from your left to their right ear"

* The text says "right", but the action described fits the left fencer better (assuming they were supposed to be right-handed with crossed arms rather than left).

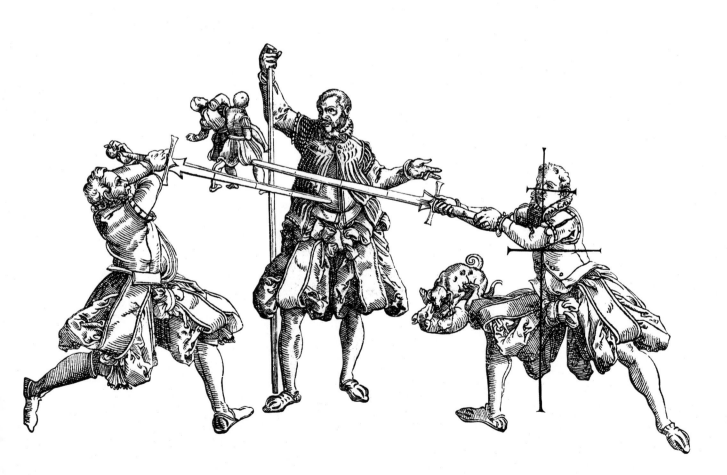

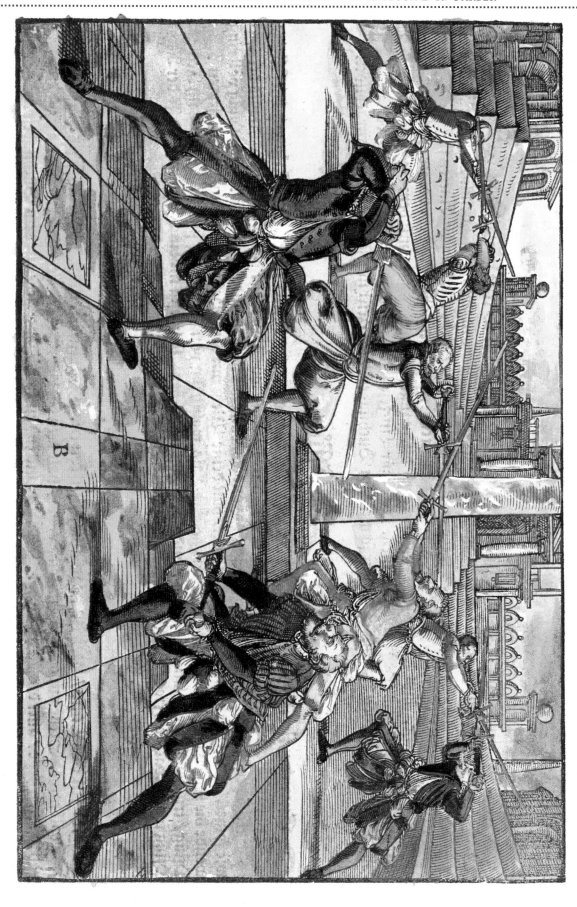

FIGURE B

Artist: Anonymous

Prior work: JML 29^V, JMM 12^R

Position: I.6

References:

Meyer	Forgeng	Garber	Position	Description
I.6^V	53	34	Large left portrait	Right Ox (Ochs)
I.6^V	53	34	Large right portrait	Right Plow (Pflug)
I.11^V	57	41	Medium scene, left portrait	Low Cut (Underhauw)
I.13	58	43	Small left scene, right portrait	Short Cut (Kurtzhauw)
I.61*	105	122	Small left scene	"slide down the back of their blade"

* Forgeng suggests that this is an error and Meyer meant Figure C.

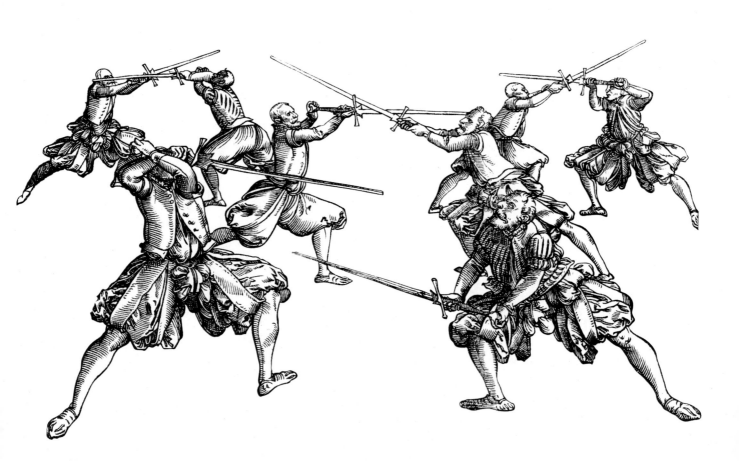

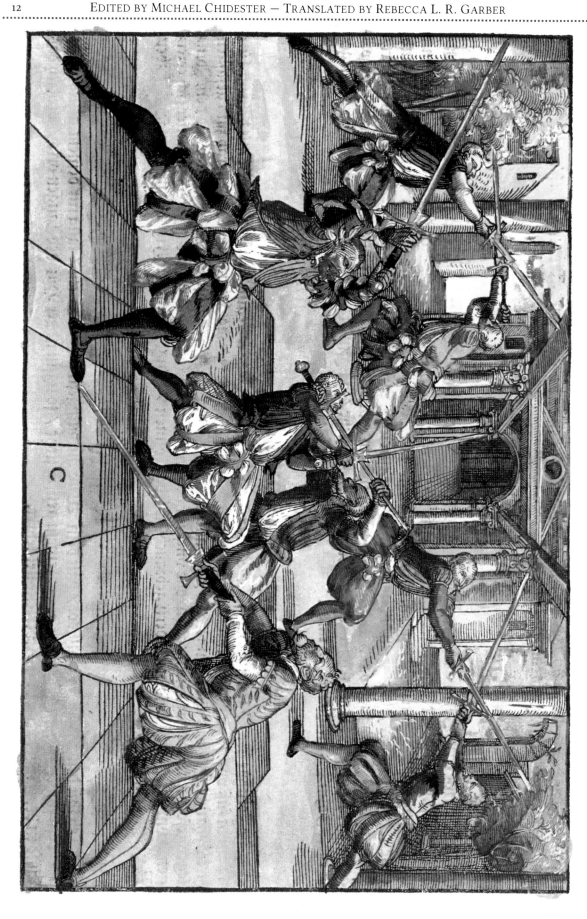

FIGURE C

Artist: Anonymous

Prior work: JML 34R, JMM 12V

Position: I.7

References:

Meyer	Forgeng	Garber	Position	Description
I.6V	53	35	Large left portrait	Day (Tag)
I.7V	54	35	Large right portrait	Fool (Olber)
I.29V	74	71	Small left scene	"hit at their left ear with the half edge"
I.37V	82	84	Small left scene	"flick quickly (with the inner flat or short edge) at their head"
I.37V	82	85	Small right scene	Simple Brace (Gerader versatzung)

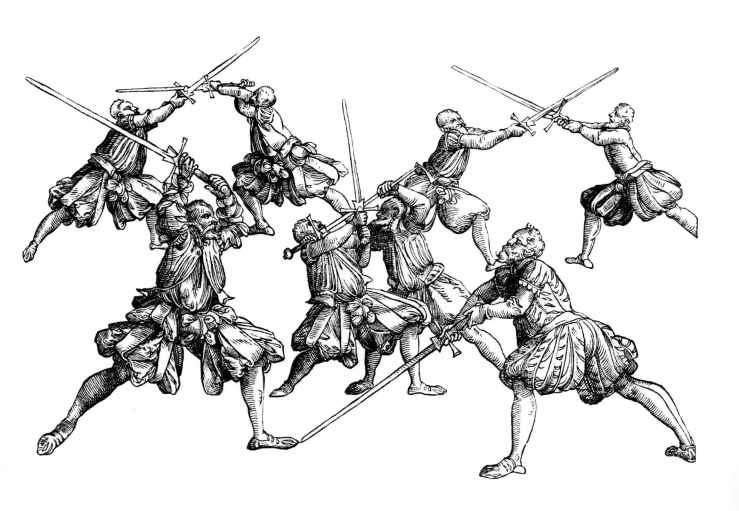

SWORD

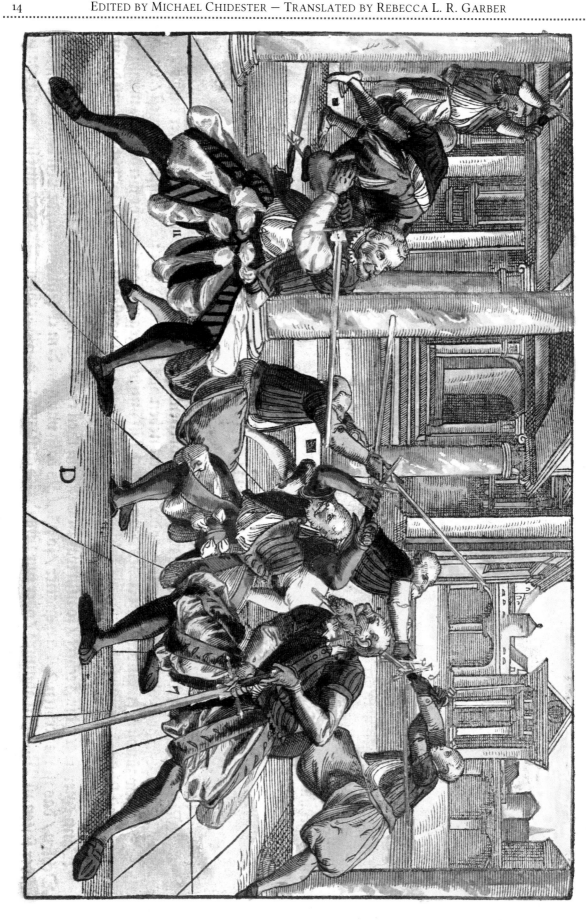

FIGURE D

Artist: Anonymous

Prior work: JML 25R

Position: I.17

References:

Meyer	Forgeng	Garber	Position	Description
I.8	54	36	Large right portrait	Change [Guard] (𝔚𝔢𝔠𝔥𝔰𝔢𝔩)
I.9	55	37	Large left portrait	Key (𝔖𝔠𝔥𝔩ü𝔰𝔰𝔢𝔩)
I.12V	57	42	Small right scene	Crooked Cut (𝔎𝔯𝔲𝔪𝔭𝔥𝔞𝔲𝔴)
I.38	82	85	Small right scene	ripping (𝔑𝔢𝔦ß𝔢𝔫)
I.62V	108	126	Small left scene	"pull towards you so that they fall on their back"

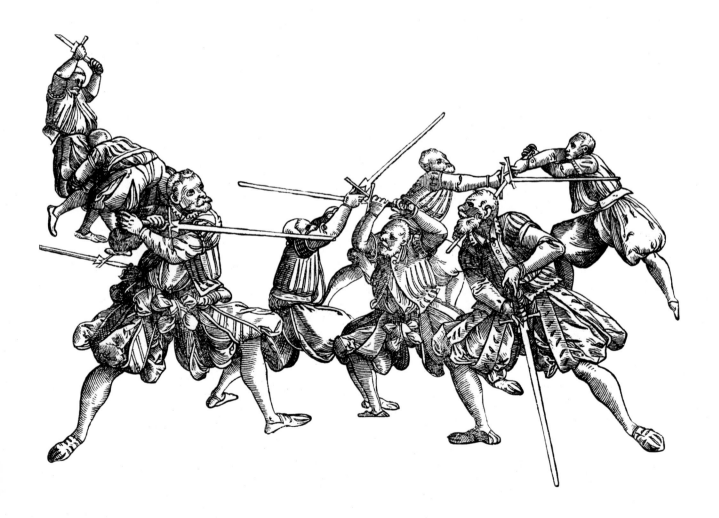

SWORD

FIGURE E

Artist: Anonymous

Prior work: JML 31^V & 36^R

Position: I.34

References:

Meyer	Forgeng	Garber	Position	Description
I.7^V	54	35	Large left portrait	Wrath Guard (Zornhut)
I.9	55	37	Large right portrait	Unicorn (Einhorn)

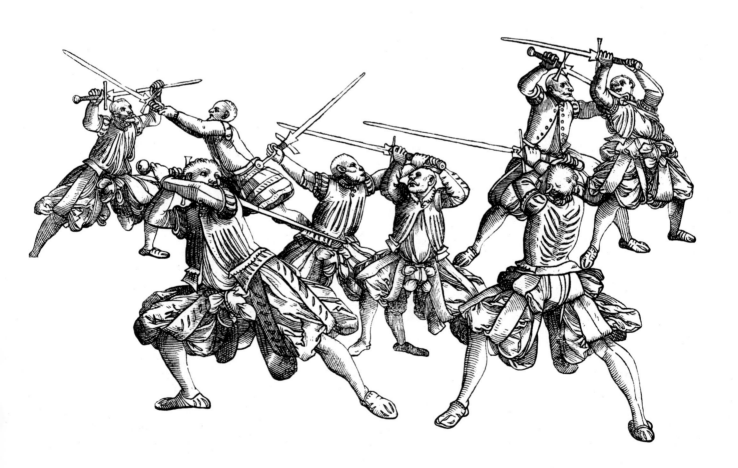

SWORD

FIGURE F

Artist: Anonymous

Prior work: JML 15R, JMM 11V

Positions: I.8V, I.39

References:

Meyer	Forgeng	Garber	Position	Description
I.8	54	36	Large left portrait	Crossed Guard (𝕾𝖈𝖍𝖗𝖆𝖓𝖐𝖍𝖚𝖙)
I.9	54	36	Large right portrait	Hanging Point (𝕳𝖆𝖓𝖌𝖊𝖙𝖔𝖗𝖙)
I.34V	79	80	Medium scene	"rip out upward with your sword toward your right"
I.39V	83	87	Large right portrait	Hanging Point (𝕳𝖆𝖓𝖌𝖊𝖙𝖔𝖗𝖙)
I.42	86	92	Small left scene	"hit powerfully and high with the flat or short edge at their left ear"
I.42V	86	92	Small right scene	"set the front point on their chest and Indesly grab the pommel again"

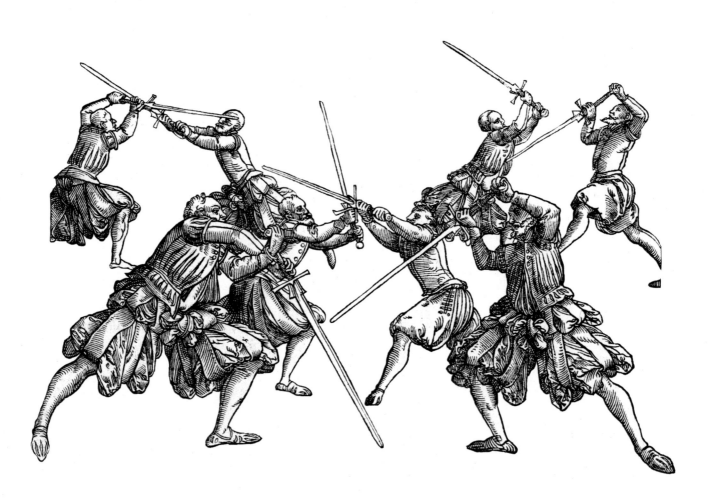

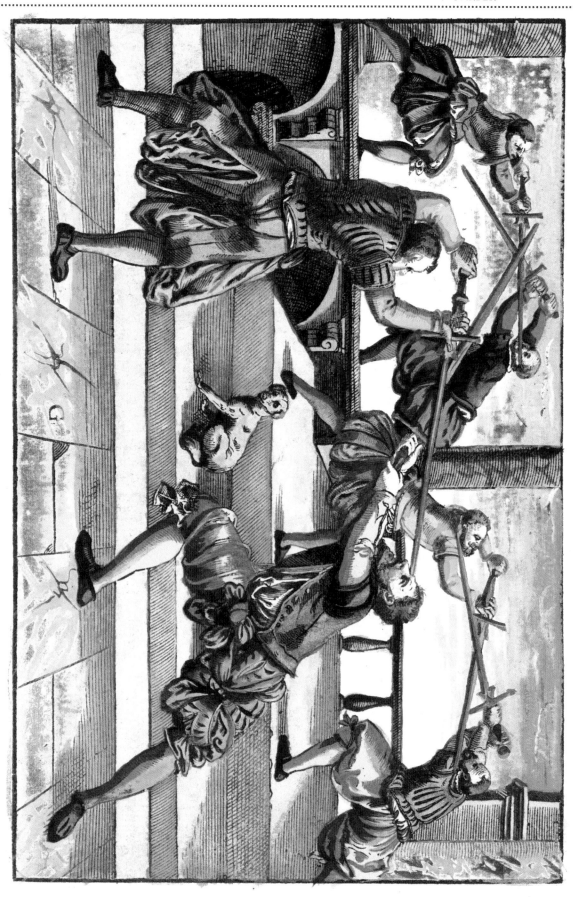

Figure G

Artist: Anonymous

Prior work: JML 22V

Positions: I.13V, I.46V

References:

Meyer	Forgeng	Garber	Position	Description
I.11V	57	42	Large left portrait	Squinter Cut ($\mathfrak{Schielhauw}$)
I.33	77	77	Small right scene, left portrait	"cut with the long edge from below at their left arm"
I.33	77	77	Small right scene, right portrait	"drop onto their sword with crossed hands"
I.47	92	100	Unspecified	"cut at their right ear with the short edge"
I.54V	99	112	Large left portrait	Squinter Cut ($\mathfrak{Schielhauw}$)

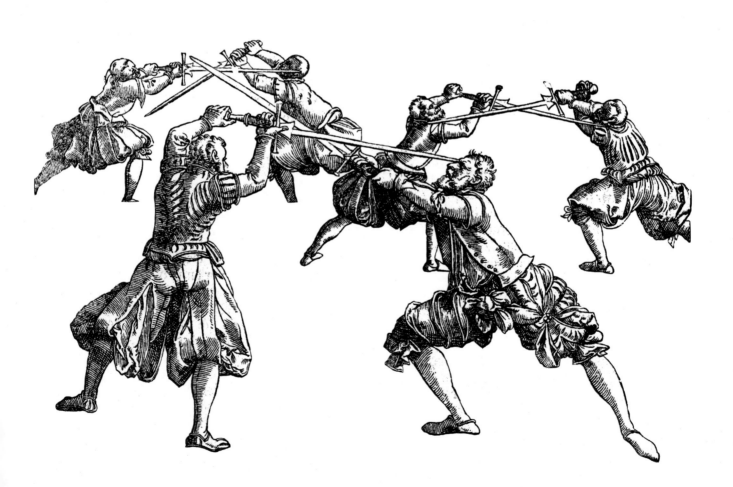

SWORD

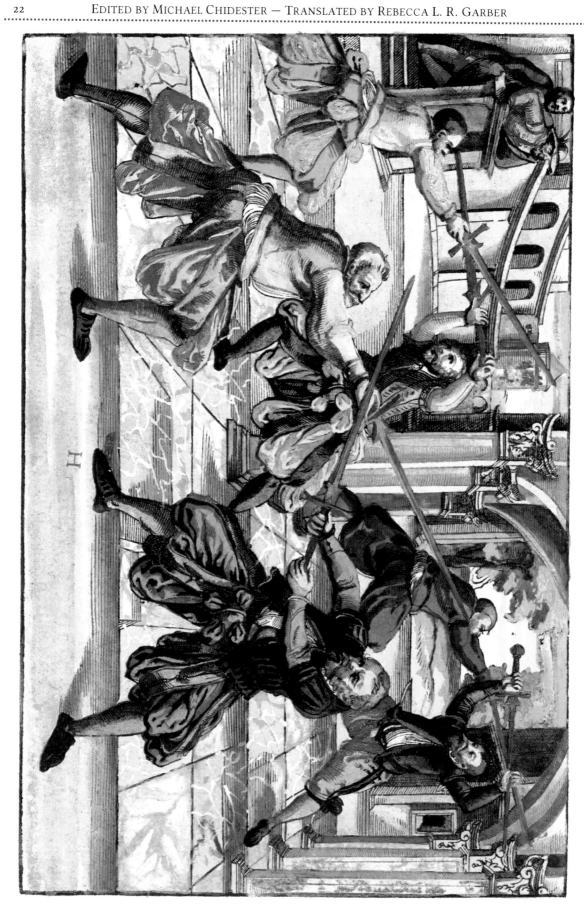

FIGURE H

Artist: Anonymous

Prior work: JML 14^R

Positions: I.32^V,* I.41^V

References:

Meyer	Forgeng	Garber	Position	Description
I.12^V	58	42	Small left scene	Crosswise [Cut] (𝔷werch)
I.14	59	44	Large right portrait	Twisting Cut (𝔚indthauw)
I.41	86	91	Small right scene	"take their sword"
I.64^V	110	130	Large right portrait	"step with the left foot further out toward your left side"

* The Figure on I.32^V is mislabeled G.

SWORD

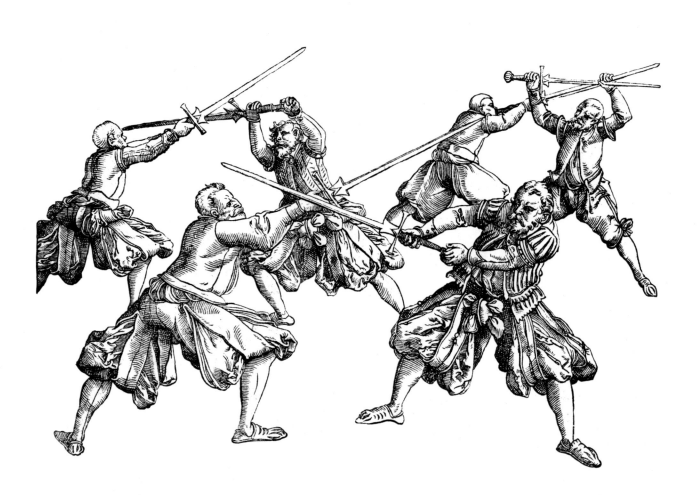

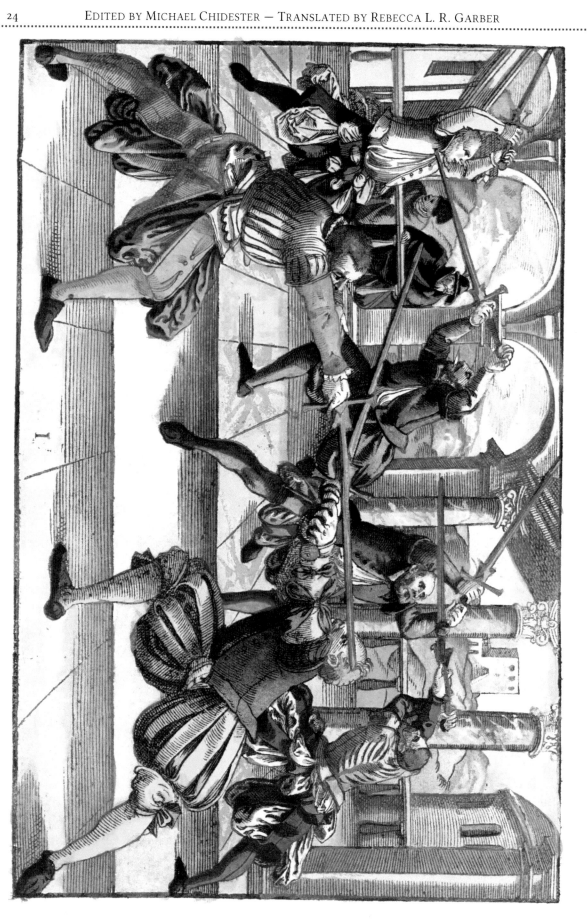

FIGURE I*

Artist: Anonymous
Prior work: JML 28[R]
Positions: I.37, I.56
References:

Meyer	Forgeng	Garber	Position	Description
I.13	58	43	Large left portrait	Double Rebound Cut (𝕻𝖗𝖊𝖑𝖑𝖍𝖆𝖚𝖜)
I.38	82	85	Small right scene, right portrait	"drop in front on their arms with the short edge"
I.41	85	90	Small left scene	"cut at them from below at their chin"
I.51[V]	96	108	Small right scene	"catch their ricasso with yours"
I.55[V**]	101	115	Small left scene	"the long edge arrives in front and across on their arms"

* There is no Figure J in this book. This is because I and J started off as the same letter, and in this period they still were often not distinct from each other.
** Meyer indicates Figure I, but Forgeng suggests that this is an error and he meant Figure N.

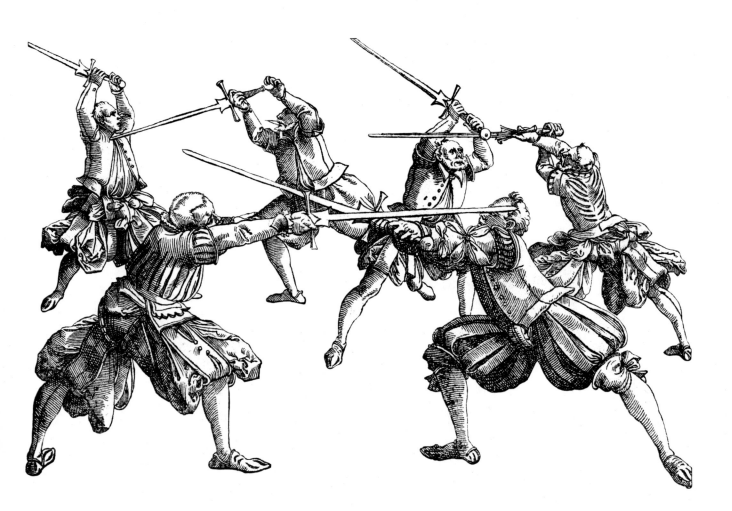

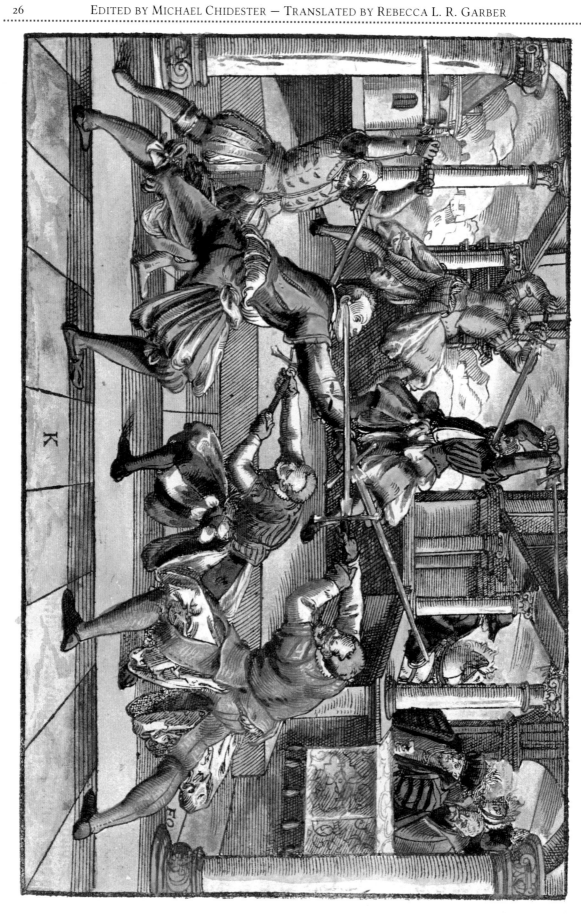

FIGURE K

Artist: F. O.

Prior work: JML 18$^\text{V}$

Positions: I.12, I.48, I.57$^\text{V}$

References:

Meyer	Forgeng	Garber	Position	Description
I.13	58	43	Large right portrait	Single Rebound Cut (𝕻rellhauw)
I.36$^\text{V}$	81	83	Large right portrait	Single Rebound Cut (𝕻rellhauw)
I.47$^\text{V}$	93	102	Small scene	Crosswise [Cut] (𝖅werch)
I.57	102	117	Small scene	Crosswise [Cut] (𝖅werch)

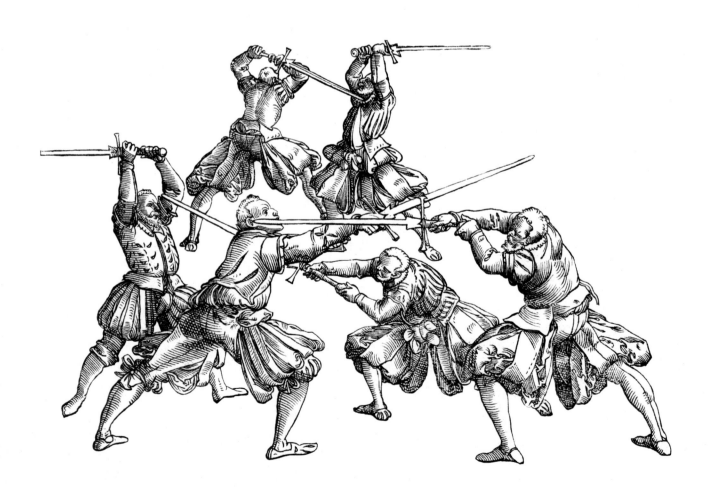

FIGURE L

Artist: Anonymous

Prior work: JML 12$^{\text{V}}$

Position: I.20

References:

Meyer	Forgeng	Garber	Position	Description
I.34$^{\text{V}}$	79	79	Medium scene	"twist the short edge under their sword inward at their head"
I.58	103	118	Large left portrait	Crosswise [Cut] (Zwerch)

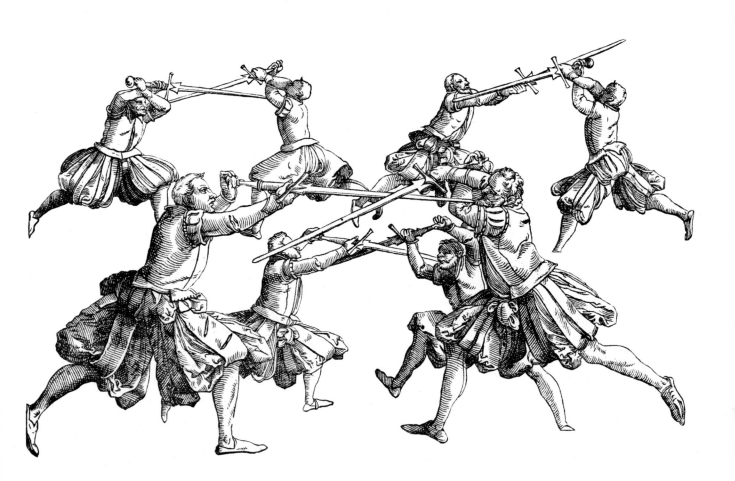

FIGURE M

Artist: Anonymous

Prior work: JML 40R, JMM 10V & 13R

Position: I.43V

References:

Meyer	Forgeng	Garber	Position	Description
I.43	87	93	Medium scene	"lift with your blade"
I.43	87	93	Large scene	"place your short edge behind their blade on their head"
I.43	88	94	Small right scene	"catch their Crosswise Cut on your hanging blade"

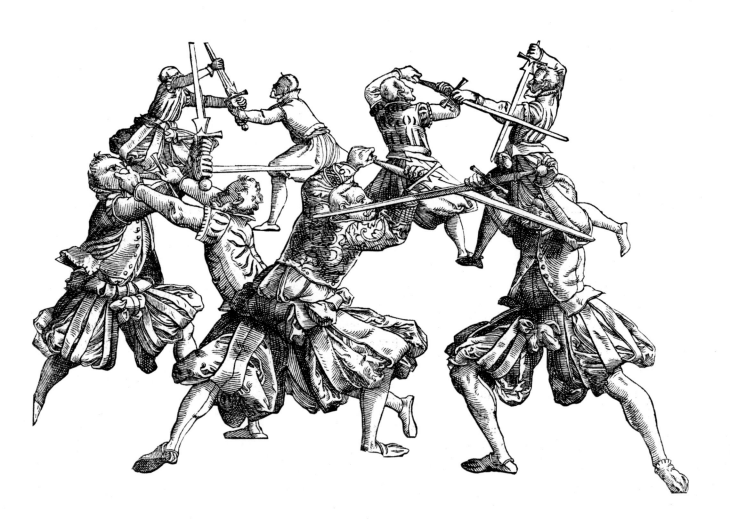

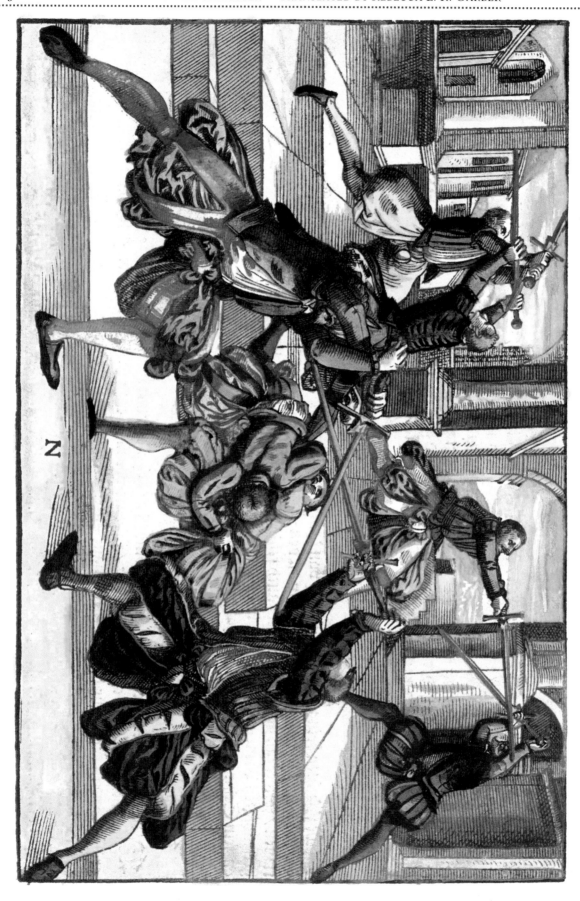

FIGURE N

Artist: Anonymous

Prior work: JML 21R

Positions: I.52, I.58V

References:

Meyer	Forgeng	Garber	Position	Description
I.42	86	91	Small right scene	"catch their cut on your long edge"
I.52V	97	109	Small left scene, right portrait	"grab your blade in the middle"
I.58	103	118	Large right portrait	"turn the long edge over their blade (up from below and from outside) toward their head"

SWORD

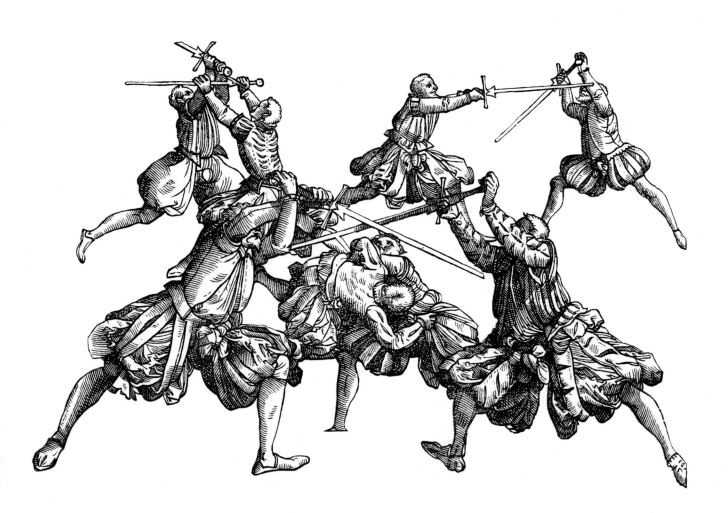

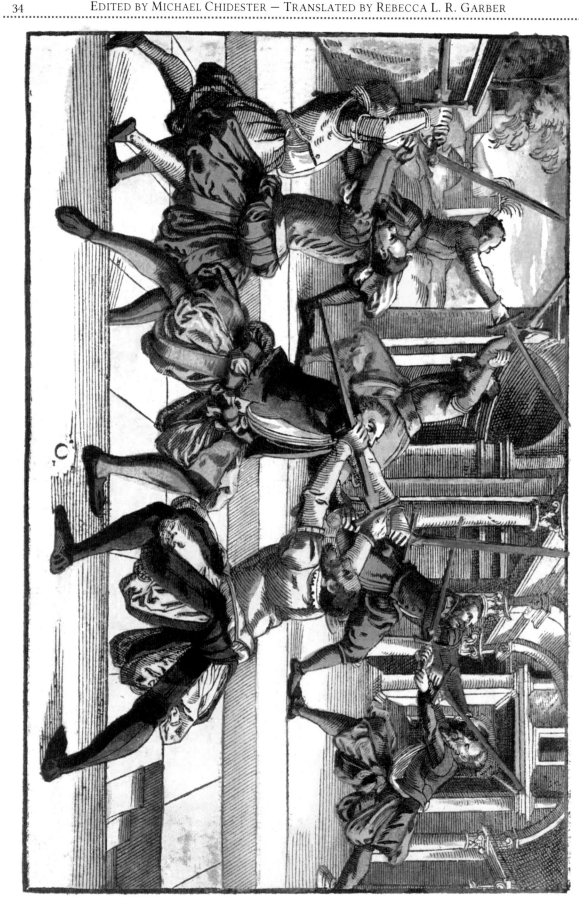

FIGURE O

Artist: Anonymous

Prior work: JML 16$^{\text{V}}$ & 38$^{\text{R}}$, JMM 11$^{\text{R}}$

Position: I.49

References:

Meyer	Forgeng	Garber	Position	Description
I.48$^{\text{V}}$	93	103	Unspecified	"rip upward"
I.50	94	105	Medium left scene	"reach with the pommel between their two hands"
I.61	106	123	Small right scene	"strike with the long edge at their head"
I.62$^{\text{V}}$	108	126	Small left scene	"catch their cut on your hilt"

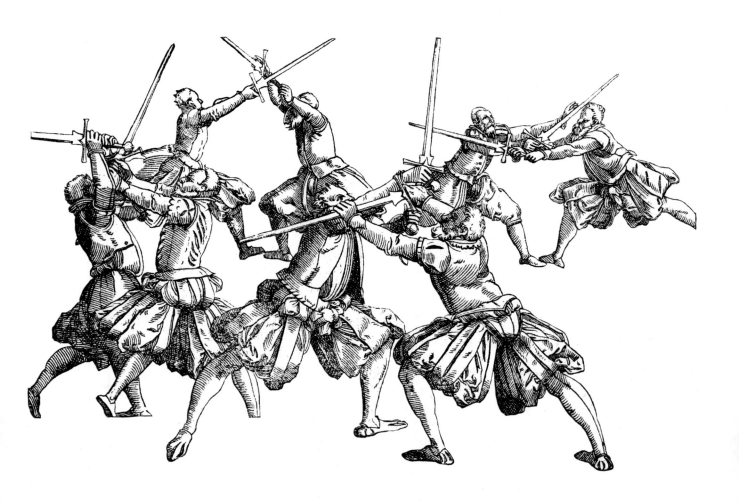

CUTTING LINES

Artist: Anonymous

Prior work: None

Positions: I.28, I.36

References:

Meyer	Forgeng	Garber	Position	Description
I.9V	55	37	Right diagram	"the cuts through the lines of paths"
I.11	57	41	Right diagram	Wrath Cut (𝔃𝔬𝔯𝔫𝔥𝔞𝔲𝔴)
I.11V	57	41	Right diagram	Middle (𝔐𝔦𝔱𝔱𝔢𝔩) or Crossing Cut (𝔘𝔟𝔢𝔯𝔷𝔴𝔢𝔯𝔠𝔥𝔥𝔞𝔲𝔴)
I.28	72	67	Left diagram	"how one should fence at the four openings"
I.36	80	82	Right diagram	"you have four primary attacks from each side"

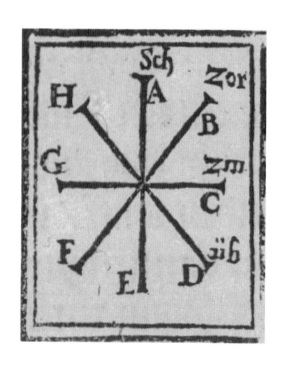

DUSACK

DUSACK

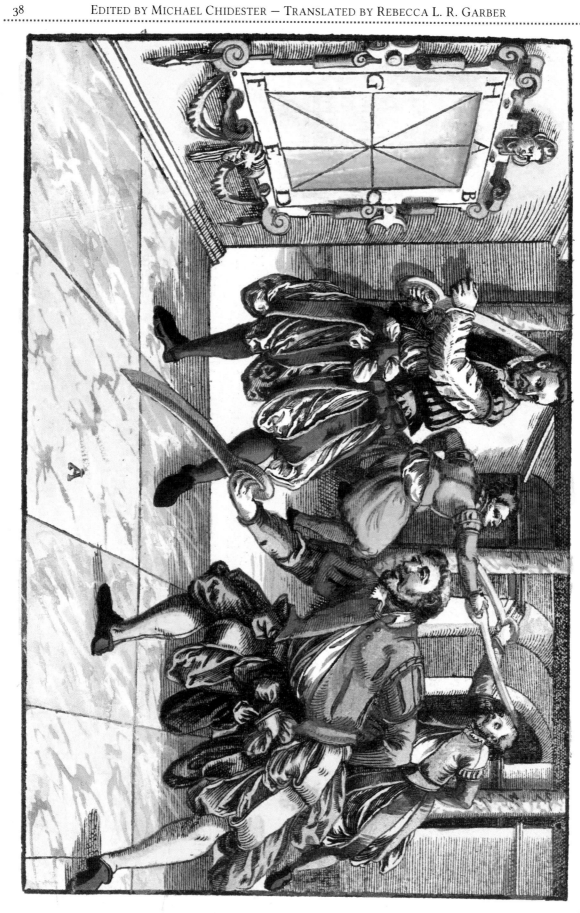

Figure A

Artist: Anonymous

Prior work: None

Position: II.3

References:

Meyer	Forgeng	Garber	Position	Description
I.11$^{\text{V}}$	57	41	Diagram	Middle (𝔐ittel) or Crossing Cut (Überzwerch-hauw)
II.47	161	202	Diagram	"cut from your left shoulder slantwise through their face"
II.49$^{\text{V}}$	164	206	Small scene	"cut back over their dussack at their face"

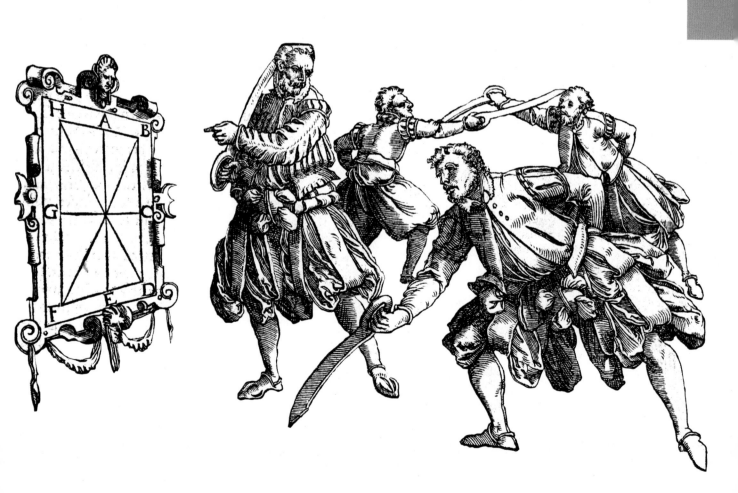

DUSACK

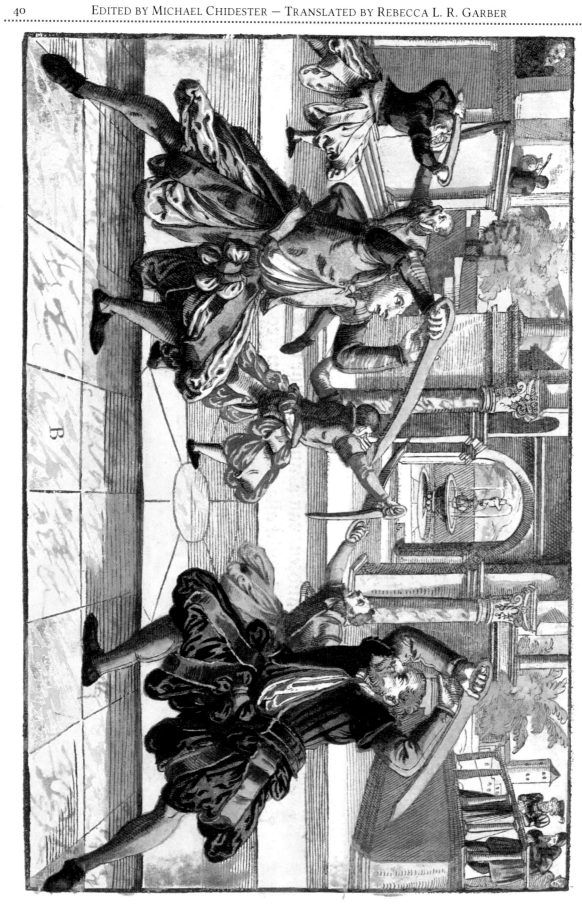

FIGURE B

Artist: Anonymous

Prior work: JML 52R, JMM 24V & 33V

Positions: II.4, II.19V, II.46V

References:

Meyer	Forgeng	Garber	Position	Description
II.4V	124	138	Large left portrait	Bull (𝖘𝖙𝖎𝖊𝖗)
II.5V	125	139	Large right portrait	Watchtower (𝖂𝖆𝖈𝖍𝖙)
II.20	138	161	Large right portrait	Watchtower (𝖂𝖆𝖈𝖍𝖙)
II.36V	151	185	Medium scene	Counteraction with Arch (𝖡𝖔𝖌𝖊𝖓)
II.46	161	201	Small left scene	"thrust the hilt into their face"

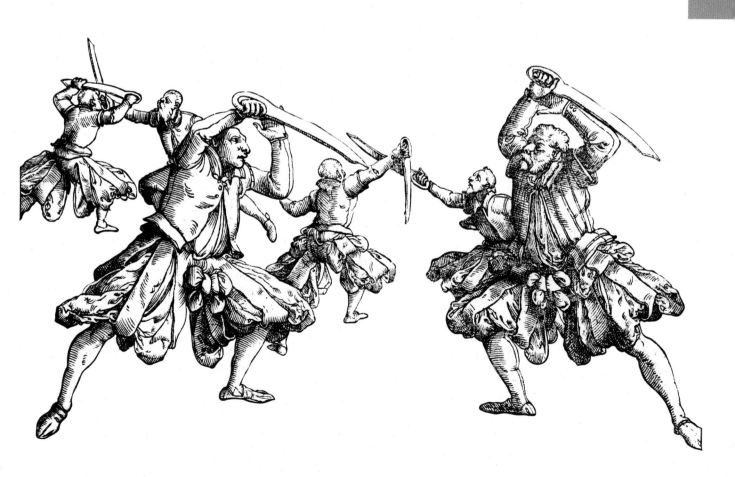

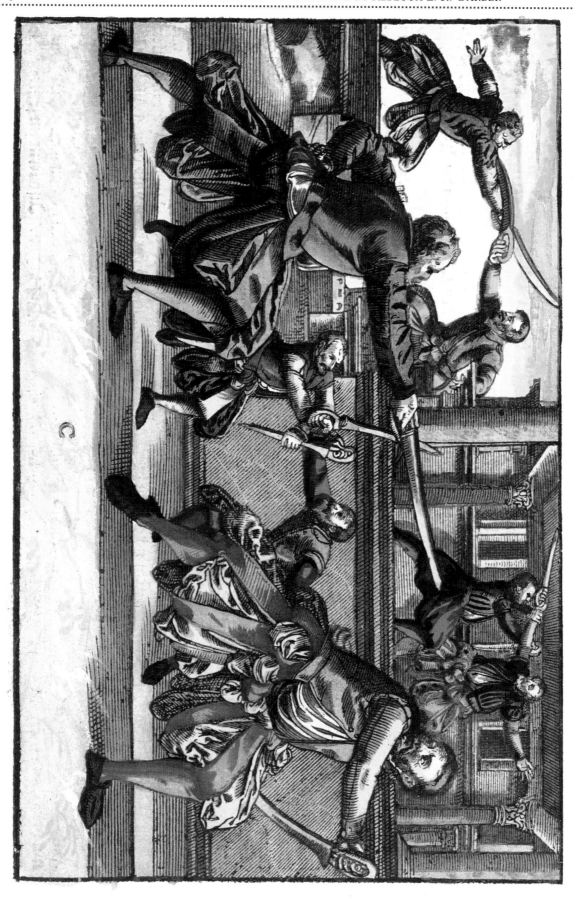

FIGURE C

Artist: Anonymous

Prior work: JML 55[R], JMM 26[R], 28[R], & 40[V]

Positions: II.5, II.43[V]

References:

Meyer	Forgeng	Garber	Position	Description
II.4[V]	124	138	Large left portrait	Longpoint (𝕷angort)
II.43	158	197	Large right portrait	Middle Guard (𝕸ittelhut)
II.45	160	199	Small left scene	"throw the curved edge out over their right arm"
II.80	199	261	Large right portrait	Middle Guard (𝕸ittelhut)

DUSACK

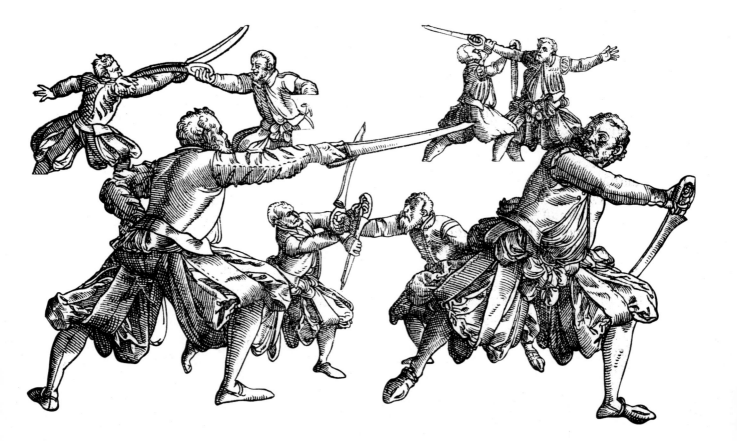

FIGURE D

Artist: Anonymous

Prior work: JMM 42V

Position: II.7

References:

Meyer	Forgeng	Garber	Position	Description
II.6V	126	141	Large right portrait	"cut strongly and powerfully next to your left [side] from below"

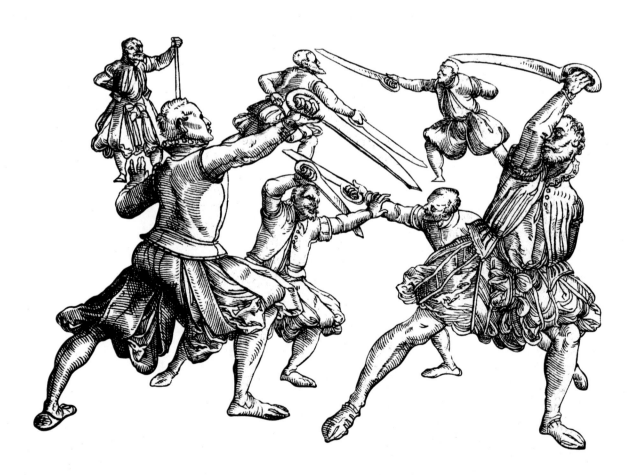

DUSACK

Figure F*

Artist: Anonymous

Prior work: JML 54^R

Position: II.33

References:

Meyer	Forgeng	Garber	Position	Description
II.32^V	148	180	Large right portrait	Simple Brace (𝔊𝔢𝔯𝔞𝔡𝔢 𝔙𝔢𝔯𝔰𝔞𝔱𝔷𝔲𝔫𝔤)
II.42	157	194	Medium scene, left portrait	"twist the hilt through"

* Meyer seems to have skipped letter E in the Dussack.

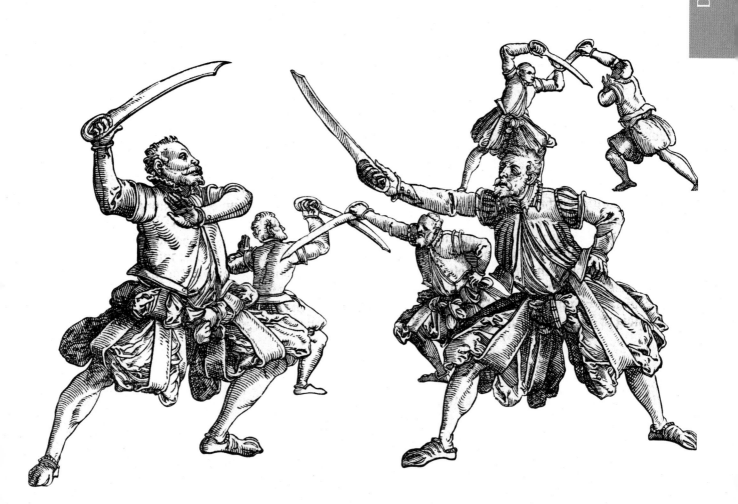

FIGURE G

Artist: Anonymous

Prior work: JMM 39V & 38R

Position: II.12

References:

Meyer	Forgeng	Garber	Position	Description
II.11V	131	149	Large right portrait	Rage Cut (𝕰𝖓𝖙𝖗𝖚̆𝖘𝖙𝖍𝖆𝖚𝖜)
II.25	142	169	Large right portrait	"catch them with the [second cut] while they are still flying in"
II.25	142	169	Medium scene	"cut with the curved edge outside of their right arm at their head"
II.48	163	204	Medium scene	"cut with the curved edge outside of their right arm on their head"
II.48	163	204	Small left scene	"hit them quickly under their left arm and behind at their neck"

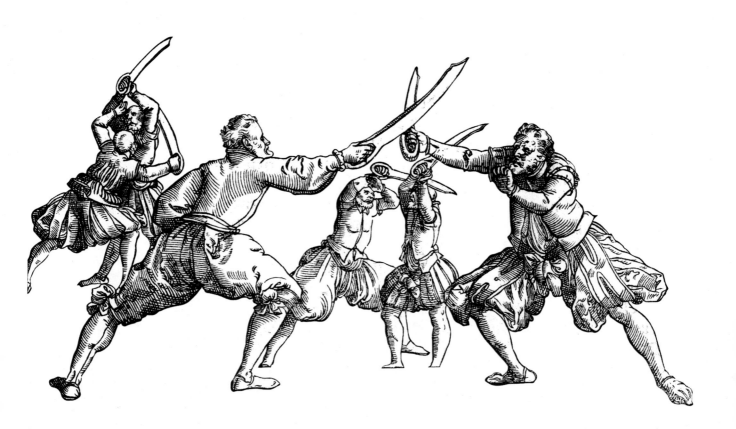

DUSACK

Figure H

Artist: Anonymous

Prior work: JML 51R

Position: II.13

References:

Meyer	Forgeng	Garber	Position	Description
II.38	153	188	Medium scene	"hit them on their head with the outward half edge"

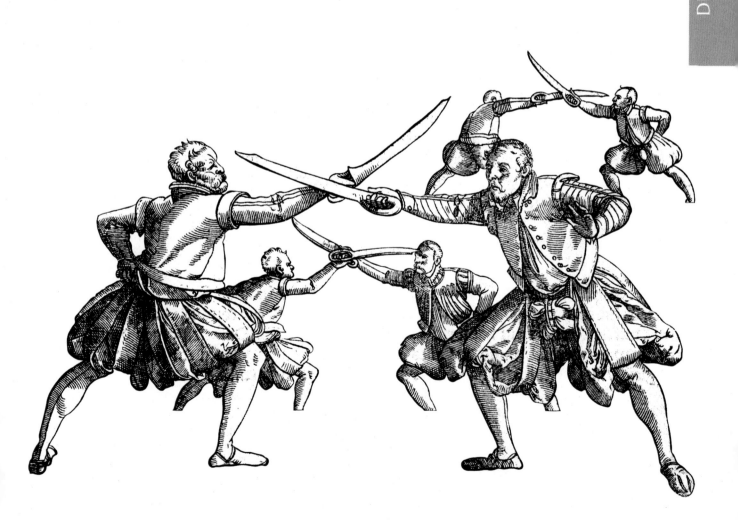

DUSACK

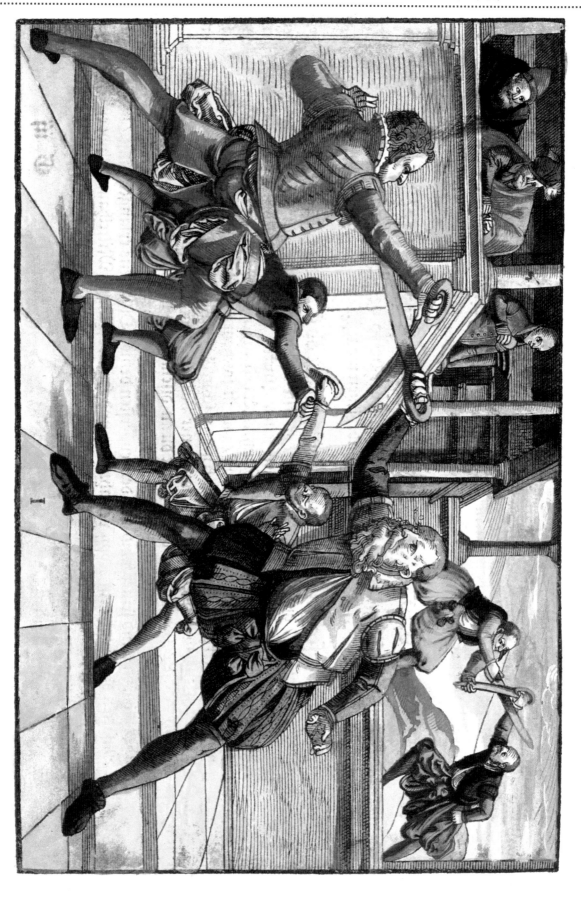

FIGURE I*

Artist: Anonymous

Prior work: JML 49R

Position: II.26V

References:

Meyer	Forgeng	Garber	Position	Description
II.23V	140	166	Unspecified	"cut slantwise upward from your right with the curved edge"
II.26	143	171	Large right portrait	"cut underneath their dusack from your right (from inside) at their arm"

* There is no Figure J in this book. This is because I and J started off as the same letter, and in this period they still were often not distinct from each other.

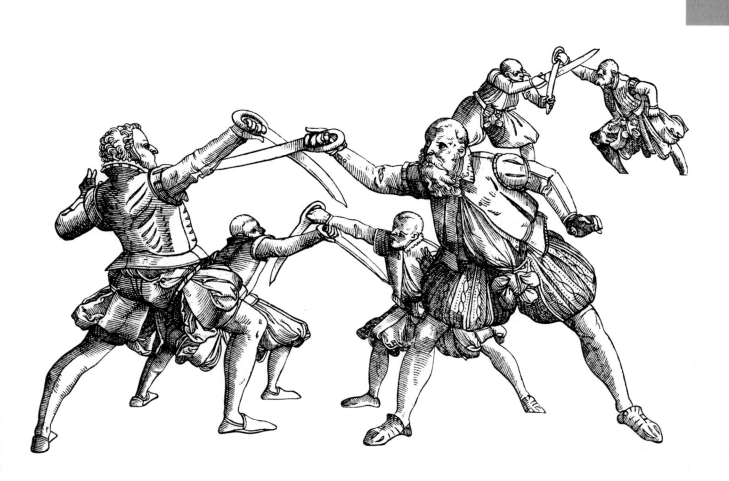

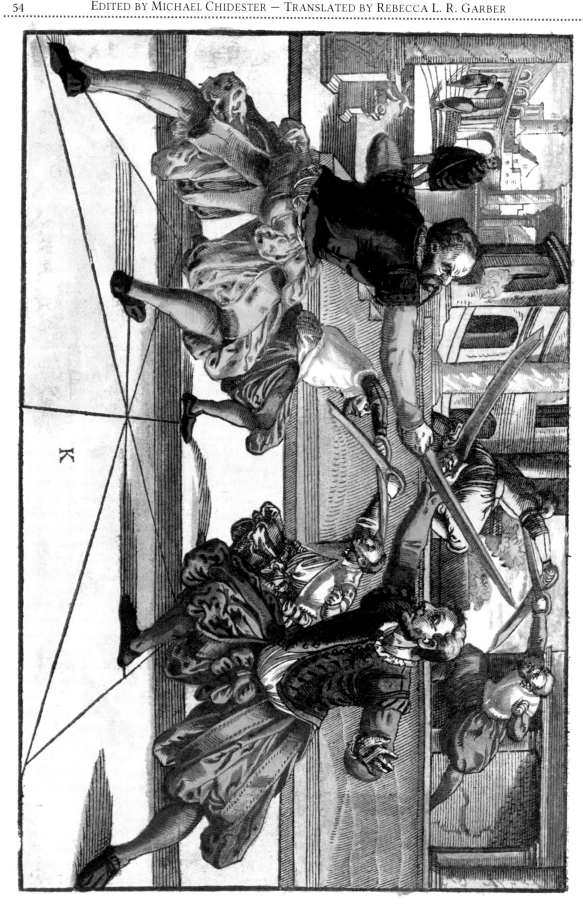

FIGURE K

Artist: Anonymous

Prior work: JMM 31V & 35R

Positions: II.17V, II.40

References:

Meyer	Forgeng	Garber	Position	Description
II.24V	141	168	Small right scene	"thrust underneath their dusack toward their face or chest"
II.30V	146	176	Small right scene	"thrust with your forward point away from you, beneath their dusack at their chest"
II.38	153	188	Small right scene	"thrust with inverted hand under their dusack in front of their chest"
II.39V	155	191	Medium scene	"pull the hilt quickly back upward toward you and cut long in response"
II.39V	155	191	Large scene	"slice from your right at their arm with a step outward"

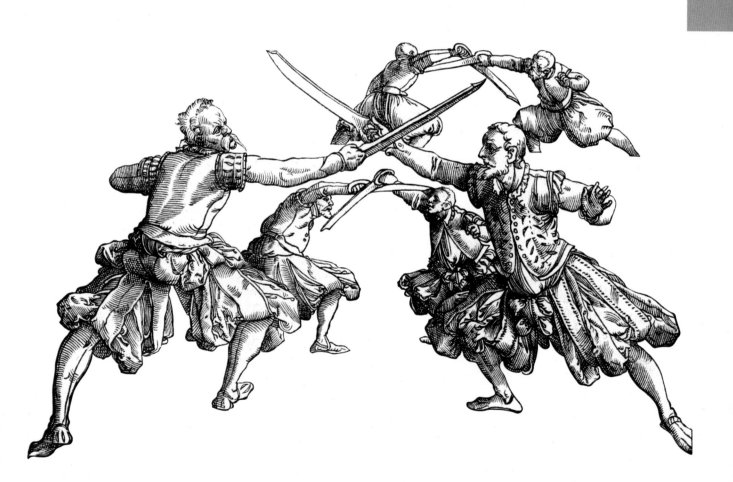

DUSACK

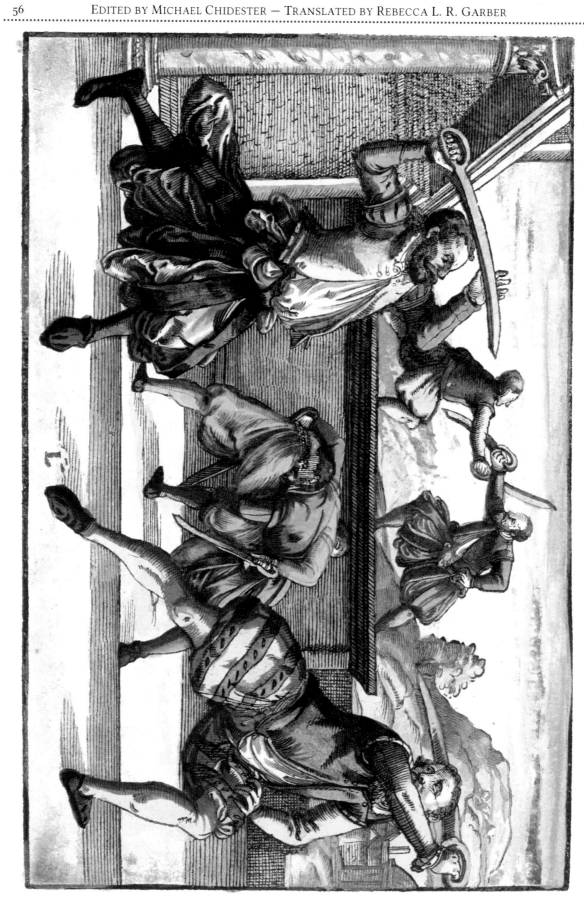

FIGURE L

Artist: Anonymous

Prior work: JML 58[R], JMM 45[R]

Position: II.22[V]

References:

Meyer	Forgeng	Garber	Position	Description
II.31	147	177	Large right portrait	Left Wrath (𝔷orn)
II.31	147	177	Large left portrait	Left Bull (𝔰tier)
II.44[V]	159	198	Small figures	"draw your long edge upward through their face upward into the air"

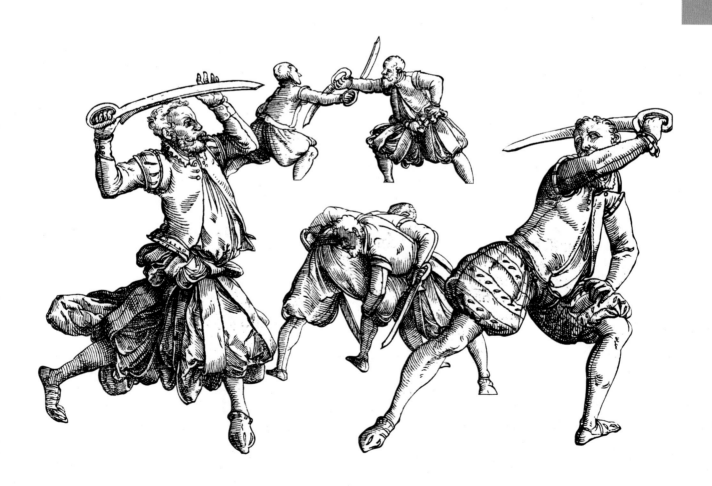

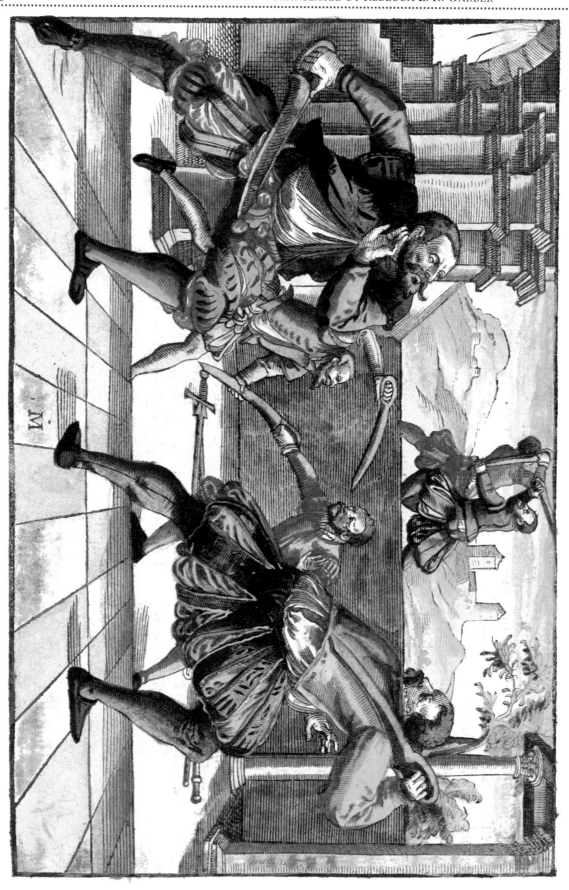

Figure M

Artist: Anonymous

Prior work: JMM 24$^{\text{V}}$ & 42$^{\text{R}}$

Positions: II.28$^{\text{V}}$, II.41$^{\text{V}}$

References:

Meyer	Forgeng	Garber	Position	Description
II.29	145	174	Large right portrait	Wrath Guard (Zornhut)
II.41	157	194	Large left portrait	Boar (Eber)

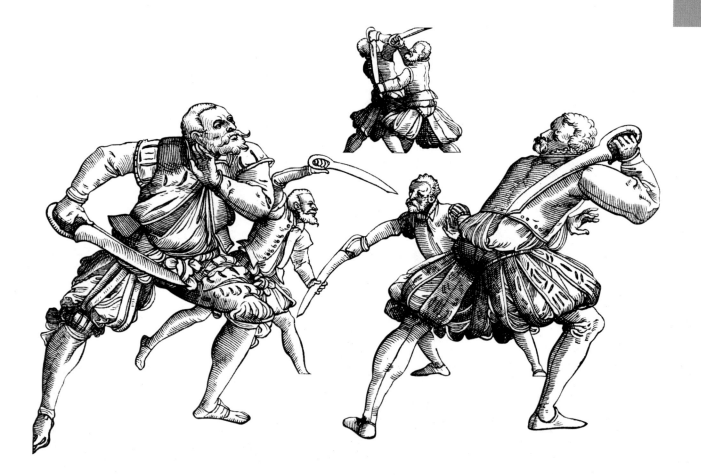

DUSACK

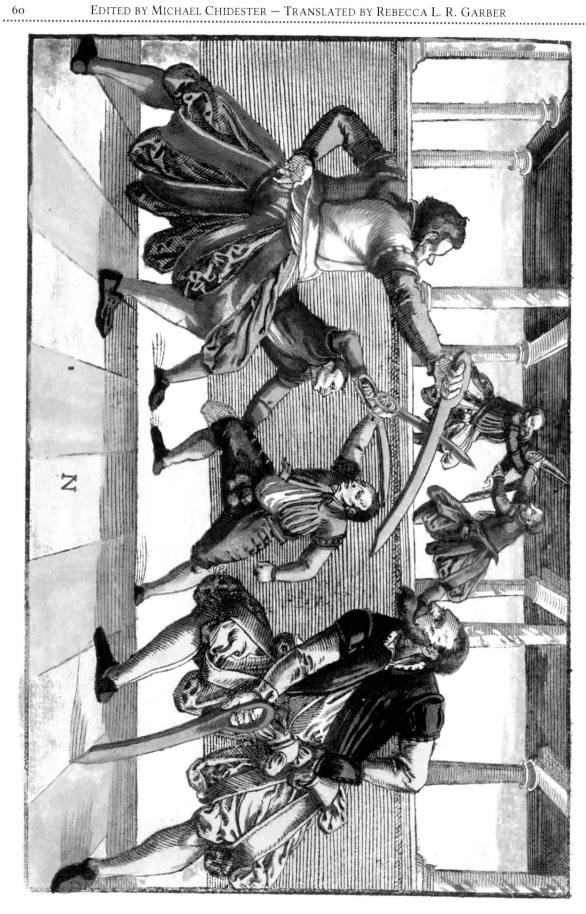

FIGURE N

Artist: Anonymous

Prior work: JML 61R, JMM 36R & 45V

Position: II.36

References:

Meyer	Forgeng	Garber	Position	Description
II.36V	151	185	Large left portrait	Arch (𝕭𝖔𝖌𝖊𝖓)
II.45V	160	201	Large right portrait	Change [Guard] (𝖂𝖊𝖈𝖍𝖘𝖊𝖑)
II.54	176	218	Large right portrait	Change [Guard] (𝖂𝖊𝖈𝖍𝖘𝖊𝖑)

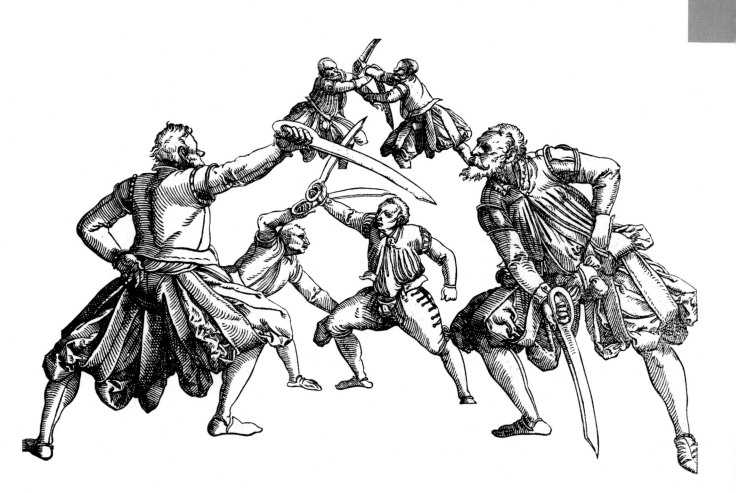

DUSACK

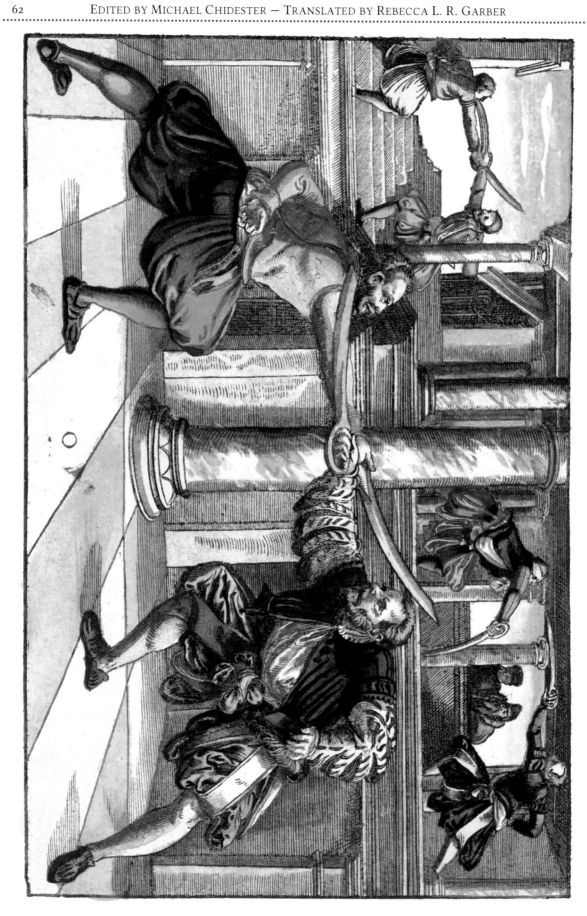

FIGURE O

Artist: Anonymous

Prior work: JMM 39[R]

Position: II.16[V]

References:

Meyer	Forgeng	Garber	Position	Description
II.12[V]	131	149	Small left scene	Rage Cut (𝕰ntrůṡthauw)
II.48	162	204	Small left scene	"thrust again with the front point over their right arm from outside"
II.48[V]*	163	205	Unspecified	Stork's Beak (𝕊trocken 𝕊chnabel)

* Meyer says that this technique is shown "in the Figure printed previously". The most recently-mentioned Figure is G, whereas the most recently-displayed Figure is B; however, neither one seems to show the action described in the text. Figure O, mentioned on previous page, is a better fit.

DUSACK

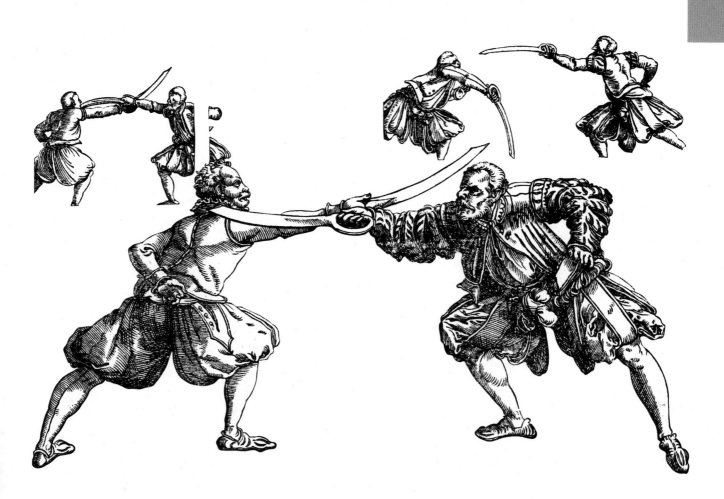

DUSACK

FIGURE P

Artist: Anonymous

Prior work: None

Position: II.10V

References:

Meyer	Forgeng	Garber	Position	Description
II.11	130	148	Small right scene	Awakening Cut (𝔚𝔢𝔠𝔨𝔢𝔯𝔥𝔞𝔲𝔴)
II.11	130	144	Large scene	"cut upward with the curved edge through their arm"
II.37	152	186	Small left scene	"cut a Middle Cut through and inwardly toward their forearm bone"
II.40V	155	191	Small right scene	"turn the long edge either downward or upward (remaining on their dusack in the bind)"

DUSACK

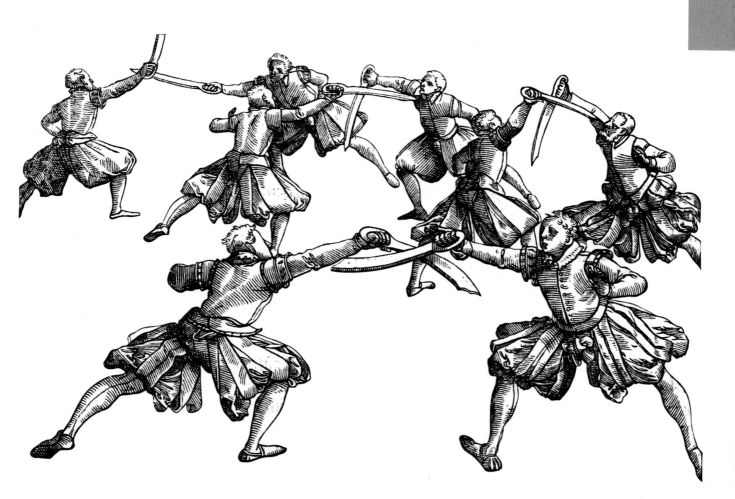

DUSACK

Rapier

RAPIER

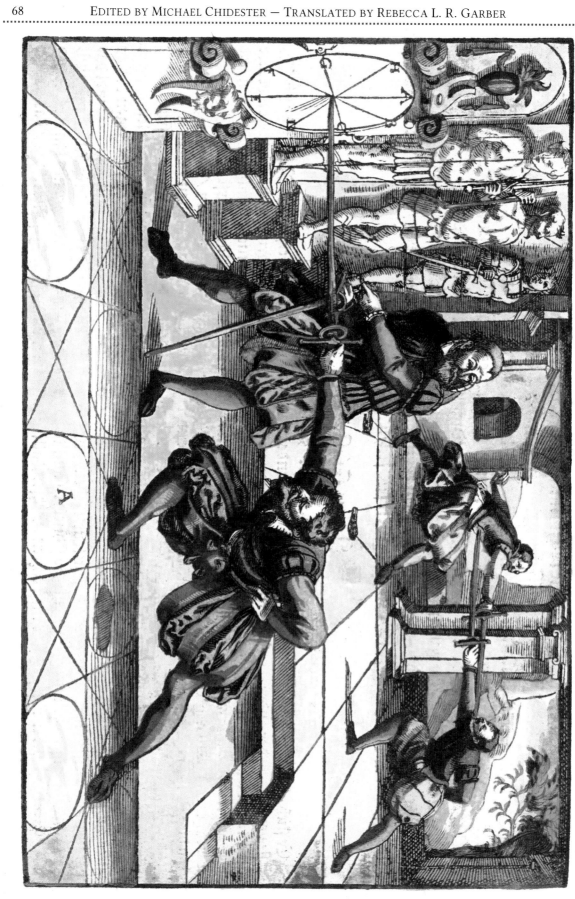

FIGURE A

Artist: Anonymous

Prior work: None

Position: II.61V

References:

Meyer	Forgeng	Garber	Position	Description
II.51V	174	214	Left statue	Upright lines
II.51V	174	214	Middle statue	Obliquely handing slanted lines
II.52	174	214	Right statue	Crossing lines
II.62	184	232	Small right scene	Face Thrust (𝔊𝔢𝔰𝔦𝔠𝔥𝔱 𝔖𝔱𝔦𝔠𝔥)
II.64V	186	235	Large figure	Flying Thrust (𝔉𝔩𝔦𝔢𝔤𝔢𝔫𝔡𝔢𝔯 𝔖𝔱𝔦𝔠𝔥)

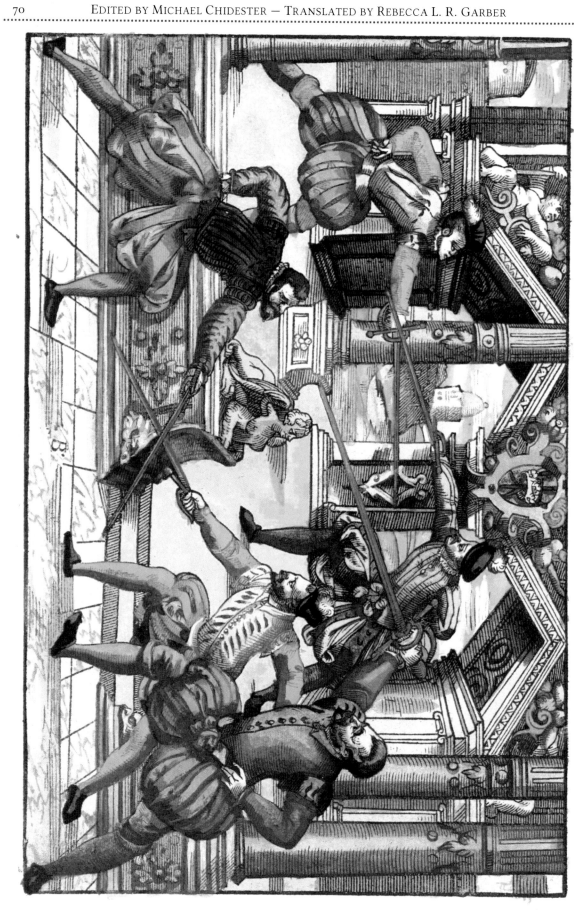

Figure B

Artist: Anonymous

Prior work: JML 75^R, JMM 49^V

Positions: II.53, II.87

References:

Meyer	Forgeng	Garber	Position	Description
II.53^V	175	217	Large right portrait	High Guard (Oberhut) including the Oxen (Ochsen)
II.57^V	180	225	Middle scene	"cut toward their feet as well"
II.60^V	183	229	Rear scene	Hand Cut (Handthauw)
II.89	206	275	Middle scene	Blocking (Sperren)

RAPIER

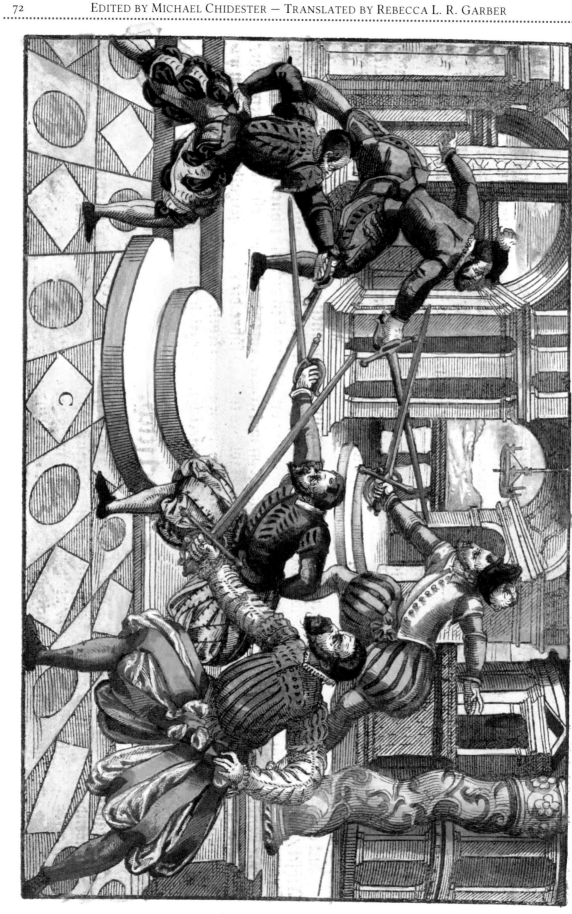

FIGURE C

Artist: Anonymous

Prior work: JML 80^R

Position: II.63

References:

Meyer	Forgeng	Garber	Position	Description
II.54	176	218	Large right portrait	Iron Gate (𝕰𝖎𝖘𝖊𝖓𝖕𝖔𝖗𝖙)
II.63^V	185	233	Middle scene	Reversed Thrust (𝖁𝖊𝖗𝖐𝖊𝖍𝖗𝖙𝖊𝖗 𝕾𝖙𝖎𝖈𝖍)
II.76	196	257	Middle left scene	"drop down from above onto their blade with the long edge"
II.77^V	197	259	Rear scene	"reach the middle of their blade with yours and bind on"
II.85^V	204	270	Middle left scene	"beat their blade quickly and unexpectedly out to the side with a hanging blade"
II.88^V	206	274	Middle left scene	"cut their in-flying blade out from your left toward your right with a hanging blade"

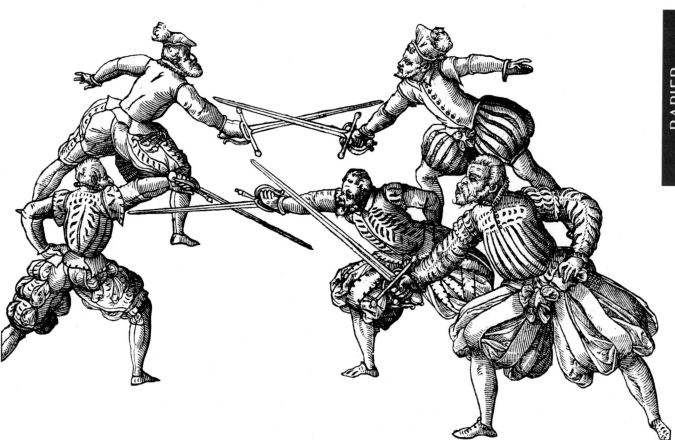

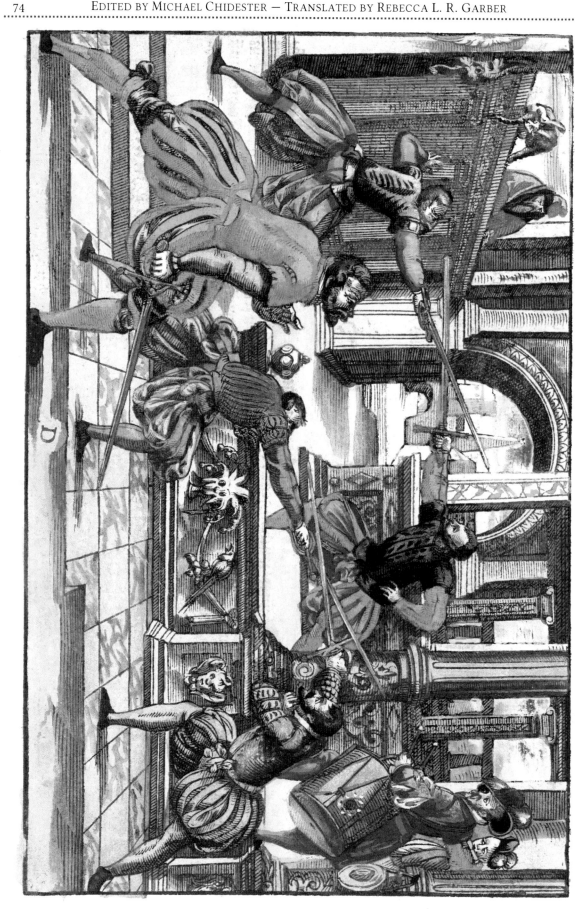

FIGURE D

Artist: Anonymous

Prior work: JML 70R, 77R

Position: II.92

References:

Meyer	Forgeng	Garber	Position	Description
II.54	176	218	Large left portrait	Low Guard (𝔘nderhut) on the right
II.92V	210	280	Middle scene	"deflect [their blade] with a slice from your left toward your right"

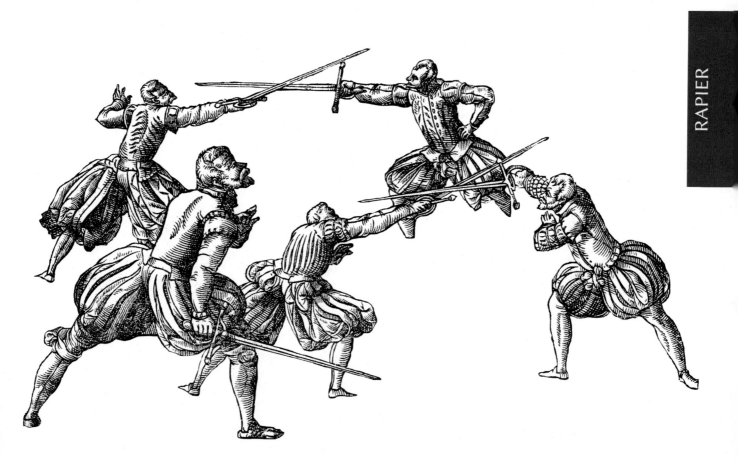

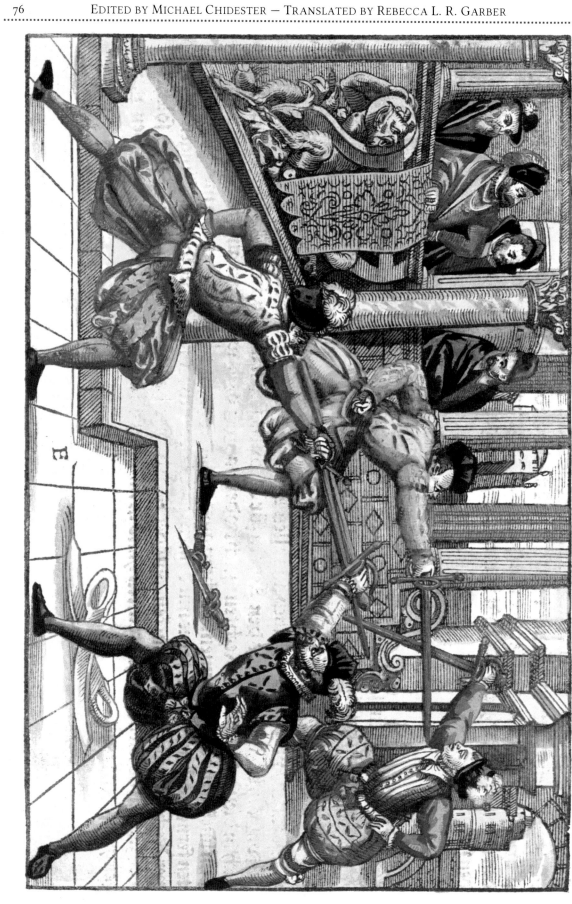

Figure E

Artist: Anonymous

Prior work: None

Position: II.69^V

References:

Meyer	Forgeng	Garber	Position	Description
II.69	191	245	Rear scene	hanging in front (𝔙𝔢𝔯𝔥𝔢𝔫𝔤𝔢𝔫)

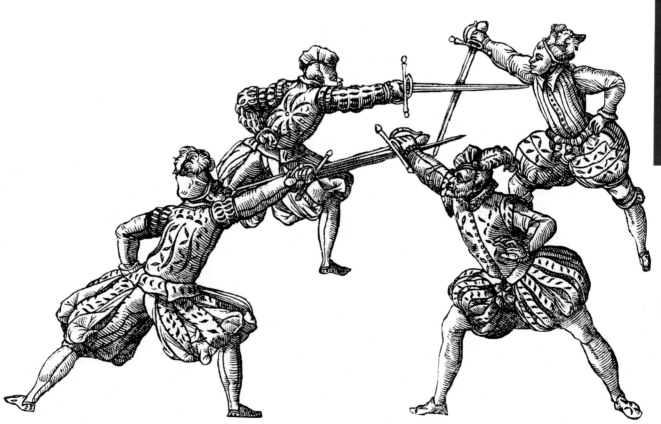

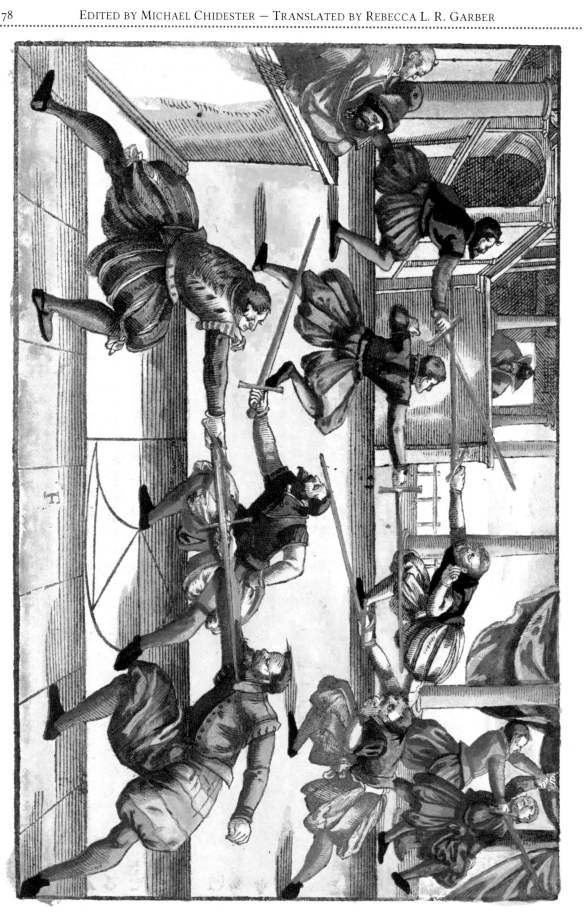

Figure F

Artist: Anonymous

Prior work: None

Position: II.74V

References:

Meyer	Forgeng	Garber	Position	Description
II.74	195	254	Middle figure	Simple Brace (𝔊𝔢𝔯𝔞𝔡𝔢 𝔙𝔢𝔯𝔰𝔞𝔱𝔷𝔲𝔫𝔤)
II.76V	196	257	Middle scene	"thrust at them straight toward their face"
II.82V	201	266	Rear left scene	"thrust quickly at their face or chest from outside and over their right arm"
II.86V	204	272	Front scene	"turn the long edge toward their in-coming thrust and thrust simultaneously in with them"

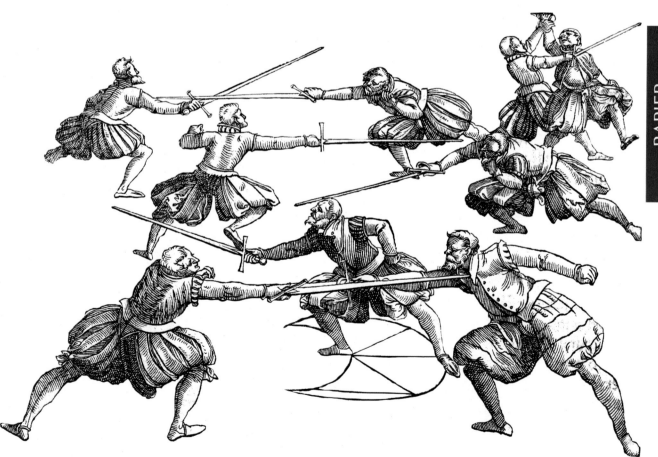

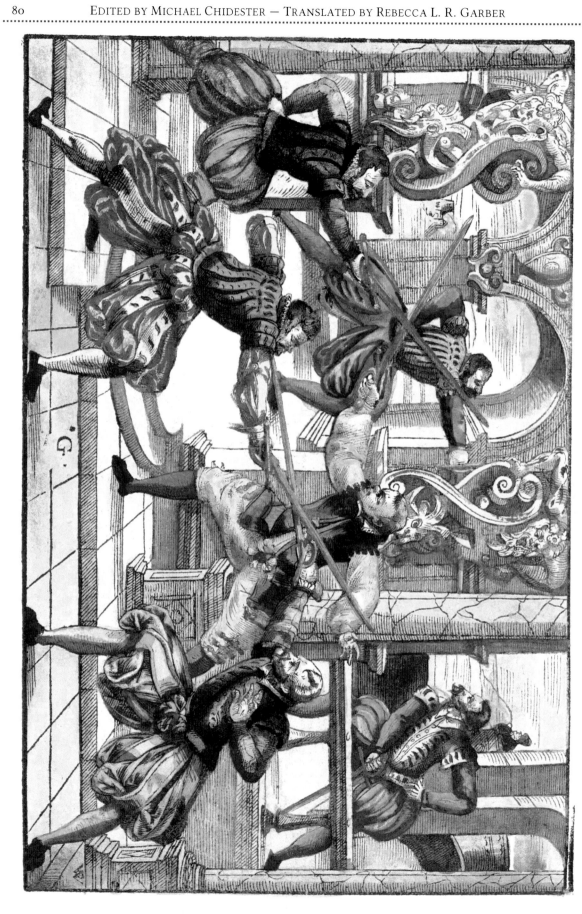

RAPIER

FIGURE G

Artist: G. W.

Prior work: JML 73$^{\text{R}}$

Position: II.78$^{\text{V}}$

References:

Meyer	Forgeng	Garber	Position	Description
II.62$^{\text{V}}$	184	232	Large scene, right portrait	Heart Thrust (Hertz Stich)

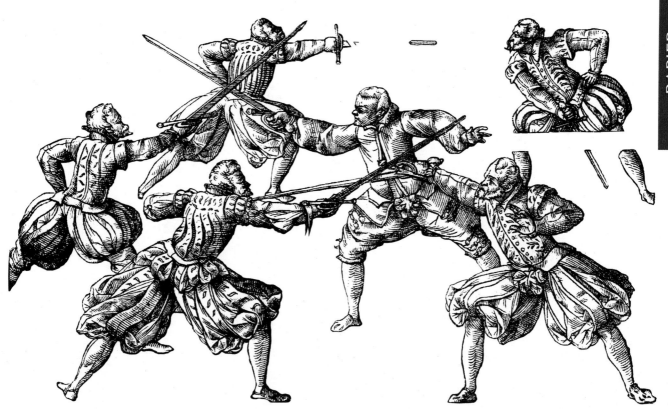

RAPIER

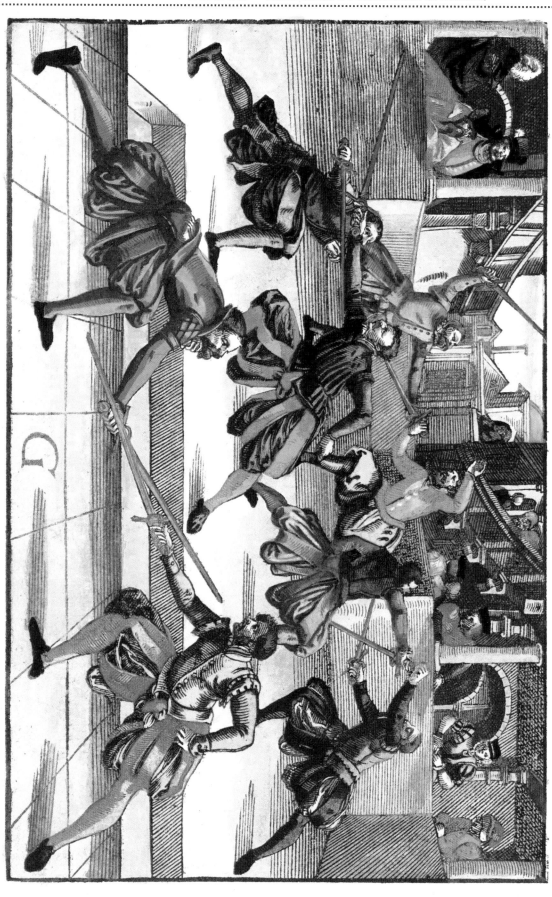

FIGURE *G*

Artist: Anonymous

Prior work: JMM 59V

Position: II.96

References:

Meyer	Forgeng	Garber	Position	Description
II.87V	205	273	Large [left]* figure	"you arrive with your hilt closer to the ground than the blade"
II.97	214	287	Middle left scene	"turn your weapon out of the counterposture into a thrust"
II.97	214	287	Rear scene, left portrait	"turn this out of their hand by twisting toward their right"
II.97V	214	288	Middle right scene	"press their blade away from you and toward their body with your weapon"

* The text actually says "right", but this is clearly wrong.

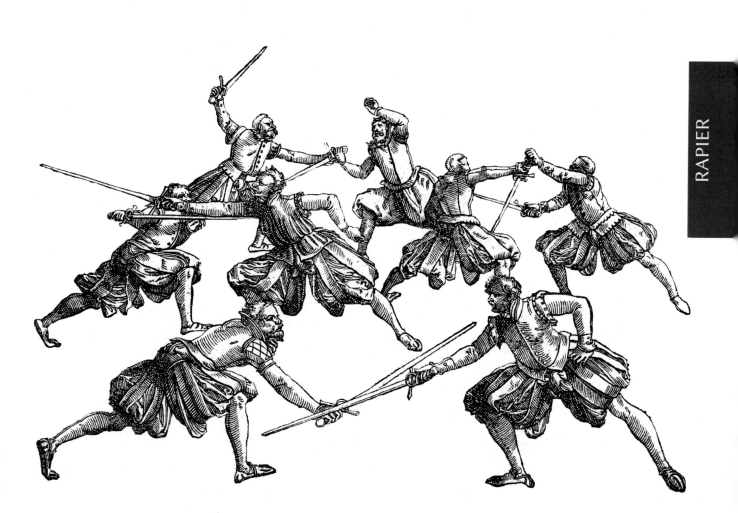

RAPIER

RAPIER

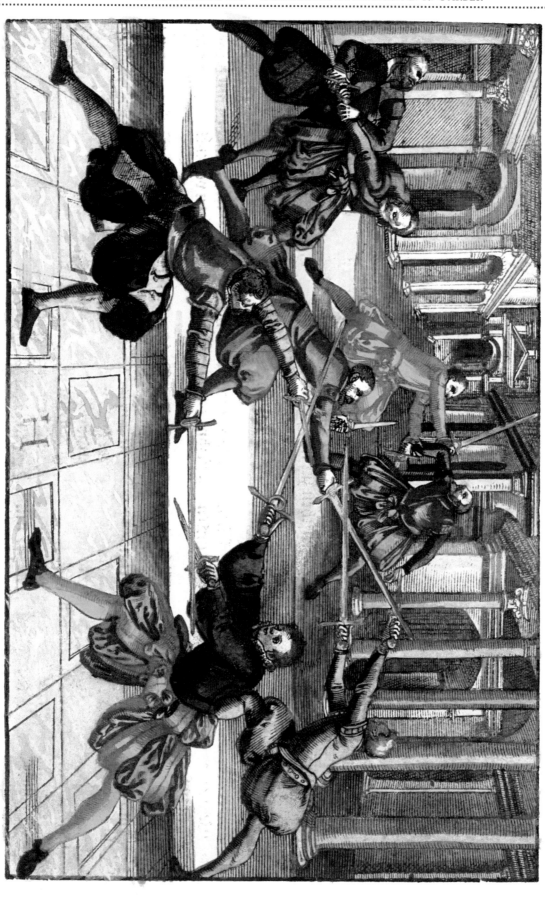

FIGURE **H**

Artist: Anonymous

Prior work: None

Position: II.102

References:

Meyer	Forgeng	Garber	Position	Description
II.97V	215	289	Middle left scene	"turn them toward that same side and jerk the weapon with the other hand"
II.101V	219	295	Large right portrait	"counteract that with your dagger"
II.102V	219	296	Middle right scene	"thrust under your dagger from outside"
II.102V	219	296	Large right portrait	"turn their in-flying thrust away from you with a hanging dagger"

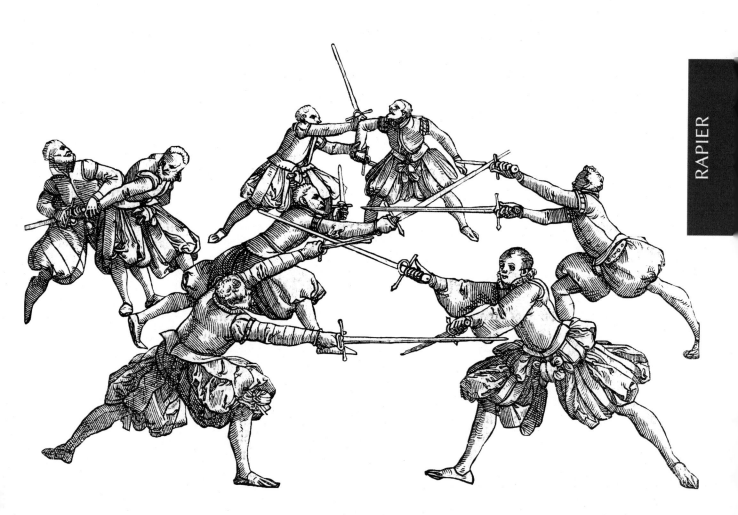

RAPIER

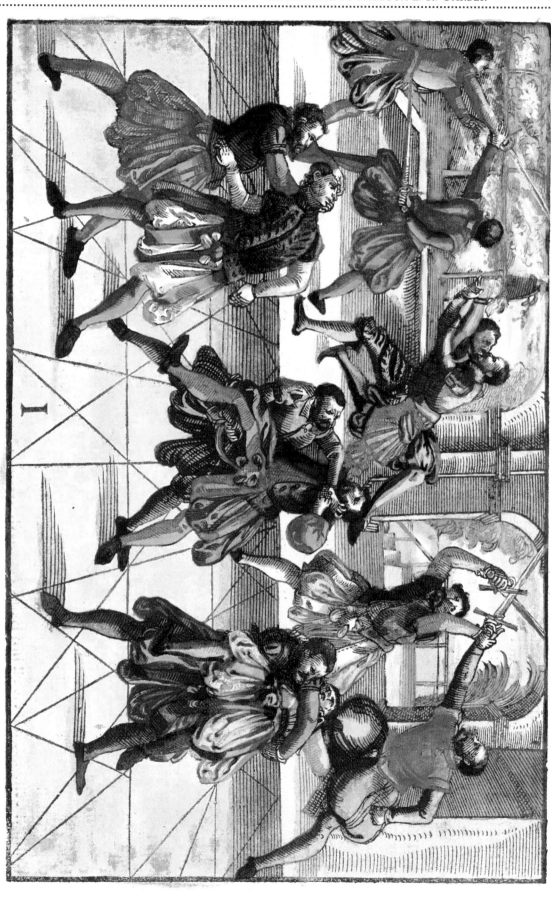

Figure I

Artist: Anonymous

Prior work: None

Position: II.98

References:

Meyer	Forgeng	Garber	Position	Description
II.97V	215	288	Rear right scene	"receive them on your blade"

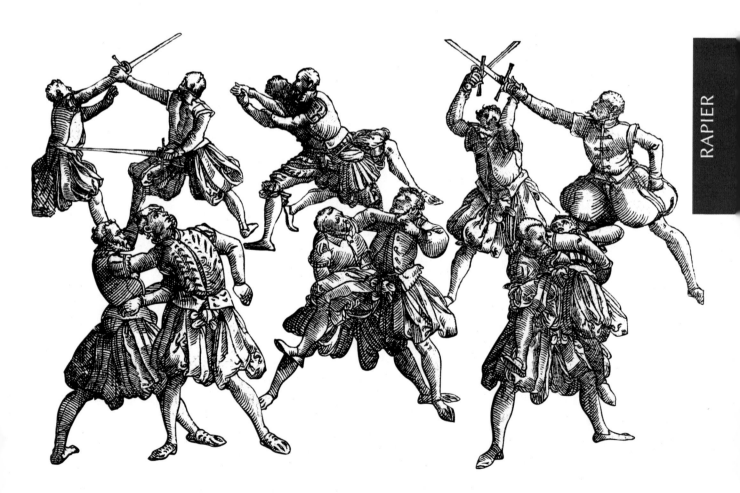

RAPIER

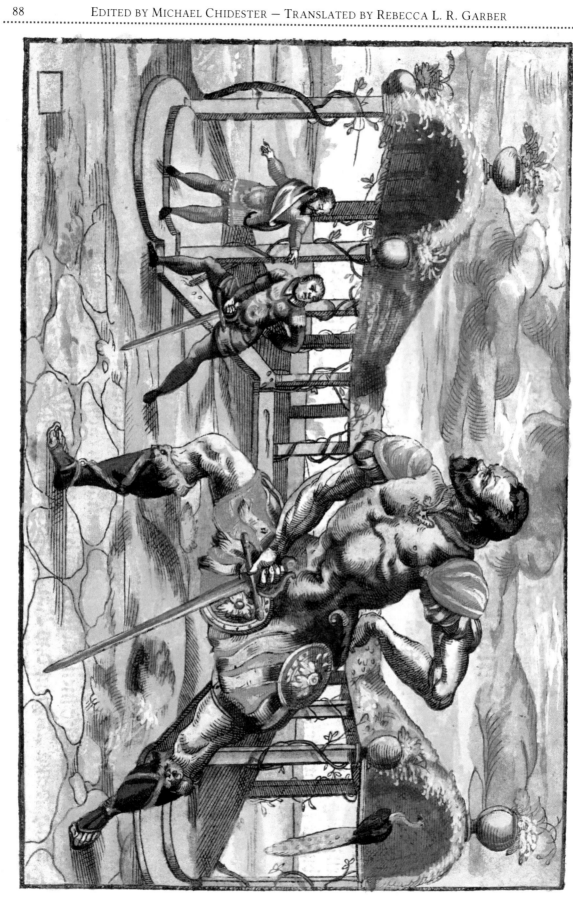

Rapier Alone

Artist: Anonymous

Prior work: None

Position: II.50v

References: Not mentioned in the text.

Meyer	Forgeng	Garber	Position	Description

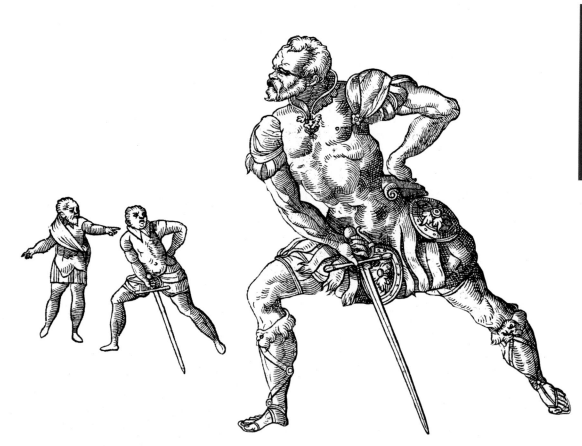

RAPIER

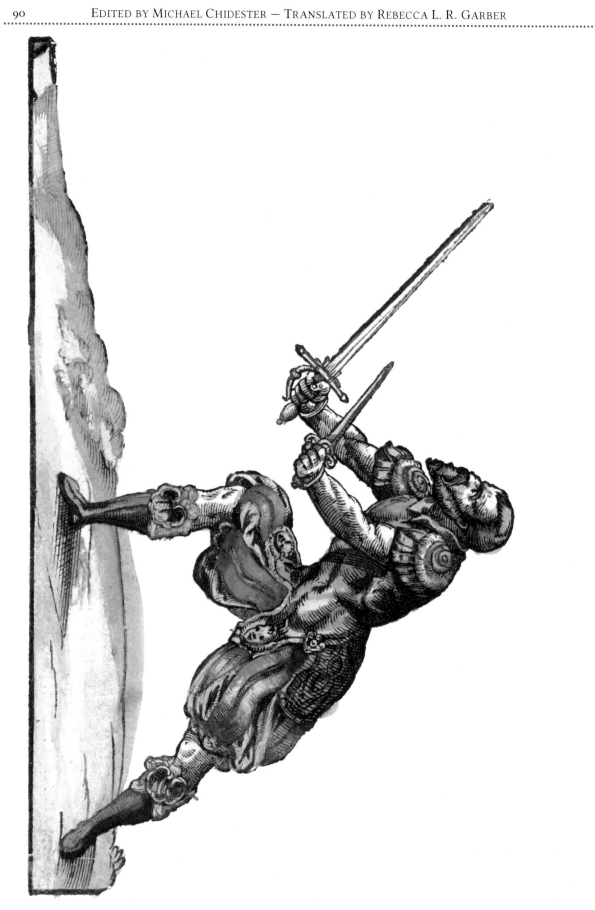

RAPIER AND DAGGER

Artist: Anonymous

Prior work: JMM 61$^\text{V}$

Position: II.101

References:

Meyer	Forgeng	Garber	Position	Description
II.101$^\text{V}$	218	295	Large figure	"step toward the opponent with both arms extended in front of you"

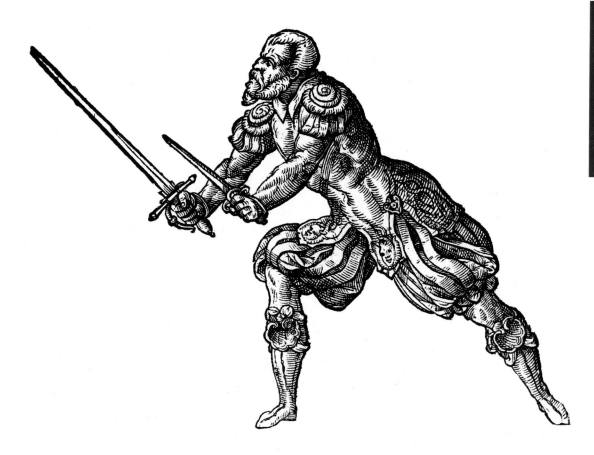

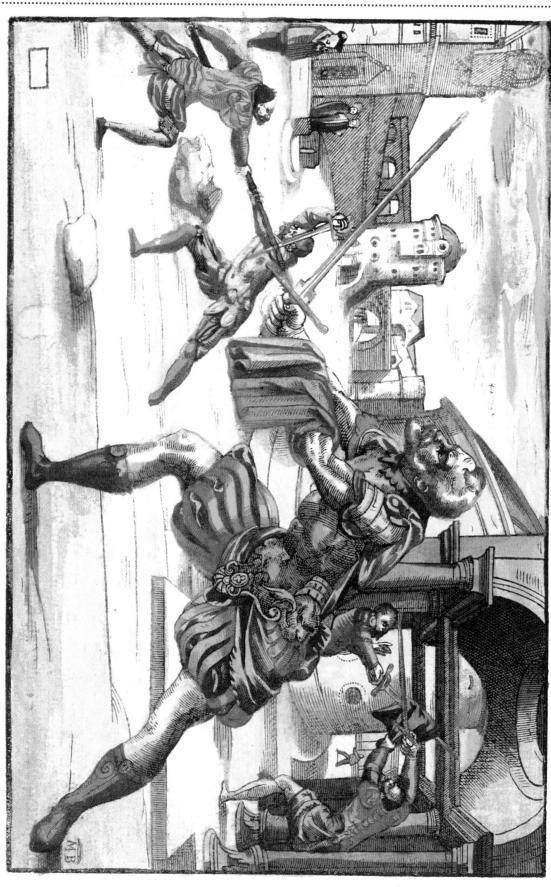

RAPIER AND CLOAK

Artist: Johann Melchior Bocksberger

Prior work: JMM 66R

Position: II.106

References:

Meyer	Forgeng	Garber	Position	Description
II.106V	224	304	Small right scene	"cut above the [blade] at their head"
II.107	224	305	Small left scene	"catch their blow on your flat hanging blade"

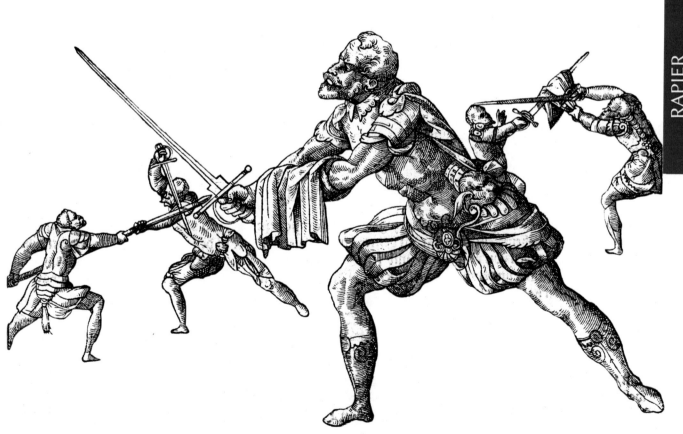

CUTTING LINES

Artist: Anonymous

Prior work: JML 78R

Position: II.58

References:

Meyer	Forgeng	Garber	Position		Description
II.52	174	214	Large figure		"three intersections"
II.57V	180	225	Large figure		Cross Cut (Kreutʒhauw)

RAPIER

DAGGER

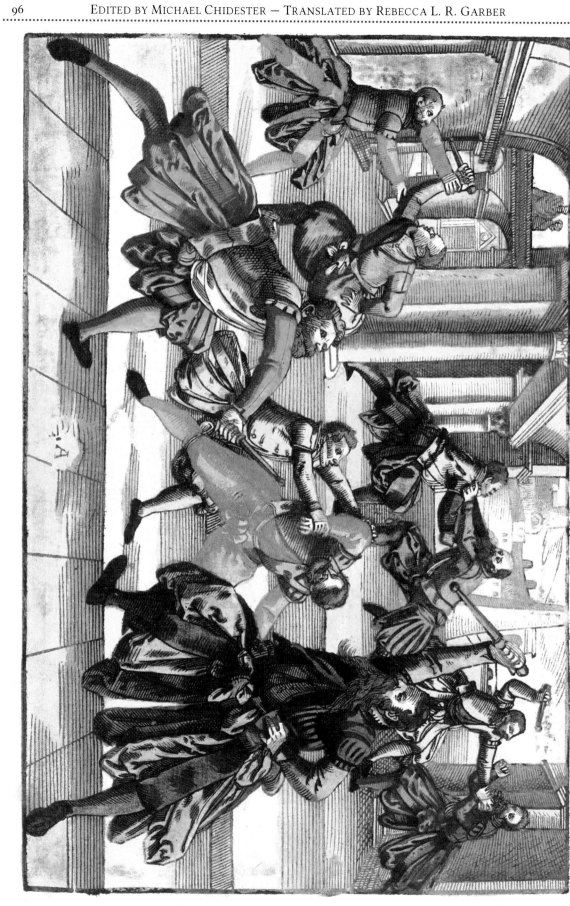

Figure A

Artist: Anonymous

Prior work: Marozzo 134V, 146V, & 147V

Position: III.1V

References:

Meyer	Forgeng	Garber	Position	Description
III.1	235	309	Large right portrait	High Guard (Oberhut)
III.14	244	327	Small middle scene	"hit the wrist joint of their right arm from below"

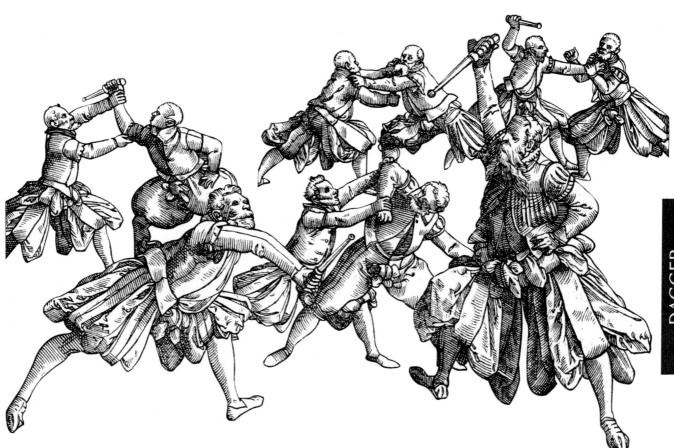

Figure B

Artist: C. Wunderdinger

Prior work: JMM 68R, 70R, & 72R

Position: III.3V

References:

Meyer	Forgeng	Garber	Position	Description
III.3	236	312	Small left scene	"thrust from below at their joint with the pommel"
III.3	236	312	Large scene	"reach quickly through under their right arm"
III.4	237	313	Small right scene	"grip them by their elbow with your left hand and jerk toward you"

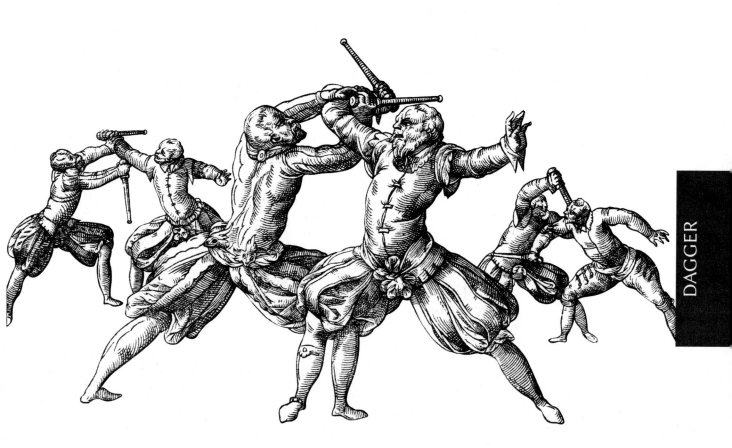

DAGGER

DAGGER

FIGURE C

Artist: Anonymous

Prior work: JMM 69R, Marozzo 142V

Position: III.5

References:

Meyer	Forgeng	Garber	Position	Description
III.4V	237	315	Small right scene	"drop your left hand onto their elbow joint and break their arm"
III.5V	238	315	Small middle scene	"jerk them onto your left side over the leg you have set forward"
III.5V	238	315	Small left scene	"grasp their dagger with your right hand reversed and break it out"
III.15V*	245	329	Large left scene	"throw them on your left side"

* This would seem to be a reference to the Figure on III.15, but the description matches Figure C.

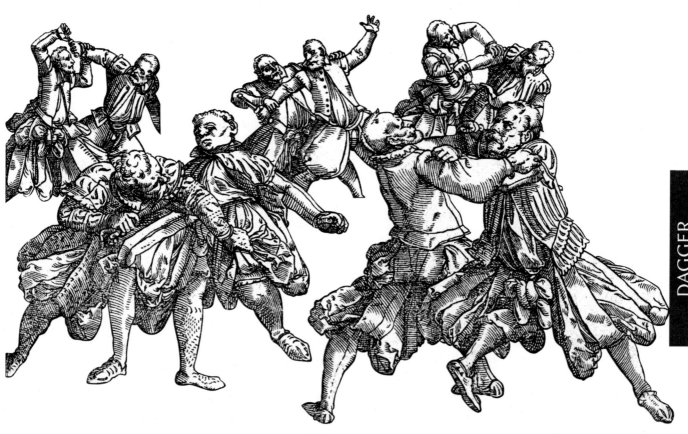

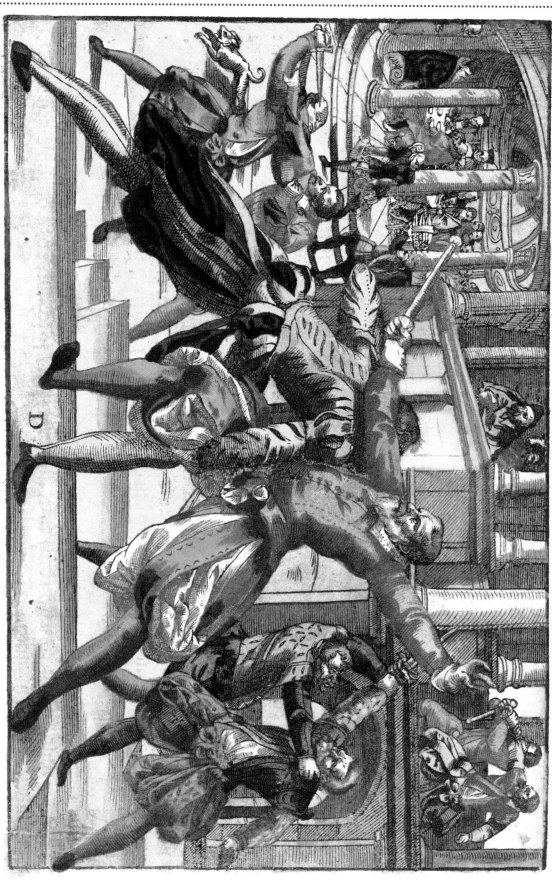

DAGGER

FIGURE D

Artist: Anonymous

Prior work: JMM 126V, 127V, 132V, & 137V

Position: III.7V

References:

Meyer	Forgeng	Garber	Position	Description
III.7	239	318	Large scene	"move your head through under their right arm"
III.8	239	318	Small right scene	"break their arm across your left shoulder"
III.8V	240	319	Medium right scene	"drop your right hand forward onto their throat"
III.10	241	322	Medium left* scene	"grip the other arm at the bicep"

* The text reads "on the right", but this is corrected in the 1600.

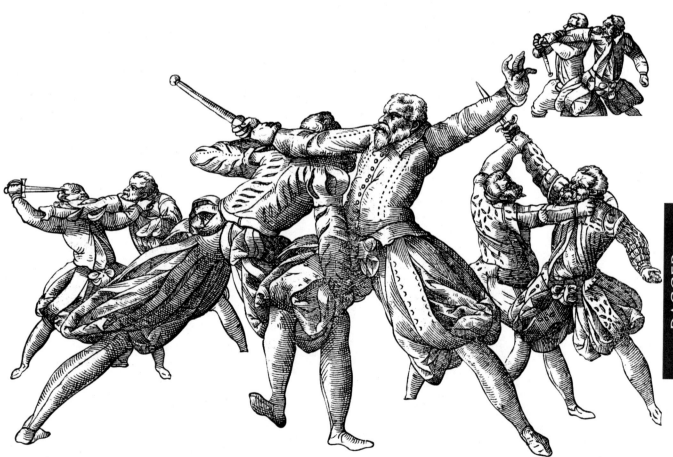

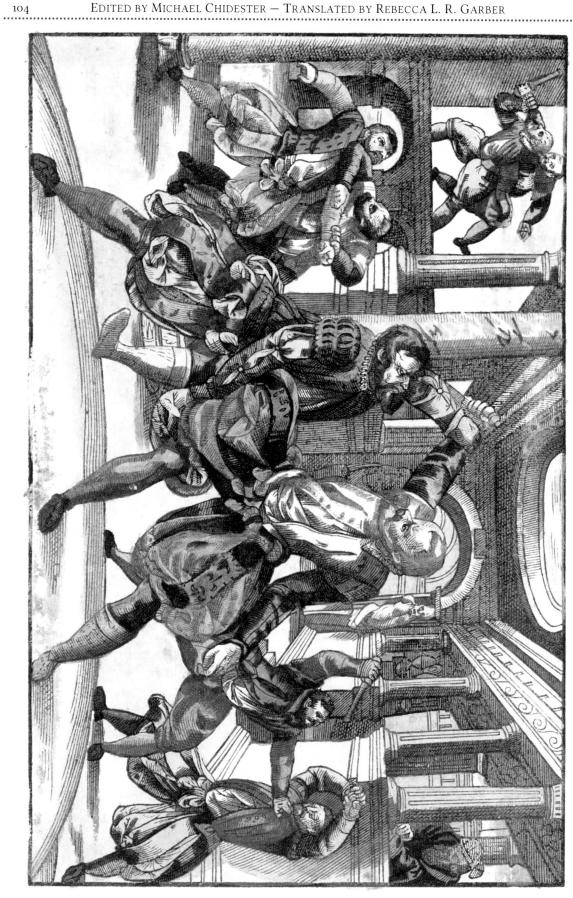

DAGGER

FIGURE [E]

Artist: Anonymous

Prior work: Marozzo 128V, 140V, & 141V

Position: III.15

References: This Figure has no letter designation in the 1570 edition; since the others are A-D and F, I have assigned it the letter E. The 1600 edition assigns it the letter A, which is obviously incorrect.

It's unclear what Meyer's intent with this illustration is. There is a single reference to a "Figure E" on III.15V, which appears in the text directly after this illustration, but the description of the play does not seem to match any scene on this page (and is a good match to a scene in Figure C).

Meyer	Forgeng	Garber	Position	Description

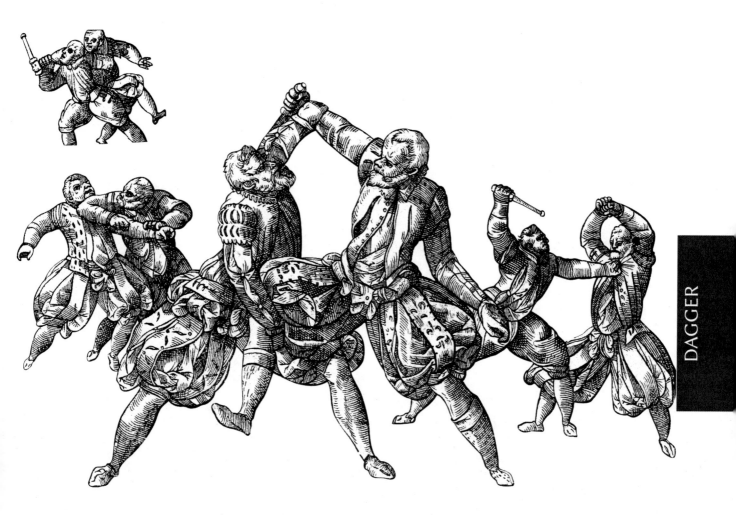

DAGGER

FIGURE F

Artist: Anonymous

Prior work: JMM 71V

Position: III.11V

References:

Meyer	Forgeng	Garber	Position	Description
III.11	242	323	Small left scene	"wrap your arm around their arm"
III.14V	245	328	Small right scene	"strongly grip that arm by wrapping your arm around it"
III.14V	245	329	Medium scene	"grab onto your clothing and force them hard into you"

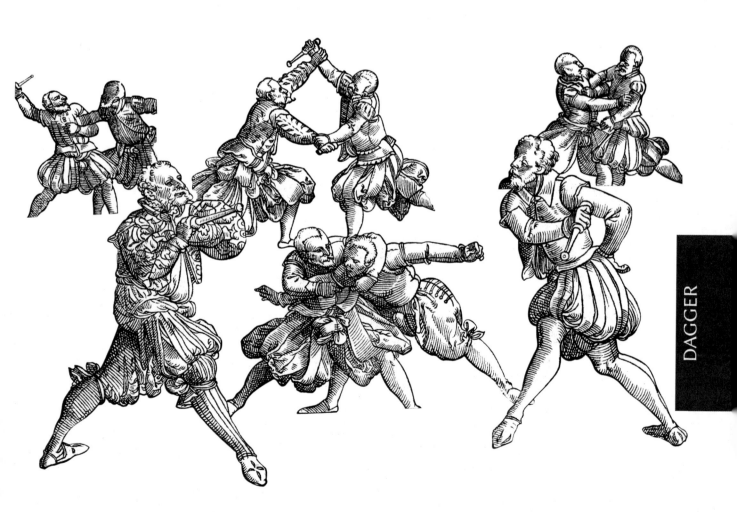

POLEARMS

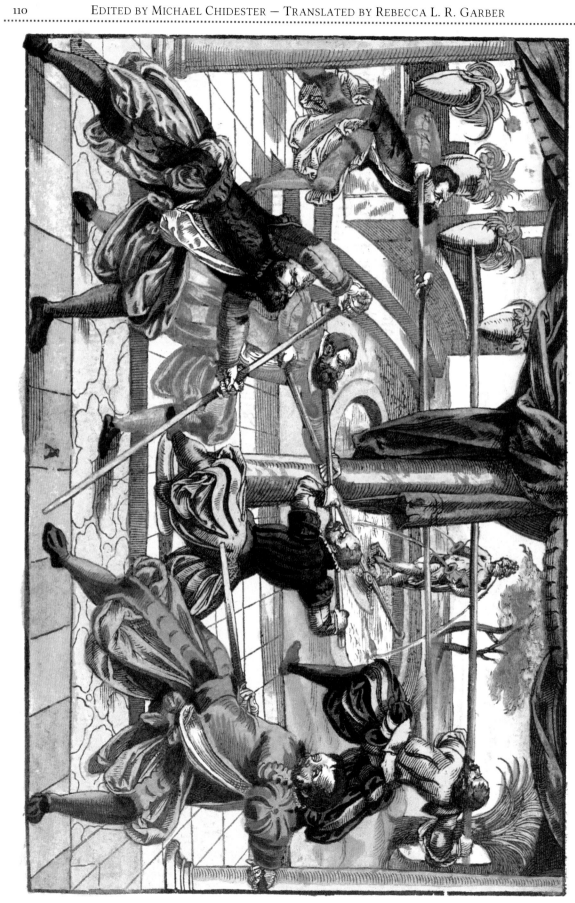

FIGURE A

Artist: Anonymous

Prior work: JMM 96^V–97^R

Position: III.17

References:

Meyer	Forgeng	Garber	Position	Description
III.16^V	249	334	Large right portrait	Middle Guard (𝔐ittelhut)
III.17^V	250	335	Large left portrait	Paddle Guard (𝔖teúrhut)
III.21	252	340	Large right portrait	Middle Guard (𝔐ittelhut)
III.36	264	363	Medium scene	"move your horizontal blade at their throat"
III.45	272	379	Small scene	pursuit (𝔑achreisen)

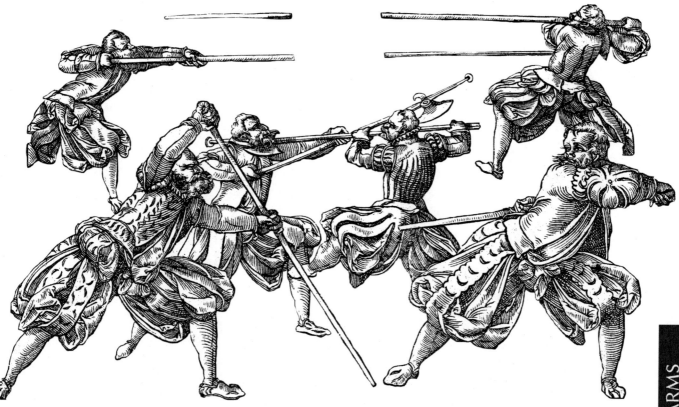

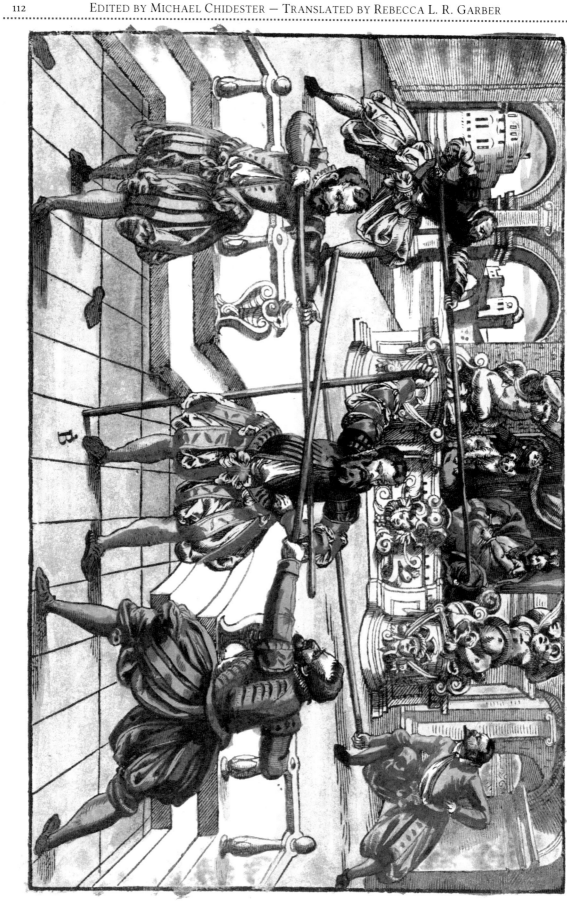

FIGURE B

Artist: Anonymous

Prior work: JMM 79[R]

Position: III.22

References:

Meyer	Forgeng	Garber	Position	Description
III.22[V]	253	342	Large scene	Simple Brace (𝕲𝖊𝖗𝖆𝖉𝖊 𝖁𝖊𝖗𝖘𝖆𝖙𝖟𝖚𝖓𝖌)
III.45[V]	273	381	Small scene, right portrait	"another thrust with one hand"

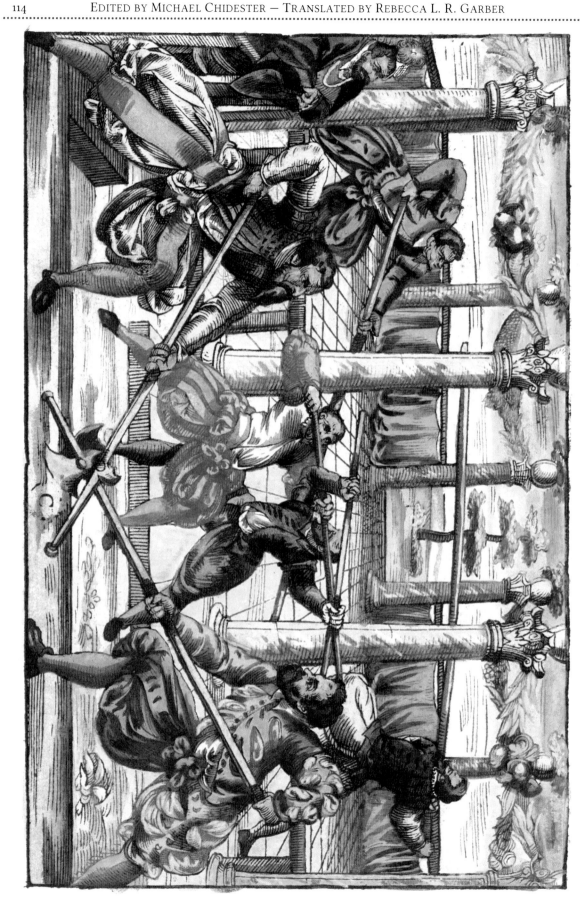

FIGURE C

Artist: Anonymous

Prior work: JMM 90V–91R

Position: III.24V

References:

Meyer	Forgeng	Garber	Position	Description
III.30	259	353	Medium scene	"throw them over your right leg"
III.38*	265	366	Unspecified	"drop unexpectedly with your halberd on theirs"
III.39	267	370	Small scene, right portrait	High Guard to thrust (Oberhut zum Stoß)
III.42V	270	375	Small scene, left portrait	Side Guard (Nebenhut)

* Meyer specifies Figure G, but this seems to be Figure C instead since G doesn't show an action against a Low Guard.

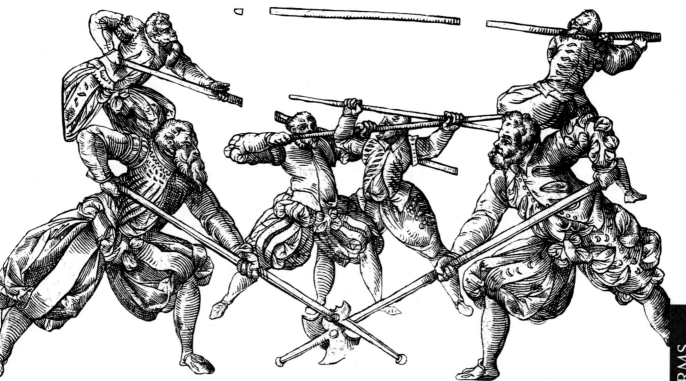

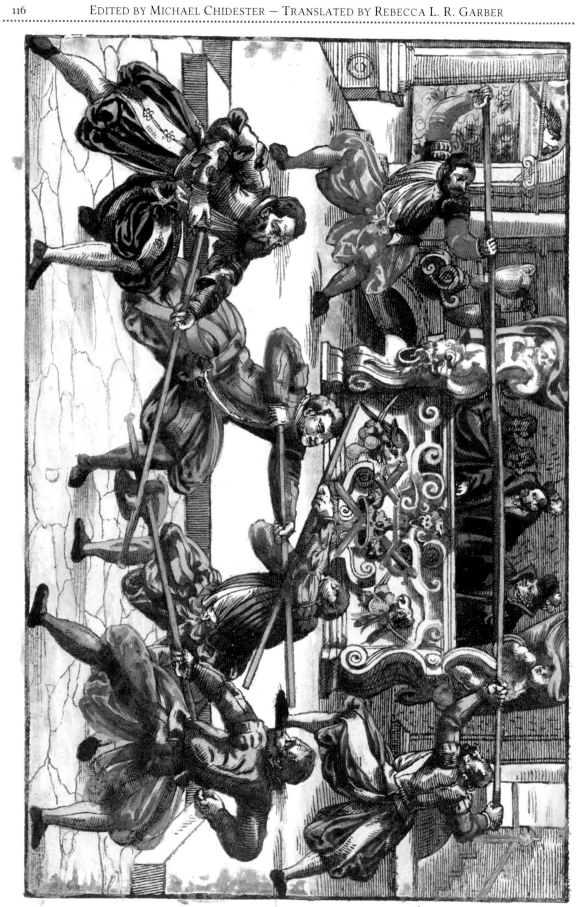

FIGURE D

Artist: Anonymous

Prior work: JMM 81ᴿ, 85ᵛ, & 93ᵛ–94ᴿ

Position: III.28

References:

Meyer	Forgeng	Garber	Position	Description
III.29ᵛ	259	352	Medium scene	"press them downward and strike them on their head"
III.36	264	363	Medium scene	"seize their blade with yours and rip downward toward you"
III.43ᵛ	271	378	Small scene, left portrait	twisting through (Durchwinden)

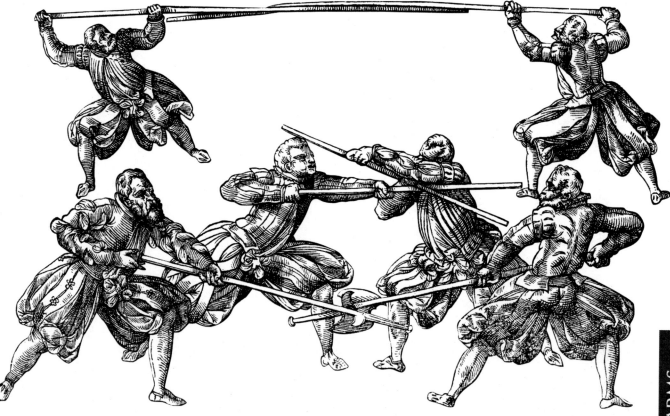

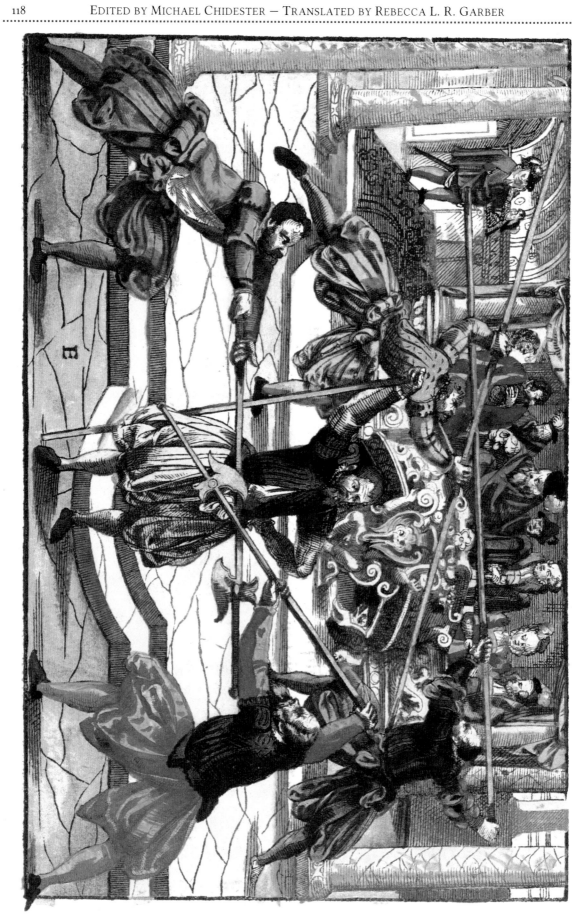

FIGURE E

Artist: Anonymous

Prior work: JMM 97V–98R

Position: III.31V

References:

Meyer	Forgeng	Garber	Position	Description
III.26V*	257	348	Large left portrait	"thrust directly at their chest over their left hand"
III.37**	264	364	Large right portrait	"beat their in-coming thrust outward with a hanging halberd"
III.46	273	381	Small scene, left portrait	"grab back on your pike with the [right hand] in front of your left hand"
III.46	274	381	Small scene, left portrait	"run in"

* Forgeng suggests that this may have been intended to describe the large left portrait on Figure F, which also bears the letter E.

** Meyer specifies Figure B, but this is incorrect as there are no hanging weapons. Figure E shows the fencer on the left with a hanging blade beating out a thrust after having stepped backward.

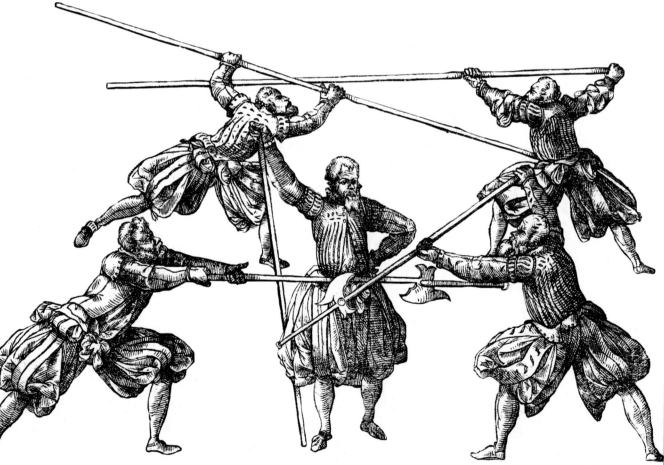

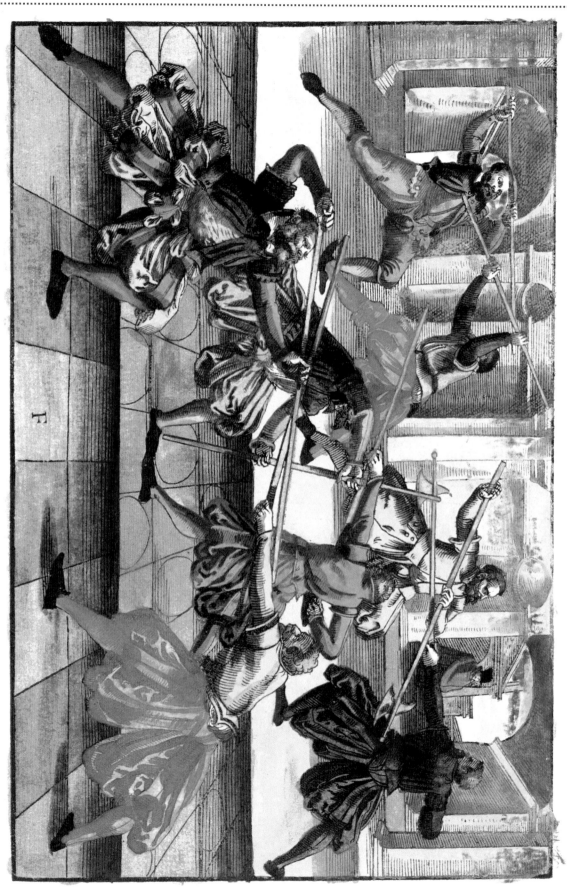

FIGURE F*

Artist: Anonymous

Prior work: JMM 81V and 86V

Position: III.36V

References:

Meyer	Forgeng	Garber	Position	Description
III.30	259	352	Medium figures	"turn the butt end inward between their hand and their staff from below"
III.36	264	363	Small right scene	"twist your blade or your entire halberd up over theirs"

* This illustration contains two letters in all copies. The "E" seems to be an error, and "F" the intentional one.

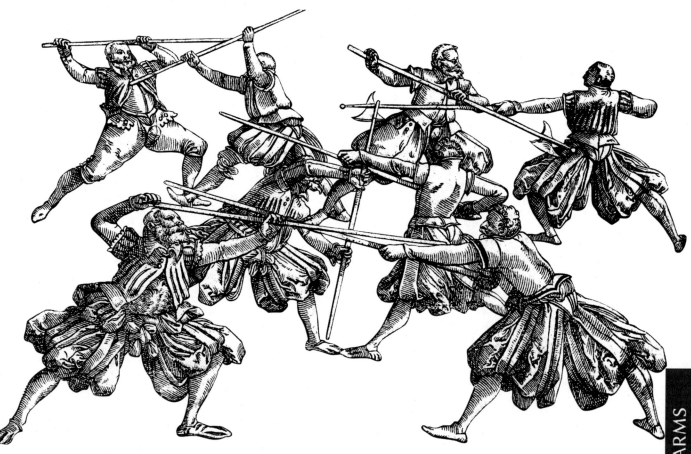

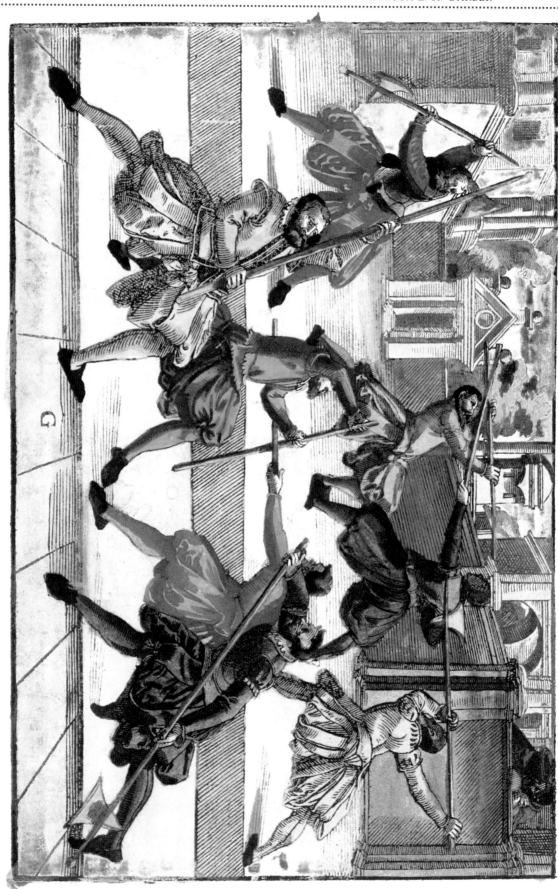

Figure G

Artist: Anonymous

Prior work: None

Position: III.37^V

References:

Meyer	Forgeng	Garber	Position	Description
III.24	255	345	Unspecified	"shove your staff swiftly over theirs close to their hands"
III.32^V*	261	358	Small left portrait	High Guard (Oberhut) on the right
III.34^V	263	363	Small left portrait	High Guard (Oberhut)

* Meyer doesn't specify an image letter for this, but G is the only one that has small solo halberd figures posing in guards. The small figures in Figure G are also referred to elsewhere using similar language.

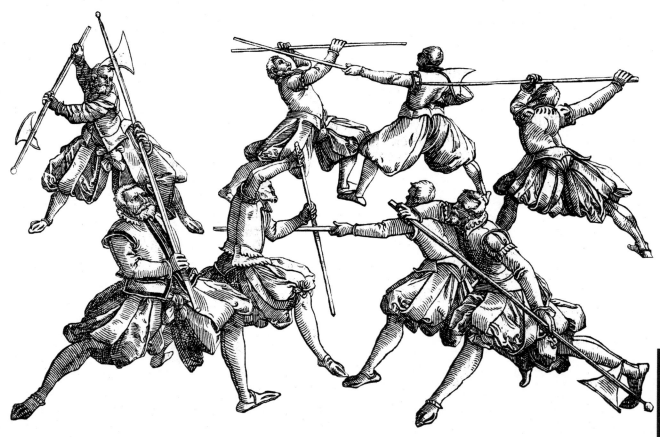

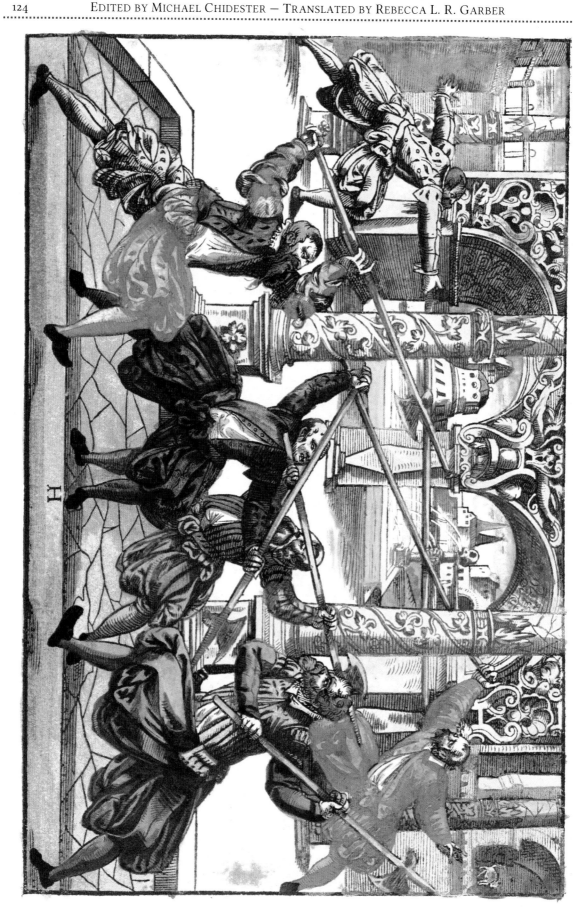

FIGURE H

Artist: Anonymous

Prior work: None

Position: III.33^V

References:

Meyer	Forgeng	Garber	Position	Description
III.34^V	263	361	Large left portrait	"reverse your left hand on the shaft"
III.45	272	379	Small scene, right portrait	"leap back with your front foot and pull the butt end upward"

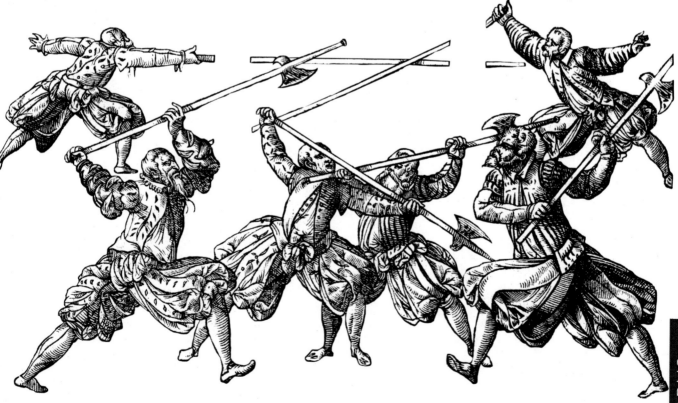

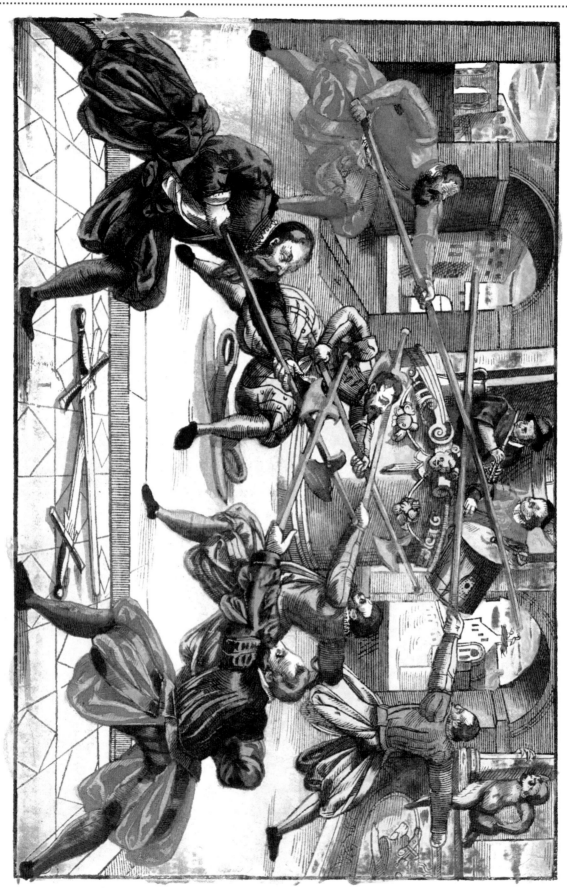

FIGURE I*

Artist: Anonymous

Prior work: None

Position: III.35V

References:

Meyer	Forgeng	Garber	Position	Description
III.35	264	363	Medium scene	"catch them with your blade around their neck and rip them toward you"
III.40	267	370	Small scene, left portrait	Suppressing Guard (𝕯empſſhut)
III.41V	269	374	Small scene, left portrait	Suppressing Guard (𝕯empſſhut)

* There is no Figure J in this book. This is because I and J started off as the same letter, and in this period they still were often not distinct from each other.

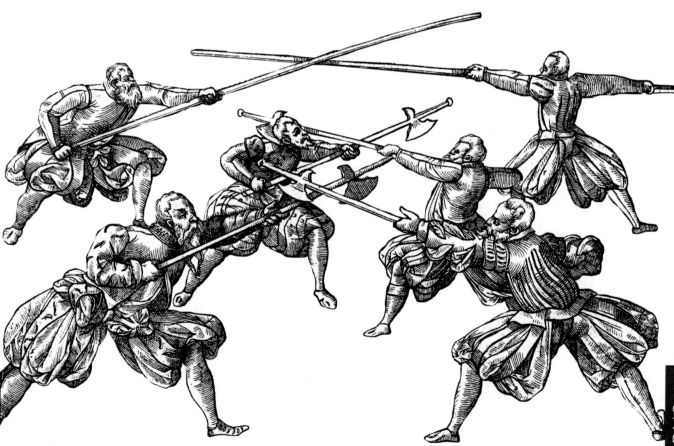

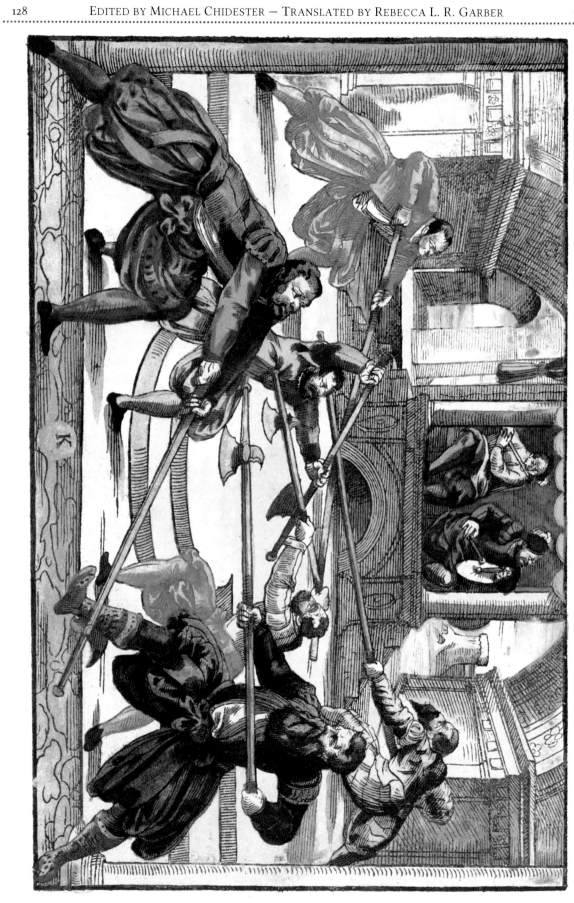

FIGURE K

Artist: Anonymous

Prior work: JMM 91V–92R

Position: III.39V

References:

Meyer	Forgeng	Garber	Position	Description
III.36	264	363	Unspecified	"use it to catch them by their forward leg"
III.37	265	365	Medium scene	"thrust for their chest"

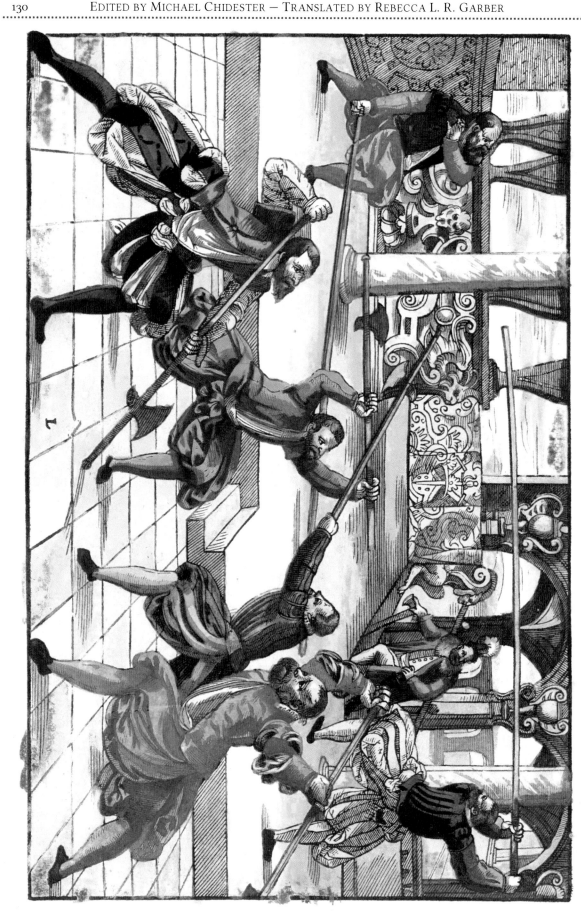

FIGURE L

Artist: Anonymous

Prior work: JMM 95V–96R

Position: III.44

References:

Meyer	Forgeng	Garber	Position	Description
III.45V	273	380	Small scene, left portrait	"how you should lift your pike upward in an arc with one hand and thrust in"

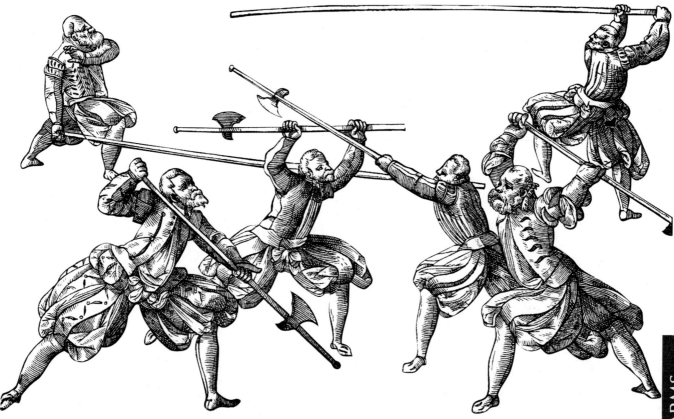

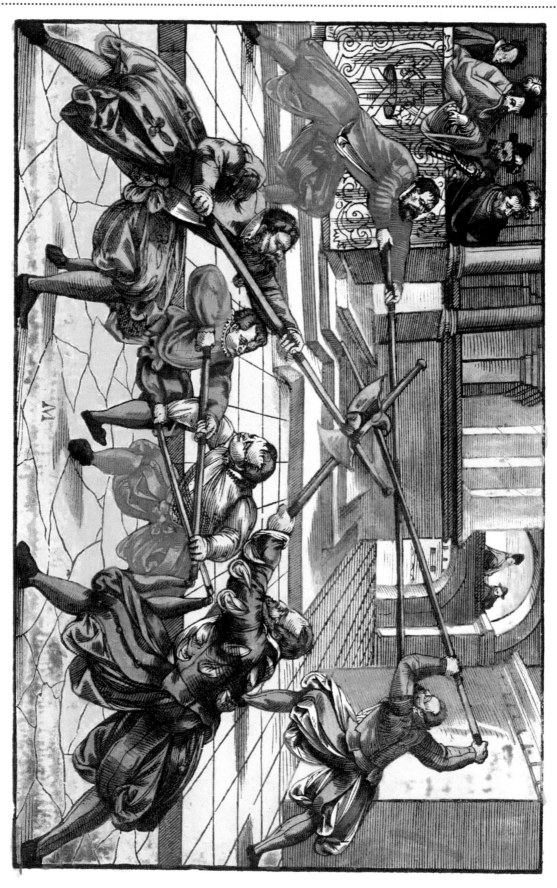

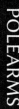

FIGURE M

Artist: Anonymous

Prior work: JMM 84V & 94V–95R

Position: III.42

References:

Meyer	Forgeng	Garber	Position	Description
III.36	264	364	Unspecified	"catch their halberd behind their blade with your horizontal blade"
III.45	272	379	Small scene, right portrait	"beat their in-flying thrust outward to the side"

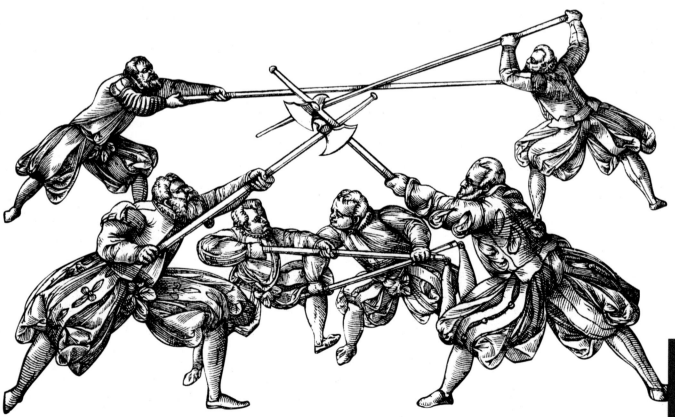

APPENDIX: MÜNCHEN

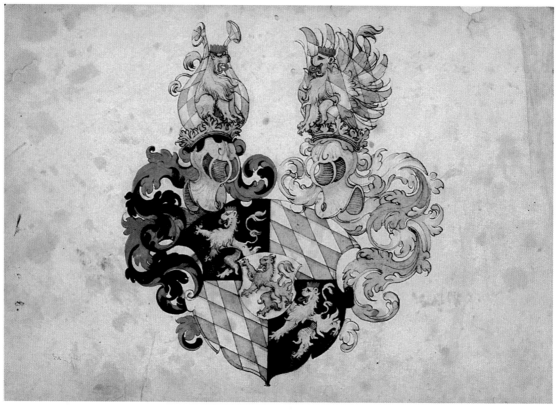

I^V

8^R

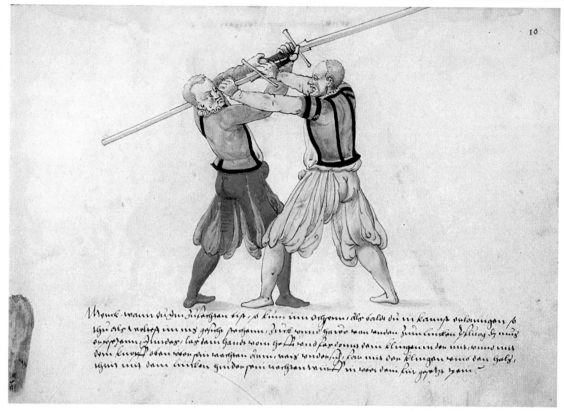

Merck wann du dein kreutzhaw thust, so küm im orthen, also bald du in kanst erlanngen, so thu als wölteft im ins gsicht stechann, kürt wund harte von einander fein linncken schling dy mitt dein knopff oban überhin wartzen dein, wartz von dann ist, kum mit dein klingen auns dem halß, thuns mit dann linncken hinder sein wartzen dein.

10^R

10^V

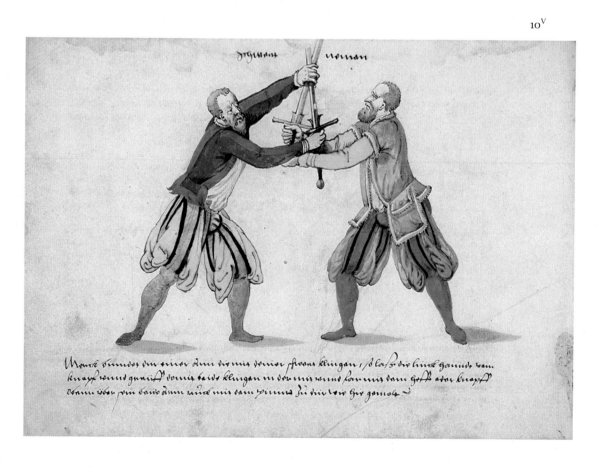

Merck wunds du einer dein dir mis seiner steren klingen, so laß die linck hannds vam knapff wunds gunist vonir taids klingan in der mitt wund kum mit dem heft odor knapff dann über pein hauß dann zuck mit dem zwirch fu dir kir her gemob.

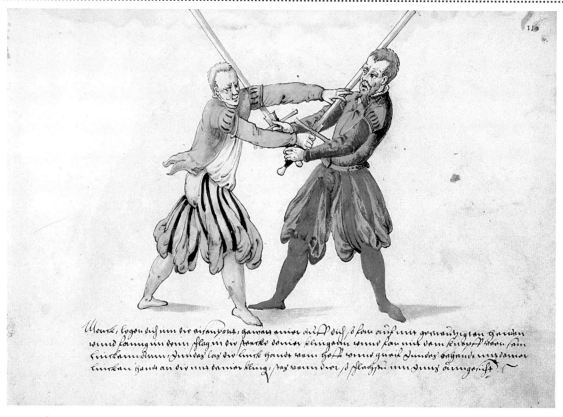

11^R

11^V

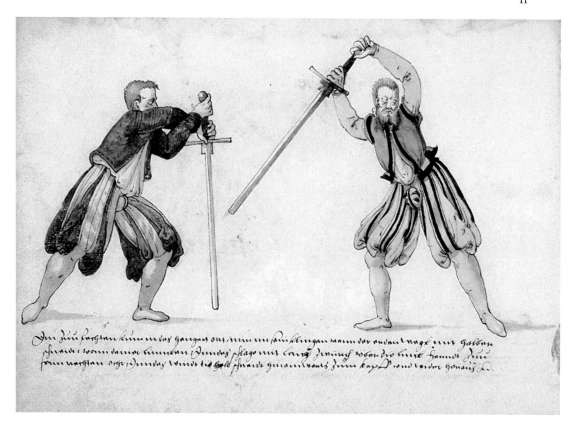

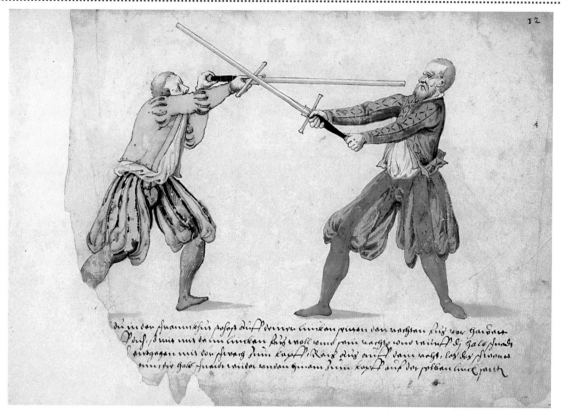

die in der spannung setzt dich deiner linken zitten den nachten tail vor hainer
dich, so nim mit dein linken fuß wol ein tein nach und richt... gals schnit
aus gegen mit dem schwarg dem kopff. Ras dich auch dain nach, las dir schwenck
nin die gals schnit ... den hinaus dem kopff auch der prisan linch pach

12^R

12^V

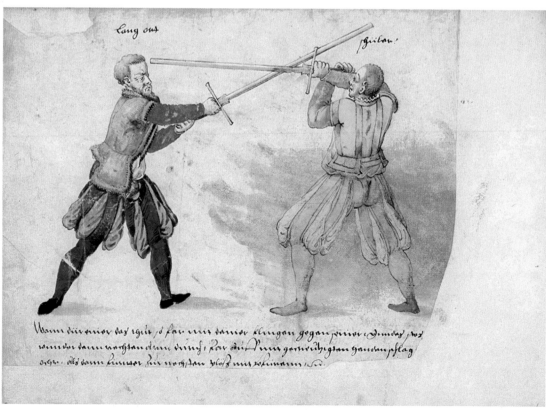

lang ort ... schilben

Wann dir einer das ... so far mit dainer klingen gegen ... w... das ...
... dain nachten dem ... har dir nim gerricht gan handen pflag
... als dann ... die nachten ploß mit schinann ...

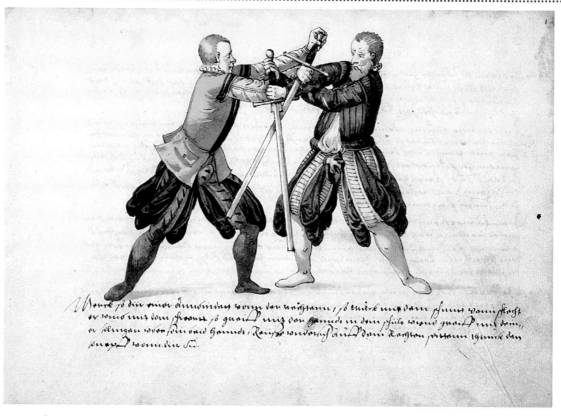

13^R

23^V

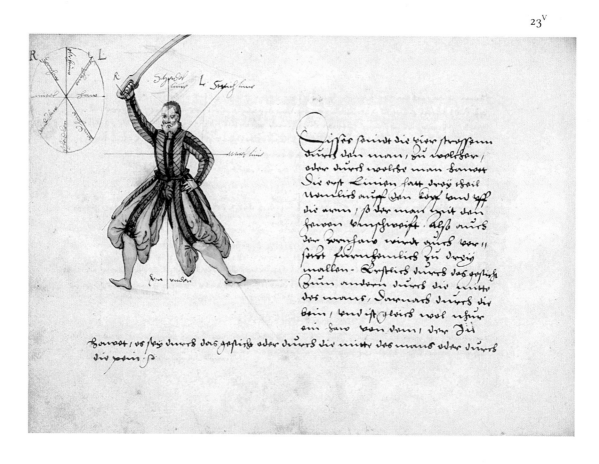

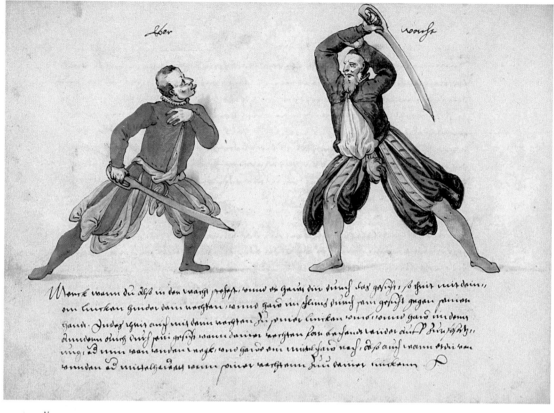

Merck wann du Zils in den wargt gehst, vnnd er hawt dir durch das gesicht, so thue mit dein
ain linckar hindar dem wartglan vnnd haw im klains durch sein gesicht gegan seinar
hand. Jndas thue auf mit dain wartglan di sainer linckan vnnd vnnd haw in dem
Rundlein durch durch sein gesicht wann dainer wartglan hat dabhand dainer aint ... durchstich
und ... im wan landan ... nagt vnnd haw im mich haw nach, das auch wann er di ...
vnndan ... michelhawt wann sainer wartglan sein dainer linckan ...

24ᵛ

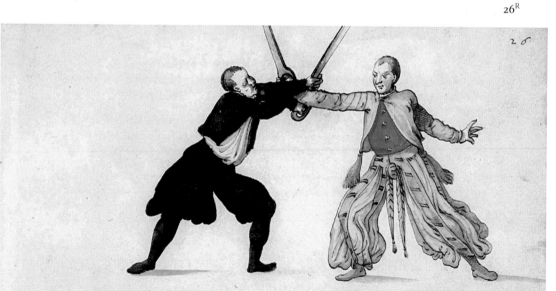

Dar wann du michls vber sain wartgan hast, das er gahen garr, als geschals das vor, so gwar
ais dainer linckan hande vber dem Rargts vnnd sein disarken laicken in dam kling vnd
gosslich in das das haimet vnd das gamols tan, ... hindorch vnnd Rargt dir Pdain
wartgan windas lag dan linck hannds als, vnnd fich vnnd pflag sin lang sin kapf
Denn dor auch mit dam wartgar.

26ᴿ

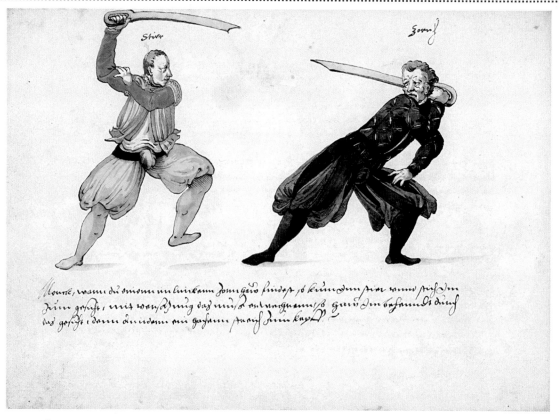

26^V

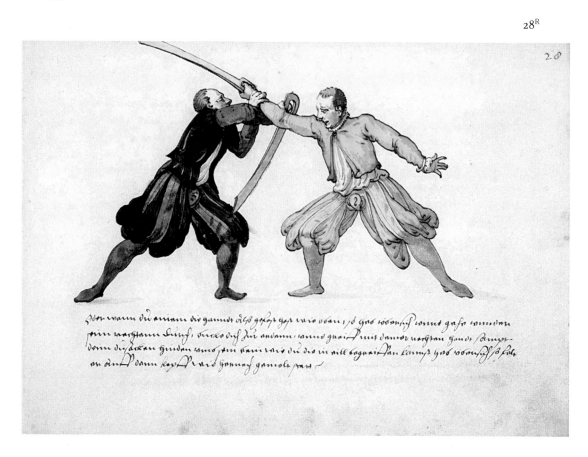

28^R

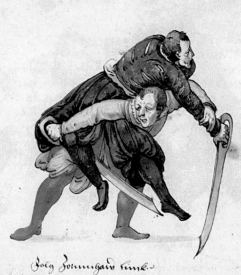

Folg Zornnhaw linck.

Merck wann di im linck ann obernhaw faßt, so zuwais wann danne linckan durch
die preich hinab wann winden, wind wann danne nachann durch fain michl links haiß
im haiß ed praiß fenck dein mann heram, haiß das sü dann derpaken ut naß kunnet
haws, zornnig dindeck mit dann rechtann knoll die im, wann haws kunnet robm

28ᵛ

30ᵛ

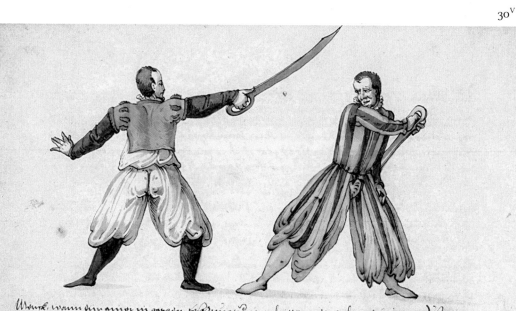

Merck wann der amer in gerader schiringsled im snitt was die faßar, so kim im hitrich
in die wahann gutvdrit, dan linck fertann dance in die haiß praid ober mit nachams
dann dem gesicht. Den andarn haws wann randan dirch mit lang schaich durch sein gesicht
Den darfan in michlhais naß, wan damer nachgant raus an dan dann so haws angarundt
dein gesicht.

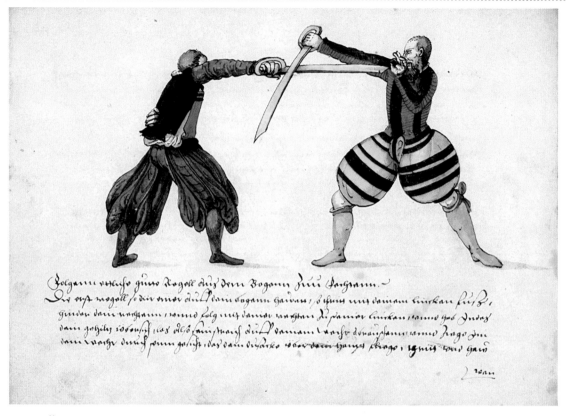

Folgann etliche gůte Regell auß dem Bogenn sein Dargann.

Die erst regell, so dir einer die... dann dogann haidett, schnÿ mit dainem linckan fůß,
hinder dain nachamm, vnnd folg mit dainem rechten die... dainer linckan, vnnd hab Jndas
dain gehiltz ubersich, las also hauptrach dir dainam, rechr durauschann vnnd rags ÿn
dein rachr durch sein gesicht, das dain duicko uber dein hauÿs schlags, Ignit vnd hais

Jsan

31^V

33^V

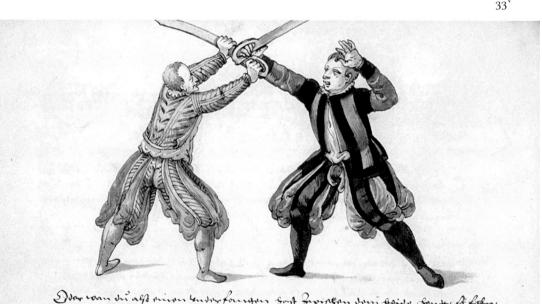

Oder wan die alß einer underfangenn bist zwischen dein baide hand, so fach,
oder wind mit dem ort, aussen uber uber sein Rechten Arm, Reiß undee,
sich auff dein Rechte sytten, Laß Jndes die linck hand ab, vnd stoß ÿn
die lang phundch uber die hand durch das gesicht, oder sto mit dem ort von
die und schlag lang nach

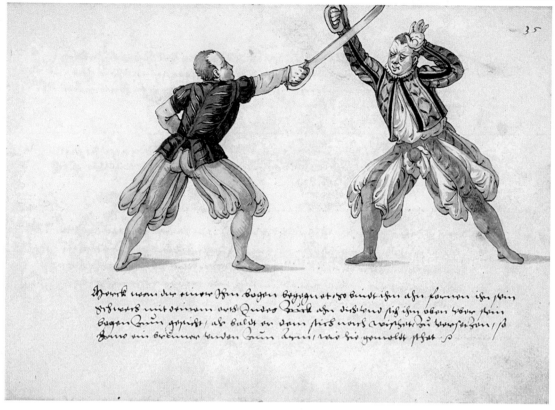

35

Zwerck wan dir einer chin begert begegnet, so binckt ihn ahr forwen ihn, hin
dhierts mit deinem ort. Indes binck ahr dihtens sih ihn vben höre thin
begen, sein gehickt, als balde er vom stich noch angeheht die berzehen, so
zann die breuwer binden sein, arm, wie die gewolt that.

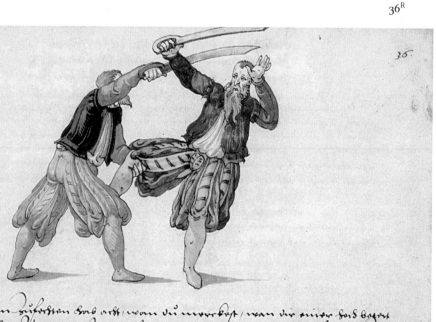

35

Ein zihohten dach acht, wan die merckest, wan die einer dach begert
vber zihauwen, so vnderfahr ihn mit dem begen, vnd koug ihn
sein arm greich mit deuner. Indes behend sein fuurgeheht sein, binden
ihr seiner binzihugen, vnd dach vberstich, vnd setz vben von die so felst er.

30

38^R

Khunnyhaist jst du an obar ad Brittee mit kennear pfundo grissen hau, wescht du in sychem shall gewolt. Dann über lauf st dich weiter mit ain gehaim straich, so kauug du dann weich Inn der lutste graist, Indes mit deiner lurken hinder deinem klaug deinem gesils und hardt eineg wunder penur achselang Hindern Inn das durkote

39^R

39

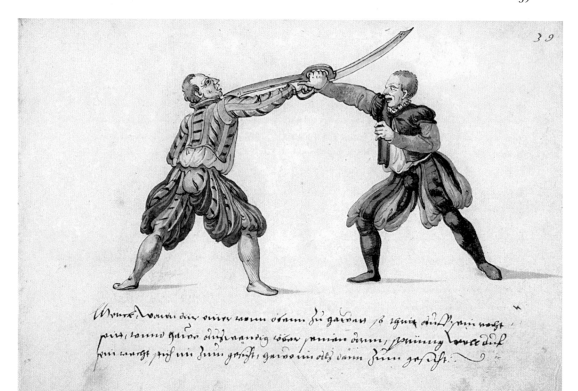

Wenick wende den einre waen deinn du gewart so schut du dj Hain wesht peis, lauue Hares dirstrandig über penur denn, pennug leuee dis sein wescht pich in dein gesils, hardo in deß dein hin gescht.

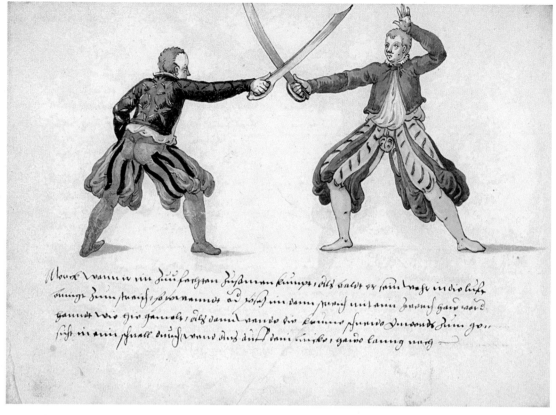

Alßdann wann er ein hieb hargegen führen will, kumpt, will baldt er sein recht in die lufft vmige dein strach, scho vornamen, oz schaf in dann perich mit ain hinrich hard word. hauock wie hie hamole, will dann rande der keiner schurib, Imvonde dein gou hiht in ain phrall duch, vamd das auf dam linkes, hand laung verch —

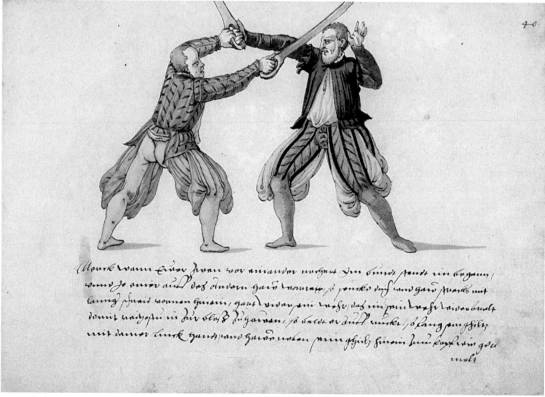

Alßdann wann ßieer fran vor anander nochnat, den chind standt ain bogaun, vand je enier auß das anderen hard vonranp, so puirks dich vand hard puarkt mit laung schrait vonnen hunain, hant vidan ein vohe, das ein mit recht vaiderbuert domit vachschti in dir bloß zu garvam, so vordt or duch enirke, so laung zmophilz mit dann lenk hand vand hard vnten, mein ghili hunain dem kazh ain gsei melt

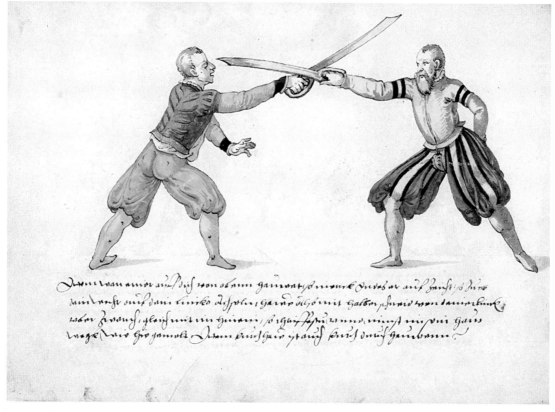

Wann man einer auf Dich von oben haut, so wart indes er auch haut, so fahr mit dem lincks Schenkel vor und ... mit halber Schneid von deiner linck über zwerch, gleich mit ein ... so ... wind, nimbt mit ... Haus ... als Hie gemalt. Inndes zeuch haut ... aus, ... als Hie gemalt.

40^V

41^R

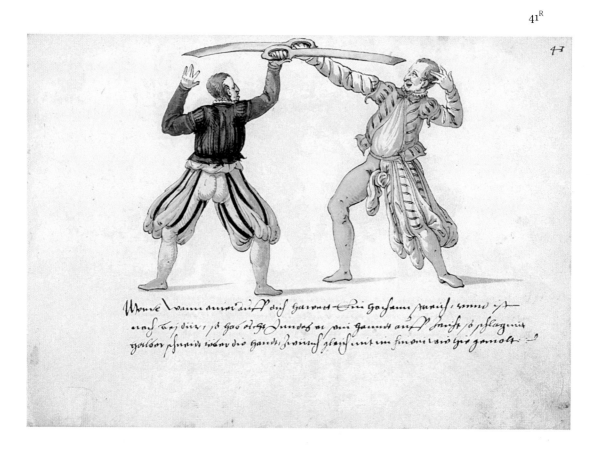

Wenn man einer auf Dich haut, ... und ist nach bey dir, so hau ob sein Inndes er ein haut auf Dich, so ... halber Schneid über die Hand, zwerch gleich mit ... als Hie gemalt.

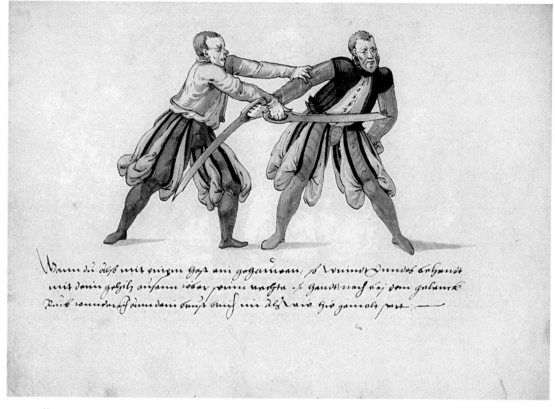

Wann du dich mit einem haft ani gegarnean, s vnind hundes erhandt
mit dem gehilz aisann oder pein nachtn es haudt nach vaz dem gelanck
kurt roundarch dann dann dmpt auch mit deh vnd hib gamols pet:—

41^V

42^R

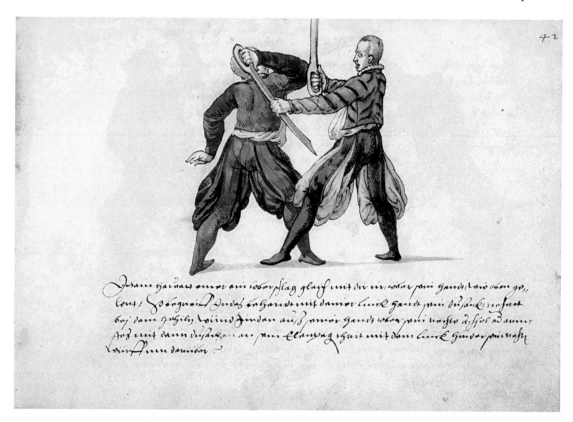

42

Itann hardaur emer ani woderphlag glach mit dir vir woder pvi haudel vnd vom go,
leus; Soorgraich hudes erhandt mit damer linck haudt pen dischen erehoit
bej dam gehilz, viind findan auch pvir haudt woder pvi nachte dehol ab annn
hof mit dem dischen an pen clampag rhait mit dam linck hinder pri nachr
Jaun Anen dannen:

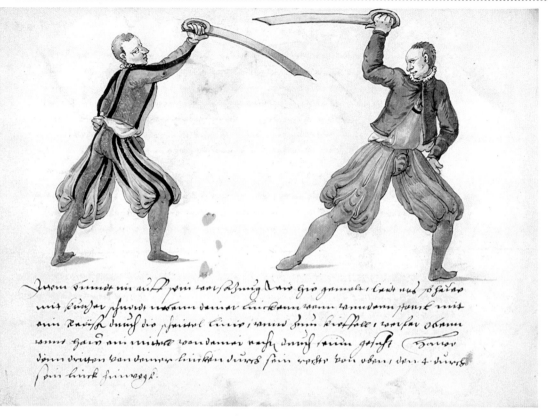

Item vinde mi auch sein verschnug das die gamolt, laid und schâto mit tiefar schwort wann denor linckan wann condem panst mit ein Raisch dunch dis pfaistel linis, wann sein kieffell, worbar obam wann hard en michll wandanoi nach, dunch sein gefoft. Hanor dem drigen van deinor linckon durch sein rechte van obem, den 4 durch sein linck hinwogg.

42V

44R

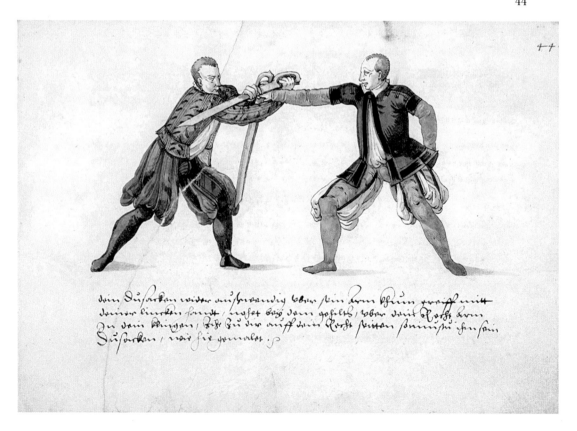

sein Dufoskon widar aufwoandig bbar sein arm thüin greiff mitt deinor linckon panet, rehet big dan gohilts, bbar deit Rechte arm in dan kluzzon, fet zu der aufh dein Recht fettan prinzst thin sein Dufoskon, wie sie gemalet.

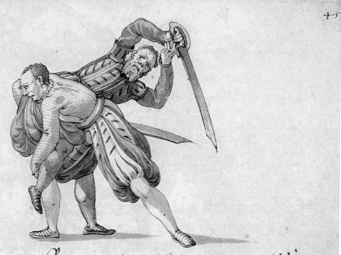

45

Item wann ir einander einlauffen unnd baide harg kument mit der schlinng, so reit begriff mit dem rechten dreyschain, oder baide dan kannst har hinder einder sein Rechtem den dreh mit daner rechten gürden unnd dem laib, unnd greiff mit daner lincken gemit in recht knieschal, so wert ir...
...mit wer dem rechten zu...

45R

45V

Die hent über einander geschlossen

Item wen dir einer begegnet in bogen und hat die hent baide zu samen wie er der zit ist, so begreiff mit daner lincken sein hent, und mit daner gestilt har über über sin recht hant, und bey dem gelenck und das sie krank weich übereinander, wie dir genent

49^V

50^R

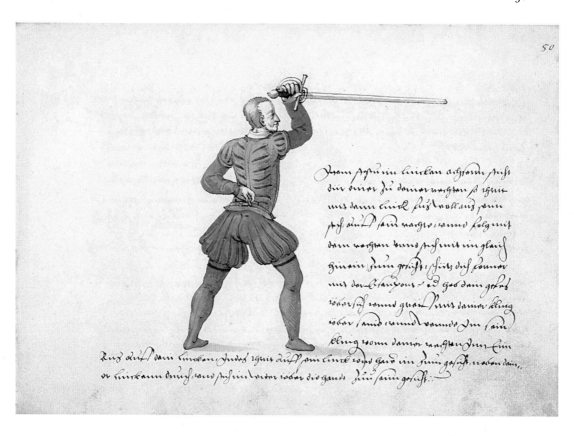

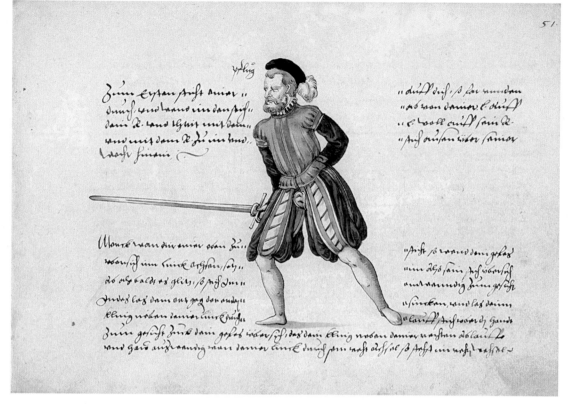

51ᵛ

52ᴿ

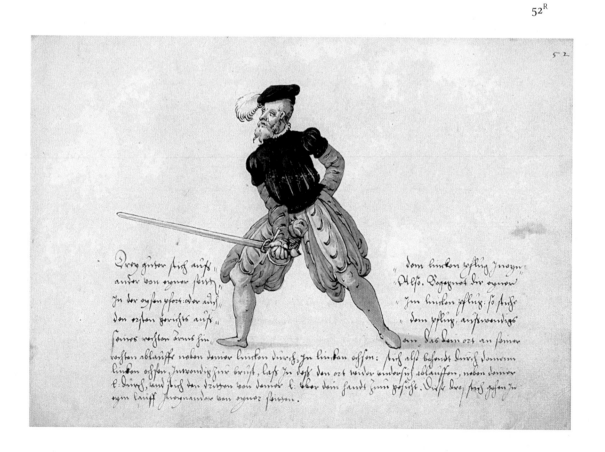

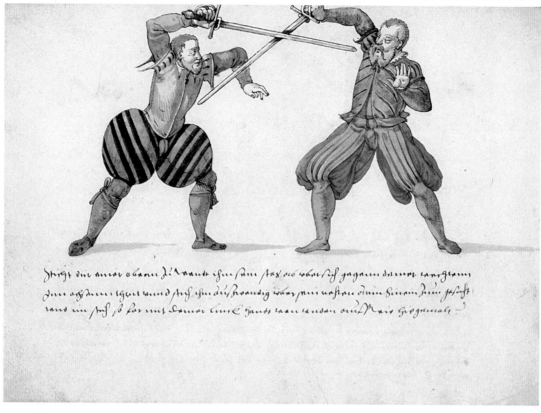

Sticht dir einer oben dir Paÿ fax aÿ gagaïn drum
dem gehörn theÿl und stich dir drÿ wandig ... mit ... dein ... dein gesicht
raiß im ... so far mit deiner ... Hand von ... auÿ Mair Geßmals ...

52^V

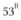

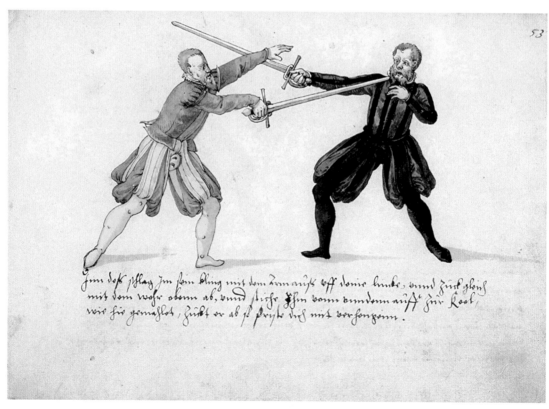

53

Im deß Pflaÿ In sein kling mit dem arm auÿ ... dem linke, und zuck gleich
mit dem wehr oben ab, und stich Ihn vorm ... auÿ zur Rost,
wie ... gemahlot, zuckt er ab so ... dich mit ...

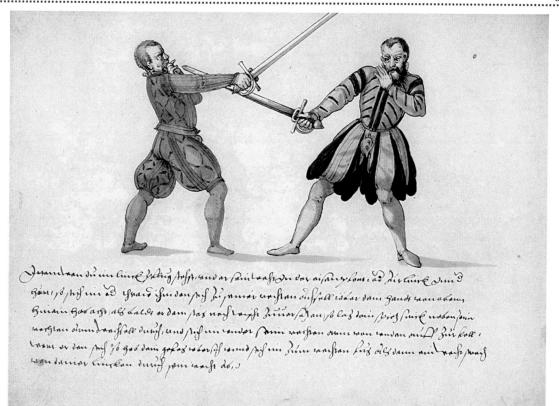

Item wan du im linck zfchig stehst, vnd er schützt nach der ausern hawt, so die linck vnd d[er]
haw, so setz mir ab schaid im dein sich, zu yener wechstar diß fall zwar dein hand wan a bom[?]
hindin hoch acht, als bald er dein sax nach rechst herüber schon, so lass dein sich linck neben sein[?]
wechstar denn der schall durch, vnd such in wider dem wechstar arm wan zu dem auff zur fall
dar er dan sich so hat dein gehat es borst, vnd sich im zum wechstar sich auch dann nit nach wech
von dainer linckan durch sein wacht do.

53ᵛ

54ᵛ

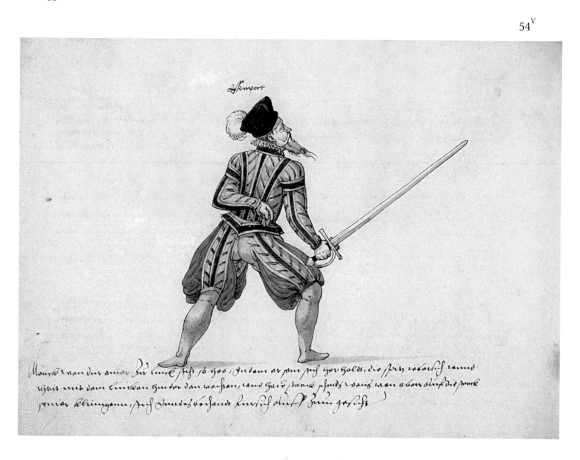

Semport

Item wan dir ainer zu linck stßt so hav, Indem er mir sich her halt, die spitz aÿtarsich rund
schuß mit dem linckan hinder dan wechstar, vnd hav starck phus, vnd wan a von auch diß spitz
yener klingann sich hindersarhant sich sich durch sein gesicht

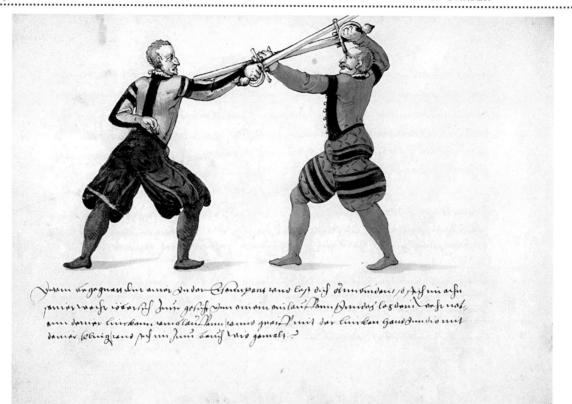

Wann ir gegnast dir auer in der Standthart vnd legt dich Abwundens, So fich vu acht...

55^V

56^V

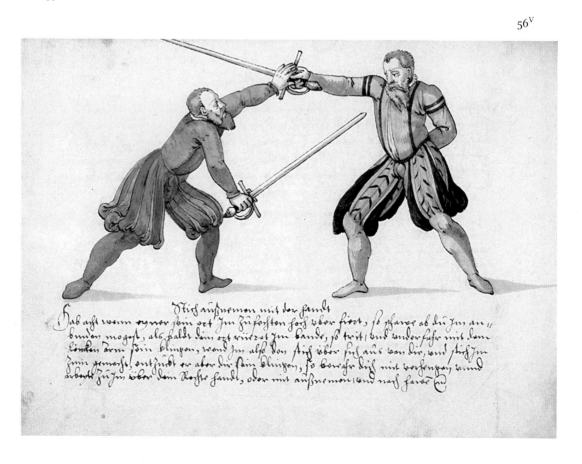

Stich aufnemen mit der hanndt

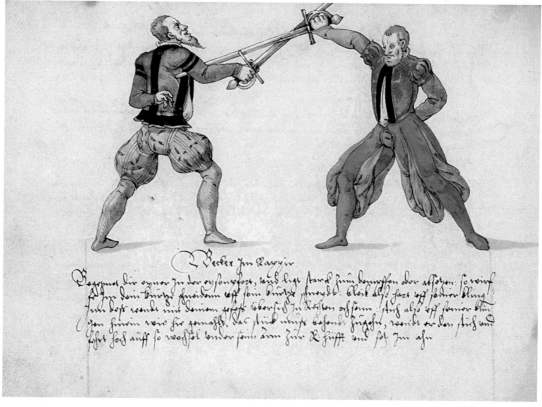

Becker Jn Rappir.

Begegnet dir eyner Jn der eysengefort, und ligt starck zum dempffen oder
schlahen. So weich
[...continued handwritten text...]

57ᵛ

58ᵛ

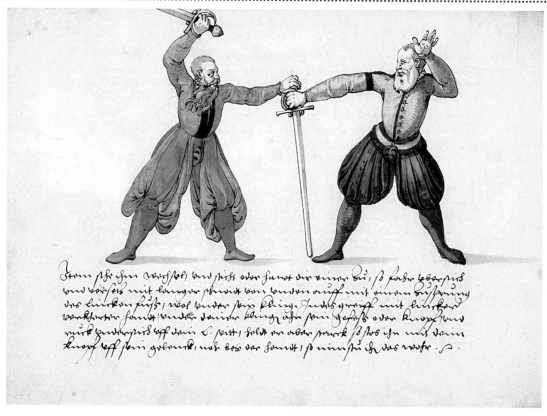

Item, ste iten wecrhsel, und ptehs oder hant der einer bis, so hade vbenspich und dorsen mit langer schwitt von onden auch mit einen surspring des dinken suiss, nos vnder sein kling, Inds greist mit linker vachswter hant, vnder dauche kling, aht sin sehesh oder knoxsten mit dandespich tess dein S. pitt, solst er aber strock sshos ihn mit dein knoxs tess sein gelennk, nos des vor hant, so nunts ih dos rehrt.

59ᵛ

60ᵛ

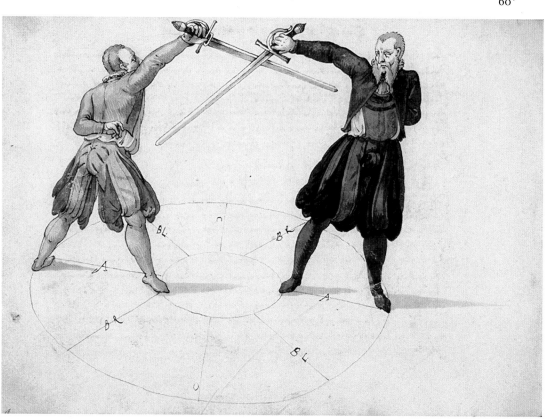

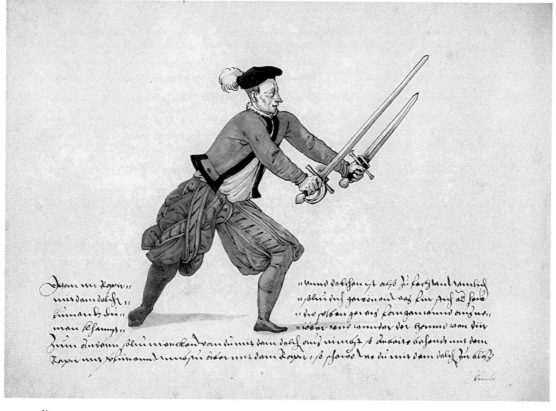

61V

62V

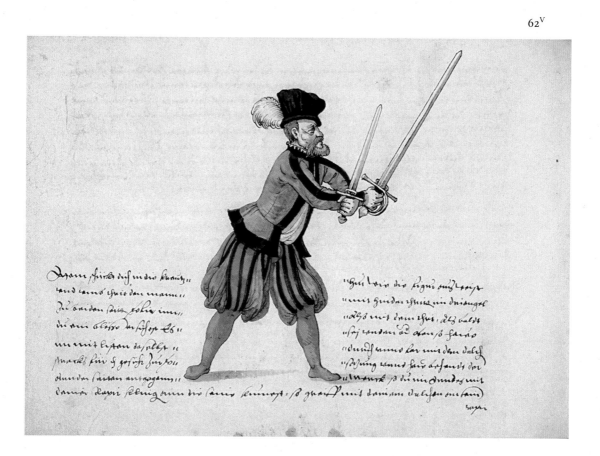

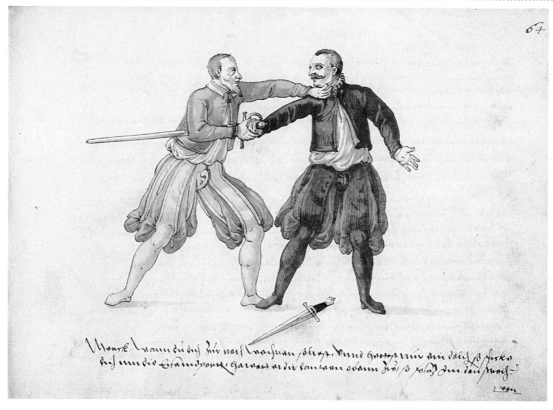

64[R]

66[R]

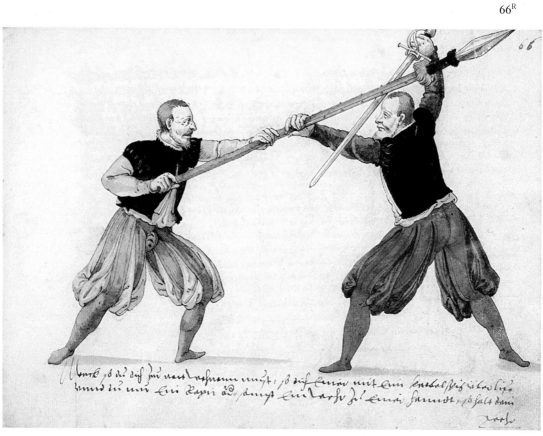

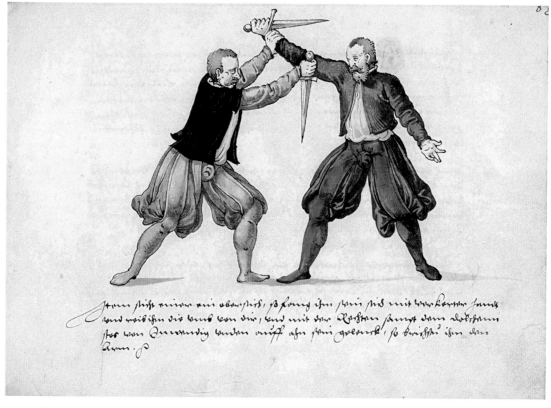

Item sticht einer ein oberstich, so fang ihm sein stich mit deiner Rechten hand und weiß ihn die bruch von dir, und mit der Rechten hand dem oberstein ster von Inwendig Unden Auff ahn sein gelenck, so brichst ihn den Arm.

68ᴿ

69ᴿ

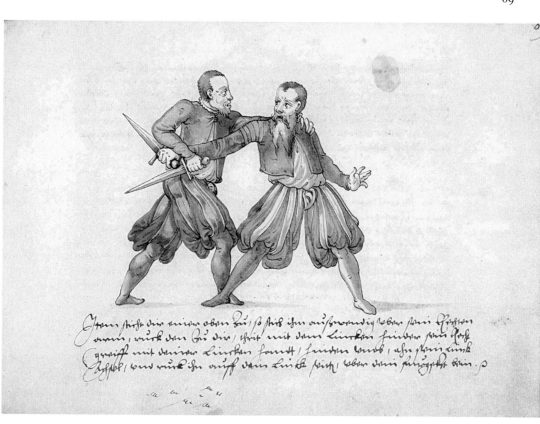

Item sticht dir einer oben zu, so stich ihm außwendig über sein rechten arm, wirf den bei dir, tritt mit dem Lincken hinder sein recht greiff mit deiner Lincken handt, hinder seinen, ah sein linck Achßel, und wirf ihn auff dem linck stich, über dem hinziehen bein.

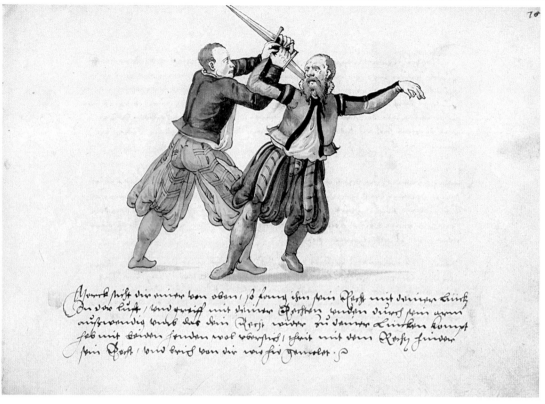

70^R

71^V

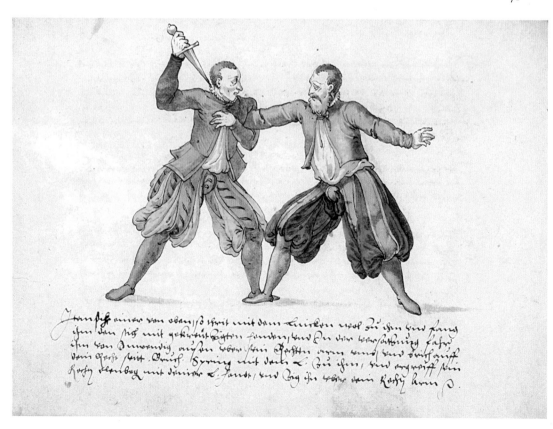

72

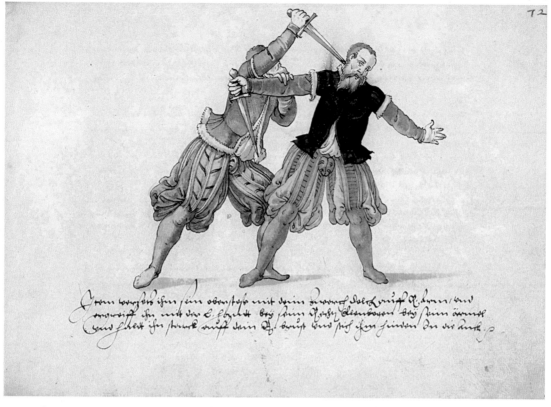

72^R

73^R

73

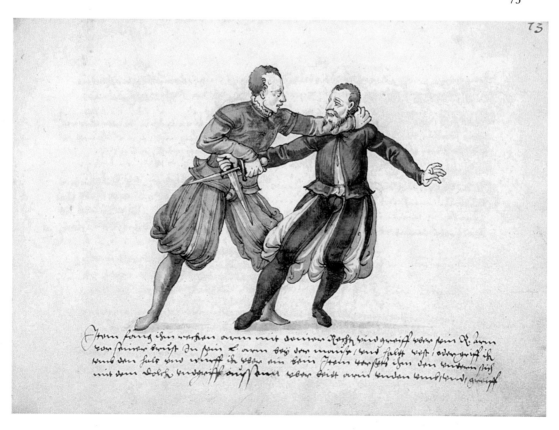

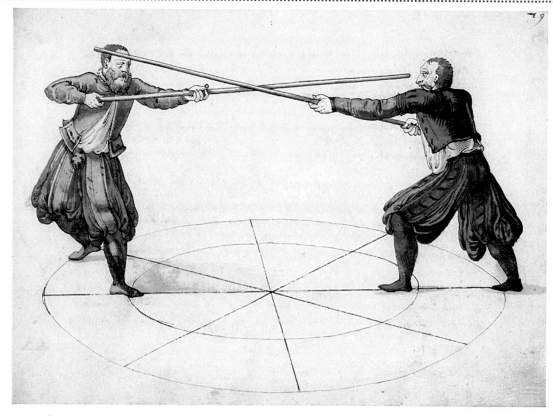

79^R

81^R

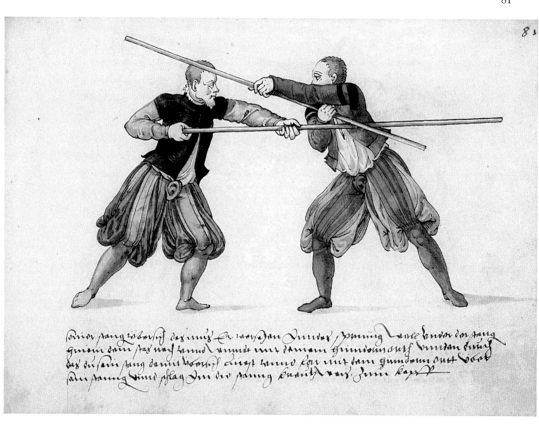

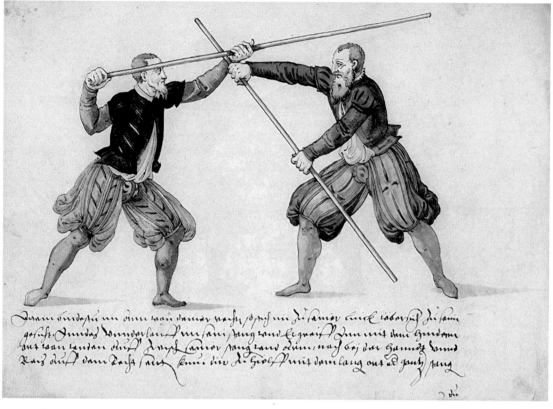

Iram vindapu in dinn man damar nach, spch in di samor buich robersch di sam
geficht, Vndas vonverlaud Vm sani pang vond tegraif Vm mit dun Hundam
dut van zutan dich, Ruch Lanor pang vand dun, nach by der Hamtz vond
Rach dich dan Racht sach kmi die R. Hroff mit dem lang ons ad puch pang

 2 die

81^V

83^V

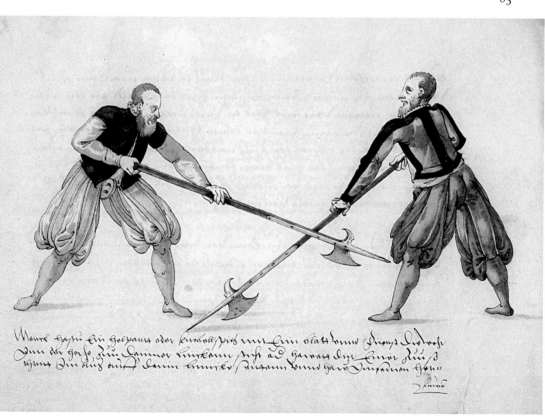

Maure Hapu Ein Holpaus ador kuadoff, dich mit Ein slatt vond Di009 Redvoh
Vm der Hasp, Ein Hanner kunkann sich ad Harras Diz Emn Rüch
chunt Ein aug ond Dann kunnex, dicann vond Har Vnpannen Hen

 Hund

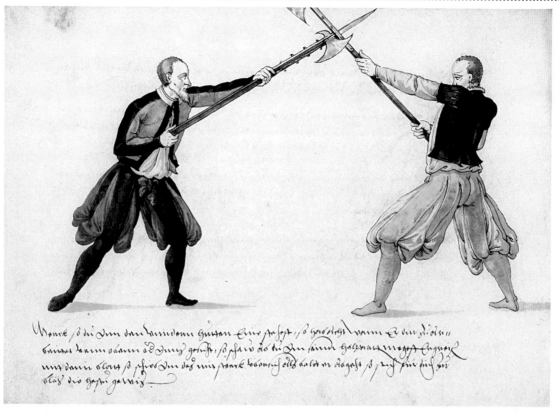

Monck is du dem dundenn Guisen Eris prosept, so groetlegt vann Er dir zloin
bniver kann dann od dnug genot, so far is do du dir dem sein Halfbaror mogot segnoif
vnd dann olois is phvos dm das mir prank bovouril old halb or degost so prif dir dir
olois dis Goset galoiz.

84ᵛ

85ᵛ

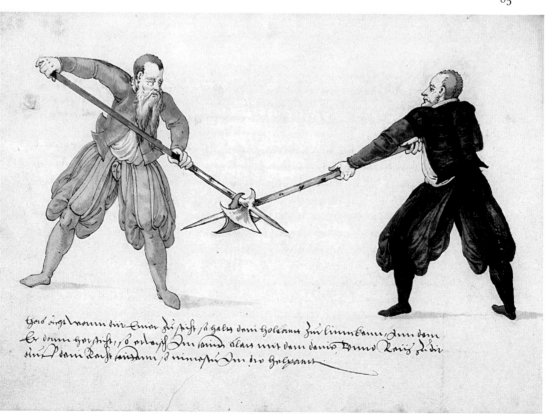

Gos iegt mann du Einn di pist so Galus dann Goloanor zin linnkann dem dem
Er dann gorptiof, so vrlapf dm vnnd olois mit dam danis, vnnd Roiz, di du
dir dann kaigt sundann so mingoftr dm dir Gosbanis.

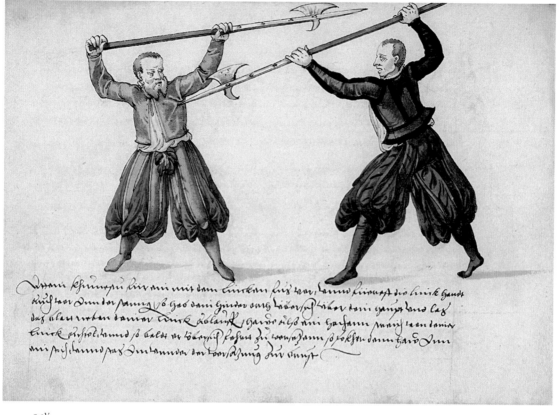

Wann schwingstu dir ain mit dem lincken fúß vor, dann kumpst du lnck handt
úch vor dem haupt, so hau dann hinder auch dúorch úber den haupt. und laß
daz glas neben dainer lnck dolaúß, haúb alß ain haúpsenn waúß ich an dainer
lnck gestolt. und so bald er dúorch fahrt, so úornamm stoßen dann haúb ich
ain stich. und gib dann der úorschúng dir cúrst.

86ᵛ

87ᵛ

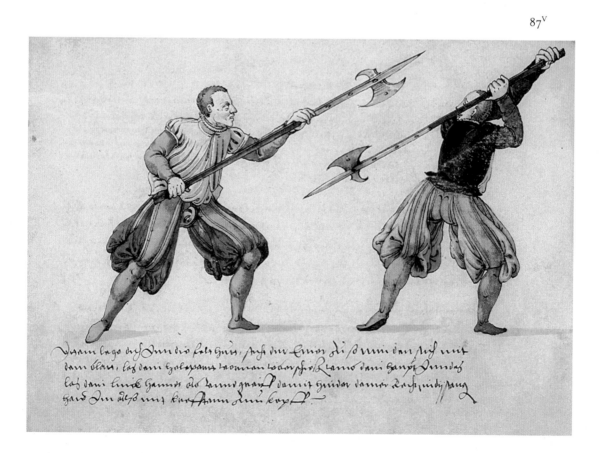

Wann lags dch ún dch falschús, steh dir knor. dir stum dan stch mit
dem glas, laß dann holtzpann waman wanshoß. laus dann haupt ún dch
laß dann lnck hannds dch kennt graiff. damit hinder dainer lach mich stig
haúb ín alß ain karstenn ún kop.

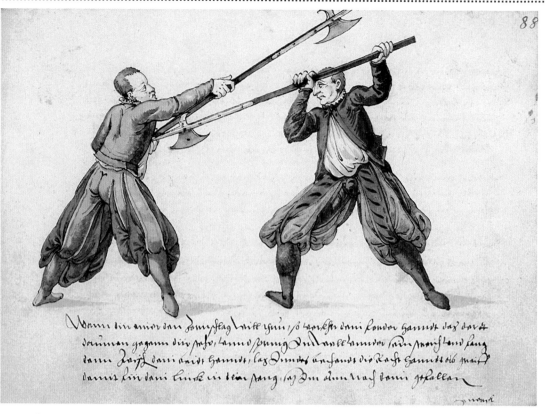

88

Wann im anor dan somschag will thun, so starkst dann souder hamidt das dort
dannan gagann dir sesso, laus dsemig vnd vnlehander sein starich lanng fang
dann karsch dann raiss hamidt, lag dimdes vnhannds des rast hamidt sib mail
damit im dan lincke ein klein fang, sag dem dan nach dann gefallan

88ᴿ

90ⱽ

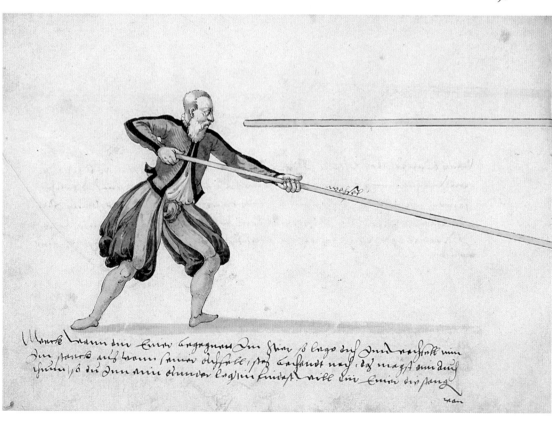
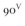

Merck wann dir einer begegnet im sten so lege dich vnd vorhalt min
der sanes ausbaim sanor oisfoll, so aushandt nach daß magst vm dich
thun, so du dem mein olenor laghen sudest will im einer ins fang

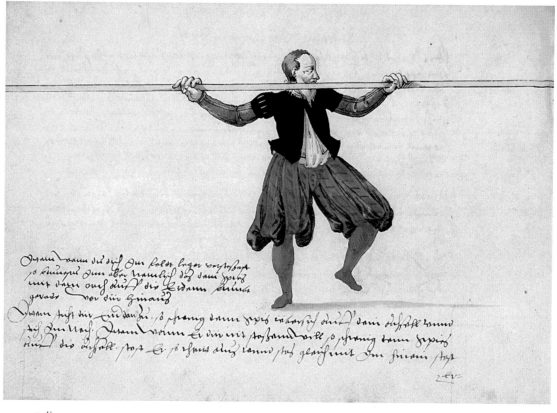

Dann wann du dich zu der kalten leger verthust
so kümbst zun oben trawlich daß dann herz
mit dar auch durch die ledann schnere
gevast vor dir hinauß

Wann steht dir der dauhi, so sprang dann herz erkersch durch dann sichstel vnnd
sich zu nach. Wann wann er din mit stehand will so sprang dann herz
durch die sichstel stost. Er so thun auch rann steh glaichnit Im hinein stost

89ᵛ

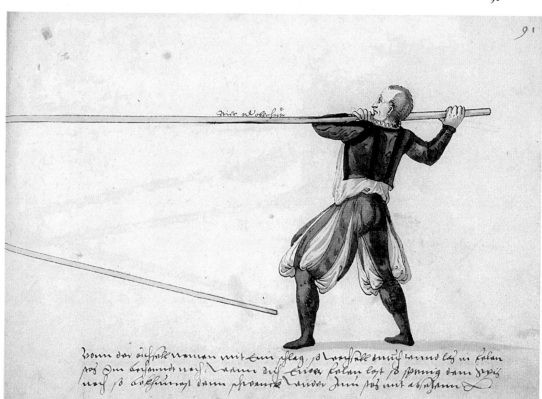

Wann der sechst rennen mit einn pflag, so verfell mich vnnd leg in kalen
stoß im rehennt nach. Wann sich enies kolan lat so sprang dann herz
nach so erschinnen dann pprang vider dein sich mit abschenn

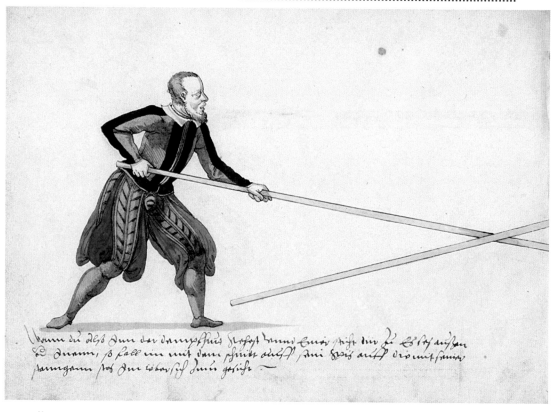

Wann du dise dem der daurgschuß stehst vnnd ewir zicht dir zu so schneiden
du drum, so fall im mit dem schütt deich sein hays auff das mit seiner
zanngzen stoß der ewarsch huis gesicht —

91^V

92^V

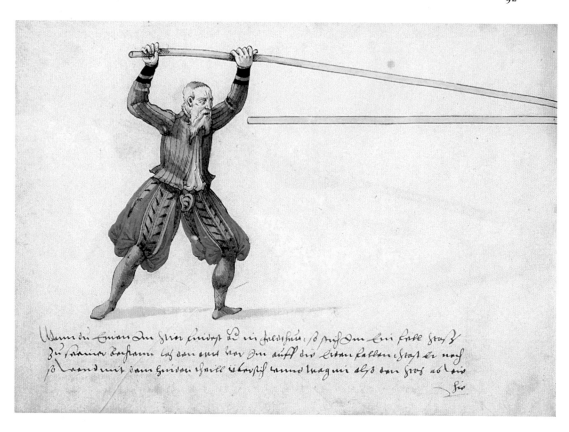

Wenn du Ewras an glier huidst so es in huldschuß so prich den ewi gall stoß
du seiner kehann lege sein aus vor im auff der leiten kallen stoß er nach
so wandmit sein keidon scheld ewarsch vnnd wagui also den gros ab seis

fir

92

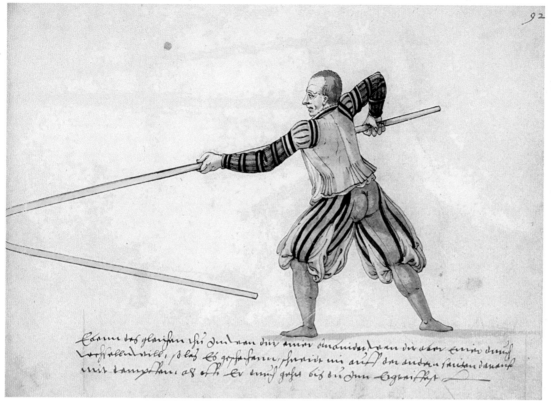

Kann dergleichen thu und von der einer einander wan die aber einer durch
verhallen will, so laß es geschehen, haut in auf der andern seiten danach
mit tampffen als ehr ehr euch geht bis du den begreiffest

93

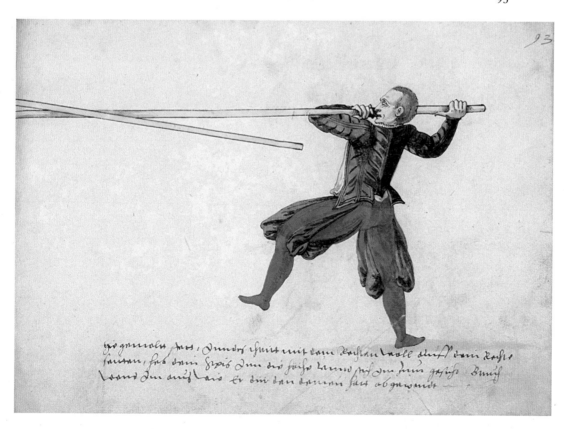

So gewalt zwo, anders thut mit dem rachen voll auff dem rache
hauten, so dann greiß im die füße und bis der in gesicht durch
womit im auch als er in den danen hat abgewandt

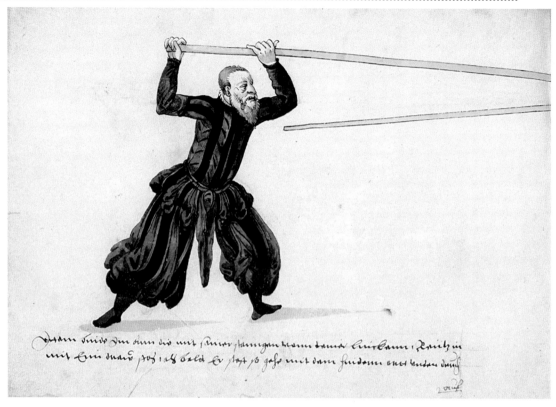

93ᵛ

94ᵛ

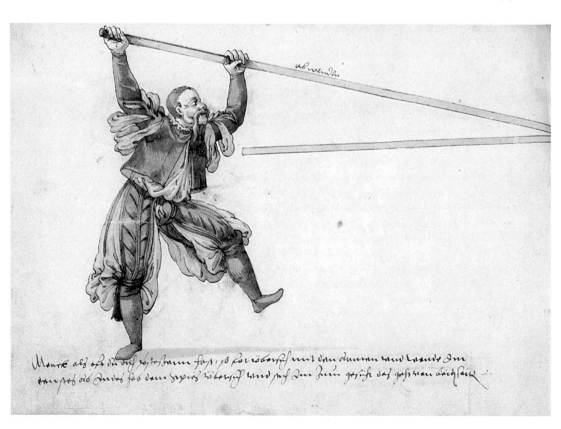

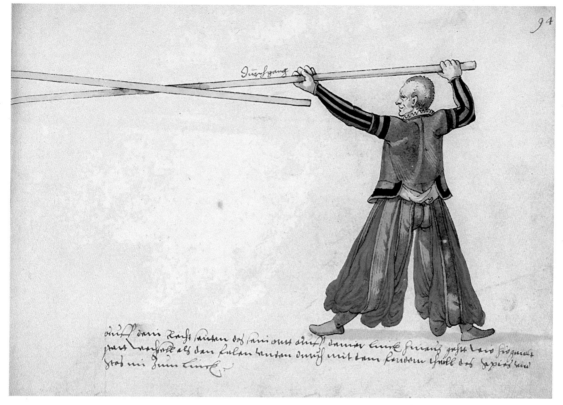

94

Durchgang

durch dann Rechts hauen des hau aus auff dann linck hinauf gehst das figürlich
grad mit nochfart als dan hulau hinten durch mit dem hindern theil des de piess haw
stab mit dem linck

94ᴿ

95ᴿ

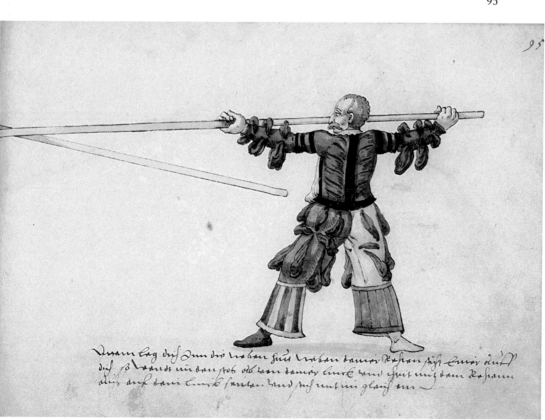

95

Wann lag dich dem die neben hus neben dann Rechen stich linir auff
dich so wendst un den stich als kan dann linck den stich uns dann Rechen
aus auch dann linck hauten Und stich nit mit glaus an

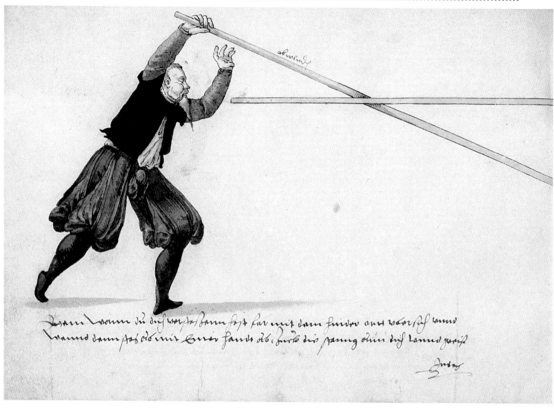

Dann wann du dich versetzt hat mit dem hinder aus verrichst vnnd wanns dann stab od~ mit einer hande ab, hurt dis paung oder dich kennd weist

95ᵛ

96ᵛ

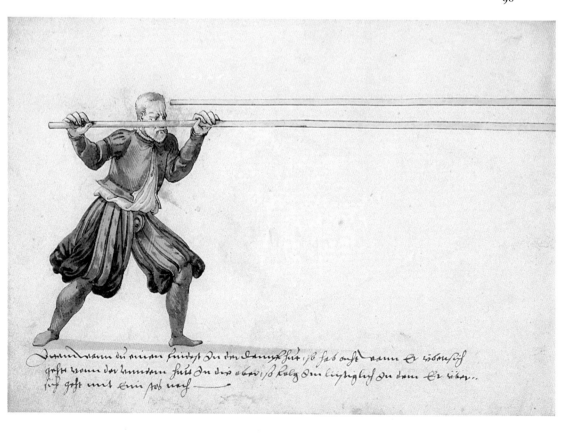

Vnnd wann du einem hinderst an den langen Spieß so hab acht wann er vberrich geht wann der hindern hut du dir vber so halt den liechtlich an dem Er vber sich geht mit einer stob nach

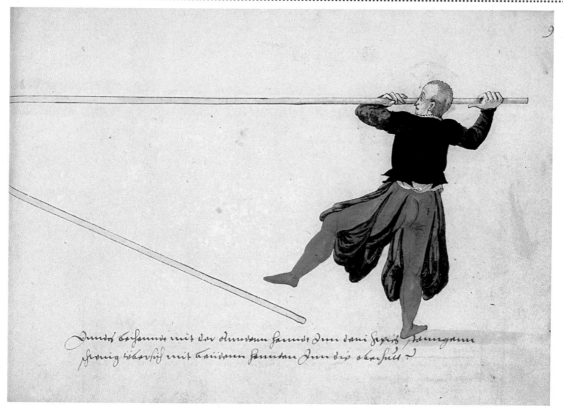

9

Jundt bestende mit der andern handt den dem her[?] daungen
stiaig übersich mit beiden henden den dz oberhalt

96^R

97^R

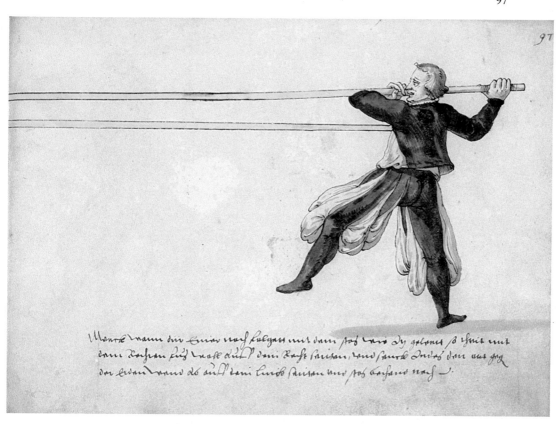

97

Merck wann der hiue nach bolgast mit dem stoß dar dy geleret so thut mit
dem rechten fuß nach dar d den Rast hauen, vnd hauer dieser den aus gog
der erden vnd do auff dem linck hauen vnd stoß bestende nach

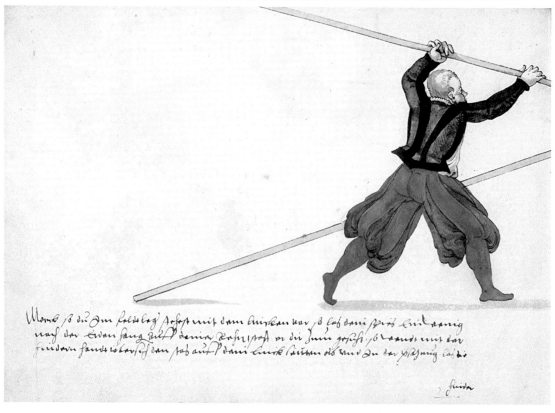

Wann so du Im felde Zog gegest mit dem linken vor so lab dein Spieß mit wenig
nach der Erden sinck mit deinem Rechten fuß an die Zum gesicht so wende mit der
fordern hande ieberstich den stab auf deinem lincke seitten ob und In der Pfinung laß die

97ᵛ

98ᵛ

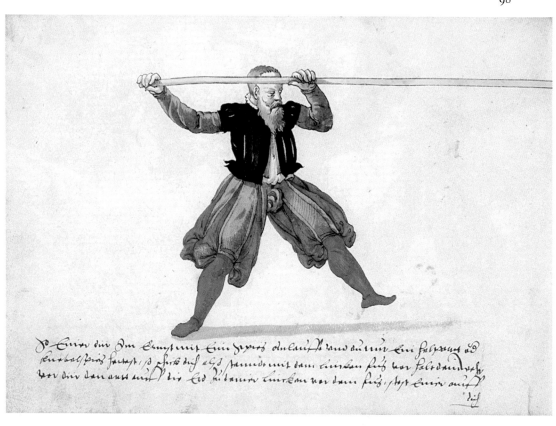

So einer dir Im lauft mit einem gegers den laufst und dir mit ein Schwanck ein
kurbelspieß sarupt so schüb dich ab und stannd mit dem lincken fuß vor felt dein Zech
vor dir dan aus mit die ab dünnir linken vor dem fuß stost einer auf

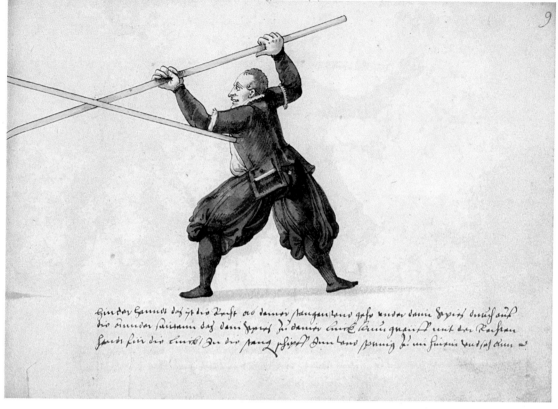

hinder hannd das ist die Recht als dann stangenhauo gehe under daine speiß durch auf
die under seitann daß daine speiß zu dainer linck seinn greiff mit der Rechten
hand für die linck In die zang schlacht dan land springtt zu mir herein vnd schlau dem

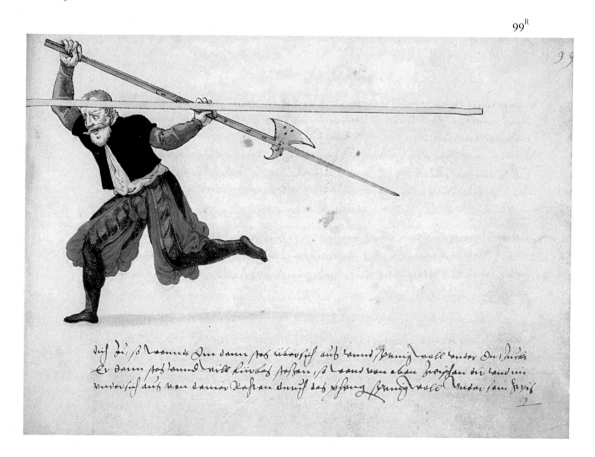

sich die schraunck In daine speiß überschich auf dannd spring wol vnder die Stücke
Er dann sich dannd mit hinden stossen so laud von oben herschen die land in
vndersich auf von dainer Rechten durch daß schwang schrung wol vnder dain speiß

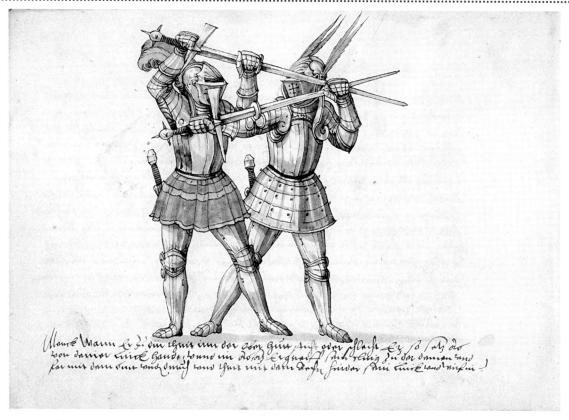

Merck Wann Er dir ein schnit ein der oben Hüt auff oder flach Ez so satz dein von deiner linck Hande, vnnd in dosig Ergreiff schirling zu der d어inen vnd far mit dein aun auch vnnd schir mit dem rechn frider dein schir Eand nichain

106^V

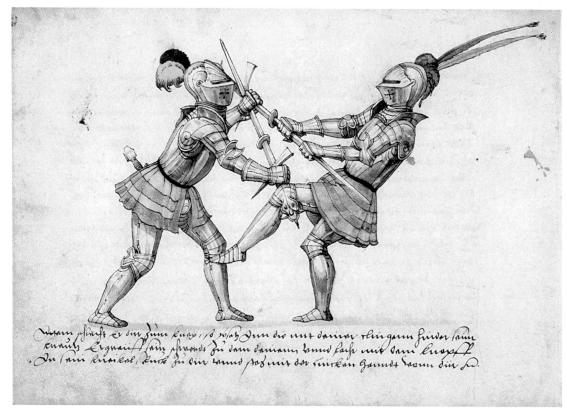

Daran schlecht Er dir Hinn knax, so wsah den dis mit dainer klingen frider dein knüx Ergnai sain prande zu dem dainam vnnd fach mit dem knox zu dein knaibel, knix zu dir vnnd pox mit der linken Hannd deon dir so

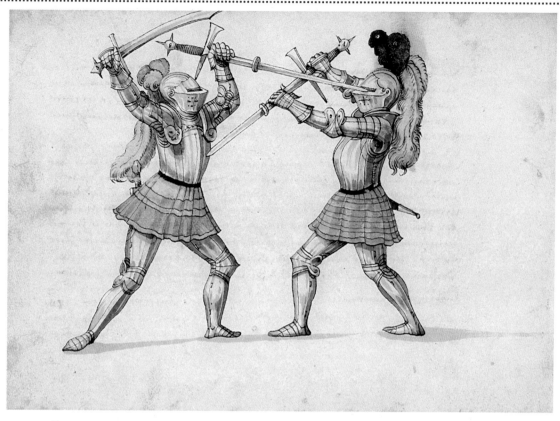

109$^{\text{V}}$

APPENDIX: LUND

LUND

2^V

5^R

Von den vier Blössen und theylung
der man.

Erstlich wirt der man getheilt in zwey theil nemlich links und
Recht wie die Linien in der figur vom oberm herab außweißt,
darnach aber in zwey theil nemlich in under und ober die oberen
zwei blöß werden dan Echter zu getheilt die anderen zwei zu pflüeg.
Dorin sol man sich also gebrauchen, Erstlich merck in welchem
theil er sein Schwert fürt under ob sein, zur Rechten oder
Lincken, wann du das versthenn hast, so greiff als baldt gegen
über an es sty wor ort oder flach der nun ein exempte.
Das zu forderst, so ihr beydt zu samen gehet und du versichst das er
sein Schwert zu seiner Rechten fürt im oberen theil es sty im
Echter es stey oder Ochsen haw, so greiff in auff seiner Lincken underen Beöße an mit
zum werffen, sonder wie weit das du ihn verjagest dir zu begegnen, als baldt er glingt
oder wirrt ist zuck und das hönpt und schlag im ob zu der blöße von weitter er komen
ist nemlich zu seiner Rechten oder mit halber schneidt und gekreuzigten henden

7ᵛ (this folio never received its intended illustration)

12ᵛ

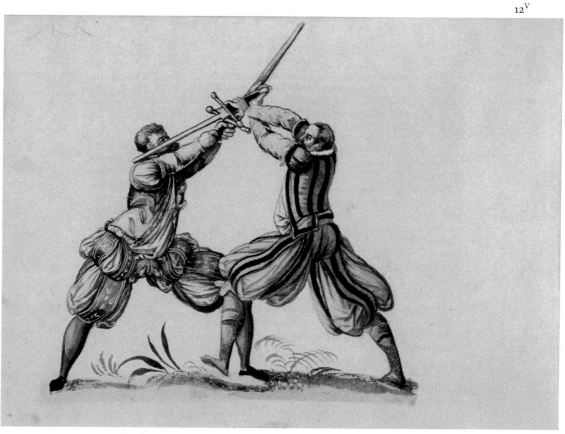

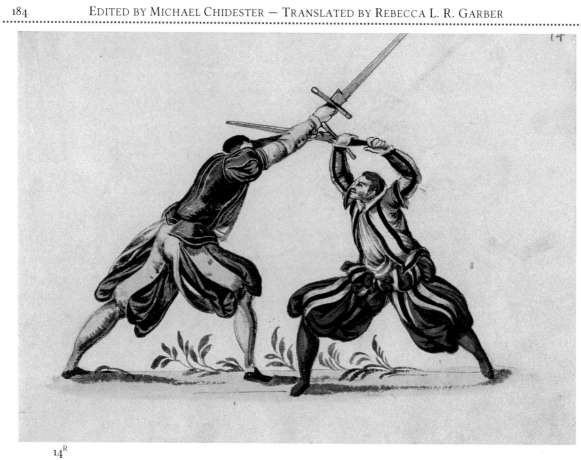

14^R

15^R

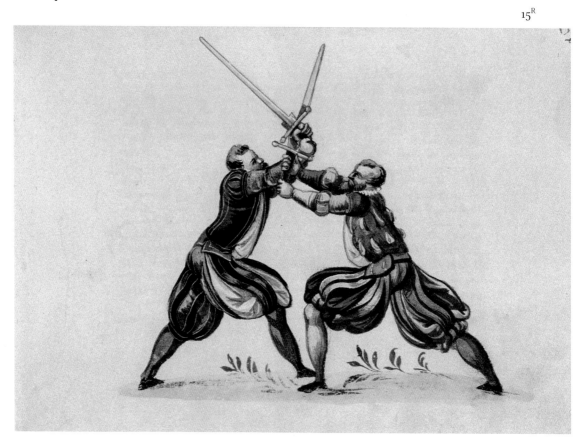

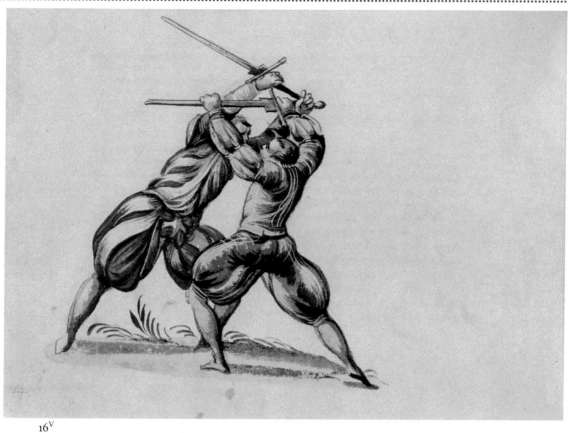

16^V

18^V

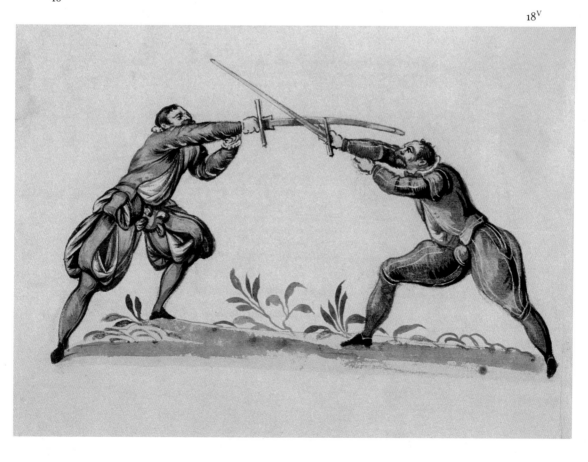

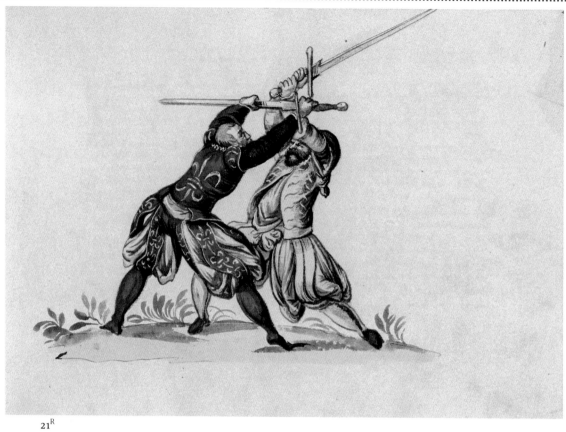

21^R

22^V

25^R

28^R

29$^\text{V}$

31$^\text{V}$

34^R

36^R

38^R

40^R

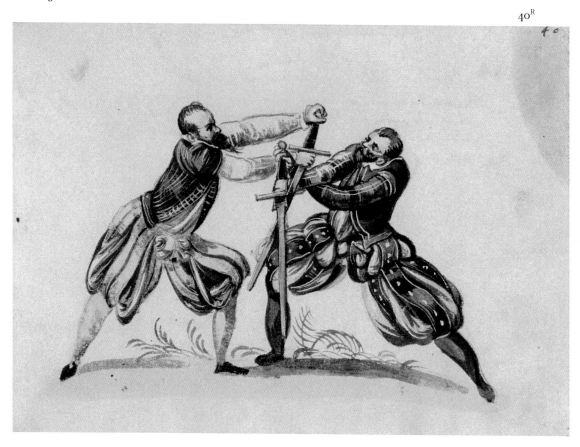

47^R

49^R

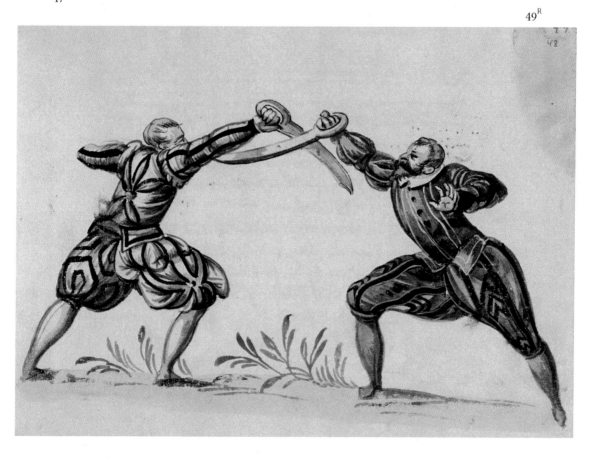

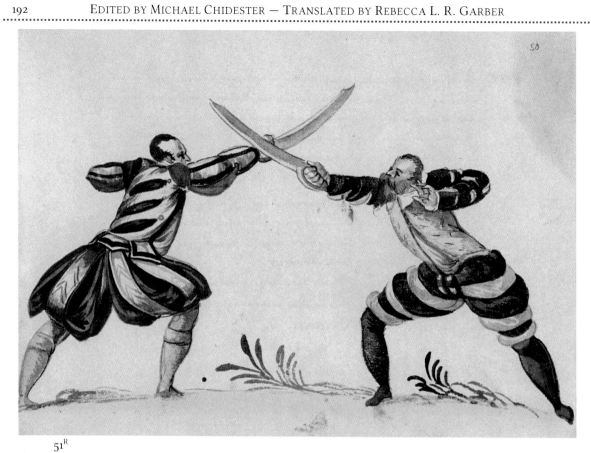

51^R

52^R

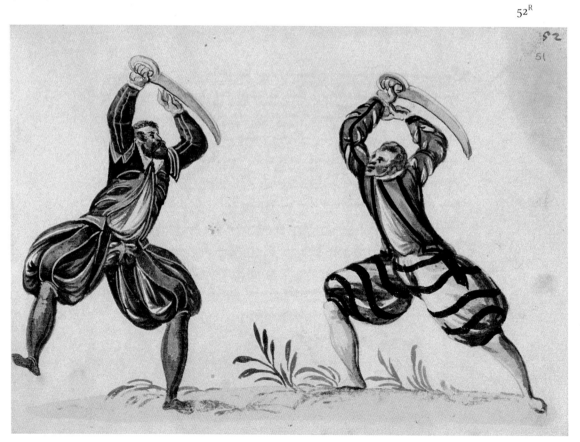

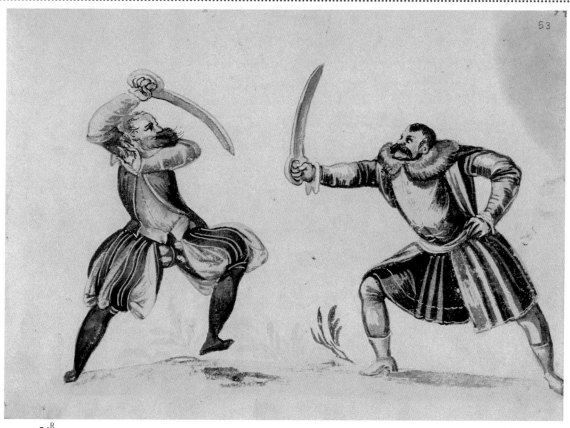

54^R

55^R

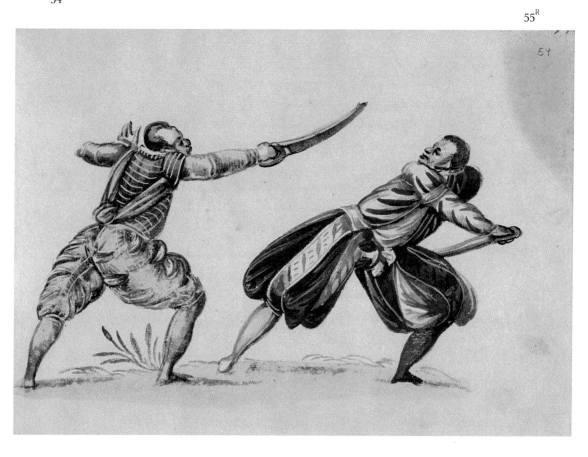

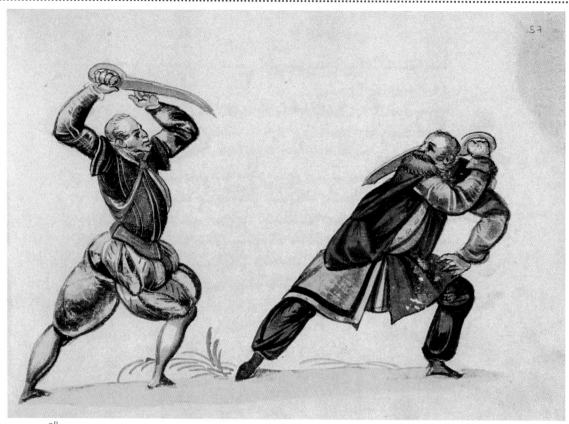

58^R

61^R

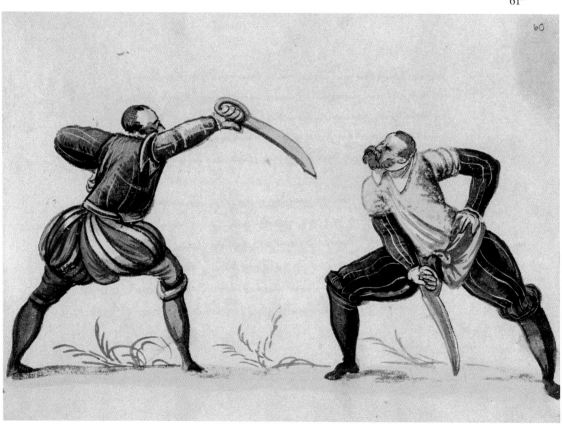

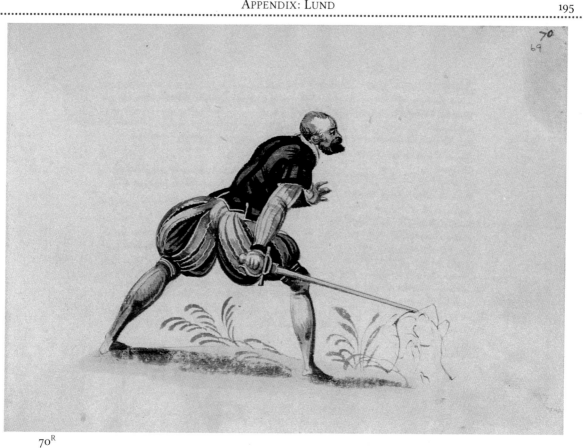

70^R

73^R

74

75^R

77^R

76

78^R

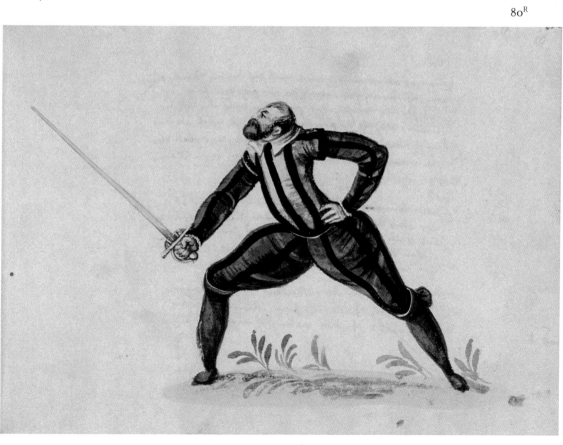

80^R

86^R

86^V

87^R

87^V

88R

APPENDIX: ROSTOCK

1ᵛ

ROSTOCK

2^V

ROSTOCK

APPENDIX: PICTURES

Index of Pictures in this Appendix

PICTURES

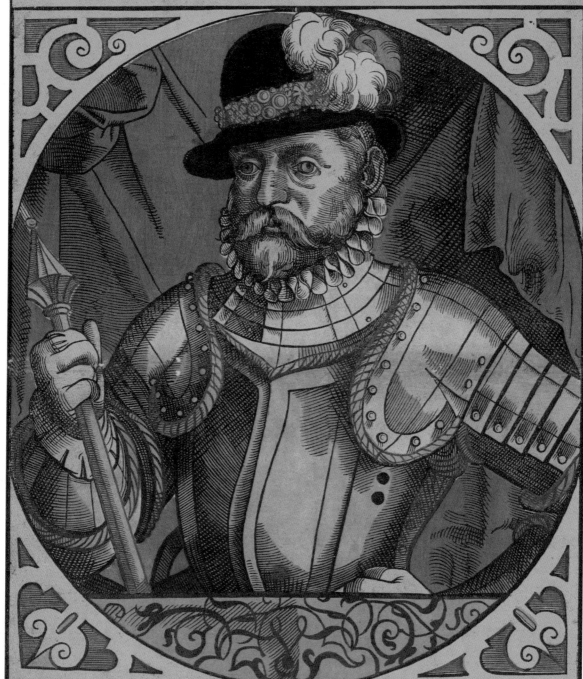

PSALMO CXXXIX.

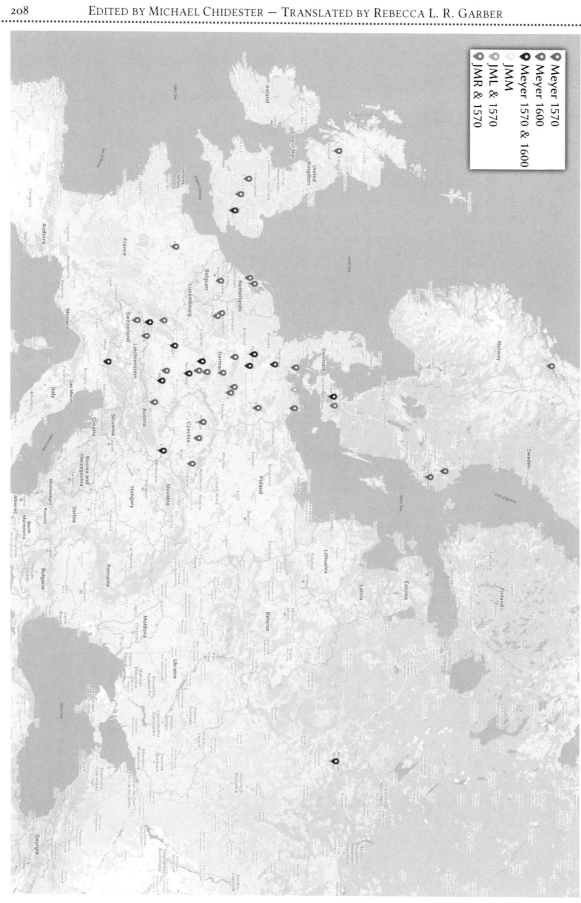

PICTURES

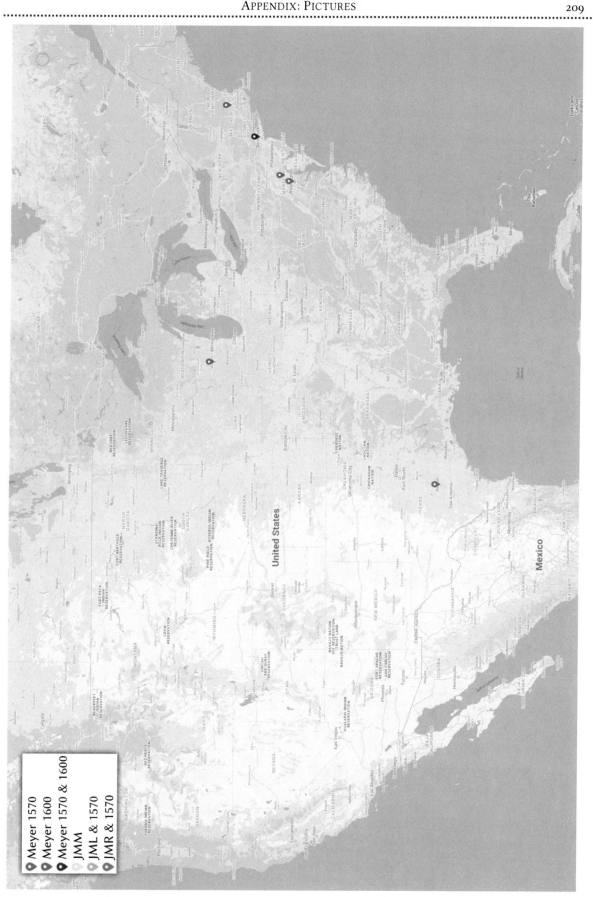

Meyer 1570
Meyer 1600
Meyer 1570 & 1600
JMM
JML & 1570
JMR & 1570

PICTURES

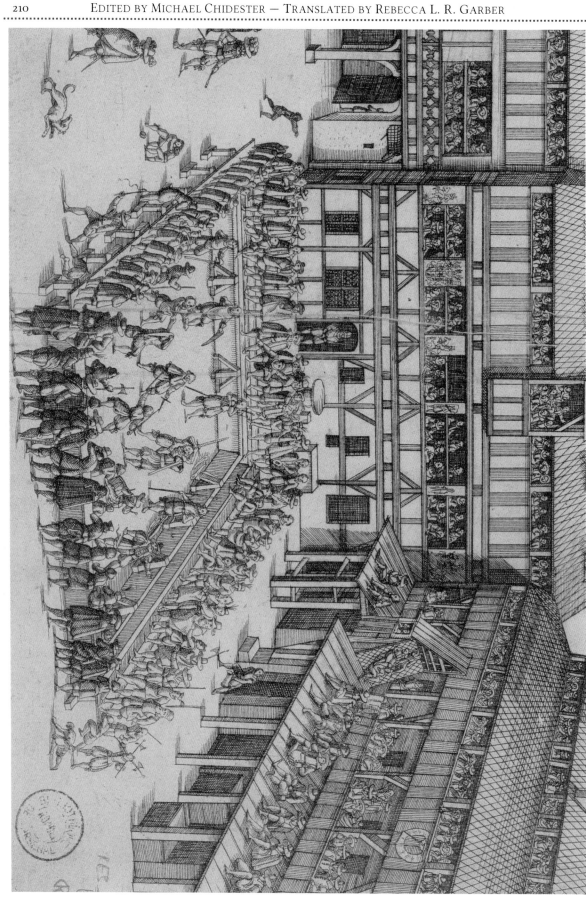

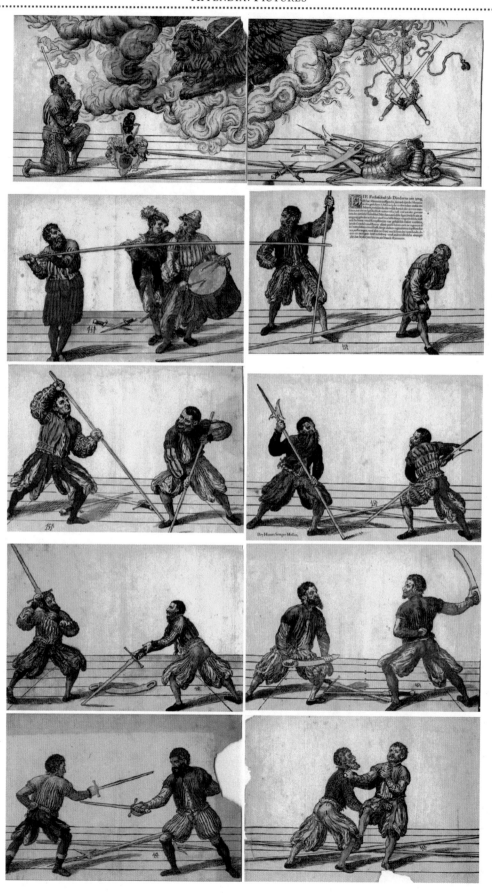

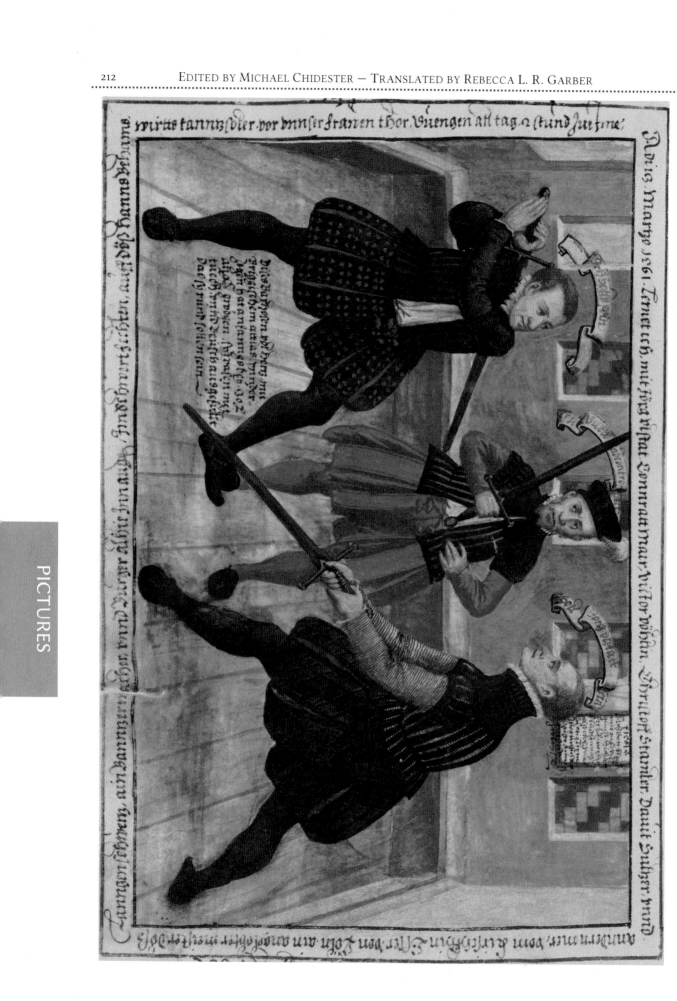

WORKS CITED

This list is limited to sources cited in this Volume. For a complete bibliography, see Volume 1.

PRIMARY SOURCES

Manuscripts

This table is modified from a fencing manuscript cataloging system developed by DIERK HAGEDORN.

FLP	*Florius de arte Luctandi* or *Fiore de'i Liberi-Paris* Paris, Bibliothèque nationale de France, Latin 11269
JML	*Joachim Meyer–Lund* or *von Solms' fight book* Lund, Universitetsbibliotek, Msc. A.4°.2
JMM	*Joachim Meyer–München* or *von Veldenz' fight book* München, Bayerisches Nationalmuseum, Bibl. 2465
JMR	*Joachim Meyer–Rostock* Rostock, Universitätsbibliothek, Mss. var. 82

Books

Albrecht
Albrecht, Andreas. *Zwey Bücher: Das erste von der ohne und durch die Arithmetica gefundenen Perspectiva. Das andere von dem darzu gehörigen Schatten.* Illus. by Hans Troschel. Nürnberg: Paul Fürst, 1671.

Cramono
Cramono Pomerano, Balthasaro. *Austeilunge oder Ordnunge des Zirckelfechtens* [Broadsheet]. Circumstances of publication unknown.

Gunterrodt
Gunterrodt, Heinrich von. *De veris principiis artis dimicatoriae. Tractatus brevis.* Wittenberg: Mattheus Welack, 1579.

Hartmann & Sachs
Hartmann, Schopper, and Hans Sachs. *Παντεχνια omnium illiberalium mechanicaarum aut sedentariarum artium genera continens.* Illus. by Jost Amman. Frankfurt am Main: Sigismund Feyrabendt: 1568.

Marozzo
Marozzo, Achille. *Opera nova de Achille Marozzo Bolognese, mastro generale de l'arte de l'armi.* Illus. by Hans Sebald Beham. Venezia: Nicolo d'Aristotile detto Zoppino, 1531.

Meyer
Meyer, Joachim. *Gründtliche Beschreibung, der freyen Ritterlichen unnd Adelichen kunst des Fechtens, in allerley gebreuchlichen Wehren, mit vil schönen und nützlichen Figuren gezieret und fürgestellet.* Illus. by Hans Christoph Stimmer. Strasbourg: Thiebolt Berger, 1570.

Sutor
Sutor von Baden, Jakob. *New Künstliches Fechtbuch.* Frankfurt am Main: Wilhelm Hoffman, 1612.

Verolini
Verolini, Theodor. *Der Künstliche Fechter: Oder Deß Weyland wohl-geübten und berühmten Fecht-Meisters.* Würzburg: Joann Bencard, 1679.

SECONDARY SOURCES

CHIDESTER 2024
CHIDESTER, MICHAEL. "Reception of Joachim Meyer's *Gründtliche Beschreibung der... Kunst des Fechtens, 1570–1686*". *Acta Periodica Duellatorum* (Forthcoming).

CHIDESTER & Stimmer 2020
CHIDESTER, MICHAEL, and Tobias Stimmer. *The Illustrated Meyer: A Visual Reference for the 1570 Treatise of Joachim Meyer.* Somerville: HEMA Bookshelf, 2020.

DACKERMAN 2002
DACKERMAN, SUSAN. *Painted Prints: The Rev-elation of Color in Northern Renaissance & Baroque Engravings, Etchings & Woodcuts*. University Park: The Pennsylvania State University Press, 2002.

DANE 2012
DANE, JOSEPH A. *What Is a Book? The Study of Early Printed Books*. Notre Dame: University of Notre Dame, 2012.

DUPUIS 2021A
DUPUIS, OLIVIER. "A New Manuscript of Joachim Meyer (1561)". *Acta Periodica Duellatorum* 9(1): 73–86. 2021. DOI 10.36950/apd-2021-004

FRANTI 2021
FRANTI, ADAM. "Art and Symbolism in the Genre of Fechtbücher." *Kunst und Zettel in Messer: Bavarian State Library Cgm 582*. Ed. by MICHAEL CHIDESTER. Somerville: HEMA Bookshelf. 2021. pp. 229–240.

FORGENG 2006
Meyer, Joachim. *The Art of Combat: A German Martial Arts Treatise of 1570*. Trans. by JEFFERY L. FORGENG. London and New York: Greenhill Books and Palgrave MacMillan, 2006. 2nd ed. London: Frontline Books, 2015.

FORGENG 2012
FORGENG, JEFFERY L. "Owning the Art: The German Fechtbuch Tradition". *The Noble Art of the Sword: Fashion and Fencing in Renaissance Europe 1520–1630*. Ed. by TOBIAS CAPWELL. London: Paul Holberton Publishing, 2012. pp. 167–168.

FORGENG 2016
Meyer, Joachim. *The Art of Sword Combat: A 1568 German Treatise on Swordsmanship*. Trans. by JEFFERY L. FORGENG. London: Frontline Books, 2016.

FORGENG 2017
FORGENG, JEFFERY L. "The Martial Arts Treatise of Paulus Hector Mair." *Die Kunst des Fechtens*. Ed. by MATTHIAS JOHANNES BAUER and ELISABETH VÁVRA. Heidelberg: Universitätsverlag Winter GmbH, 2017. pp. 267–284.

HORSBATSCH 2020
HORSBATSCH, OLENKA. "A Passion for Prints: Netherlandish Engravings in an Early Sixteenth-Century Prayer Book." *The Reception of the Printed Image in the Fifteen and Sixteenth Centuries: Multiplied and Modified*. Ed. by GRAŻYNA JURKOWLANIEC and MAGDALENA HERMAN. New York: Routledge, 2021. pp. 97–113.

JACKSON 2001
JACKSON, H. J. *Marginalia: Readers Writing in Books*. New Haven and London: Yale University Press, 2001.

KIEFFER 2022
KIEFFER, FANNY. "Dessiner le geste technique à la Renaissance: le dialogue entre le peintre Tobias Stimmer et le maître d'armes Joachim Meyer". *Arts, Civilisation et Histoire de l'Europe* 20: 49–72. 2022.

KINTZ 2021
KINTZ, PIERRE. "Tobias Stimmer, illustrateur du Fechtbuch de Joachim Meyer." *Martial Culture in Medieval Town*. 18 June 2021.
<http://martcult.hypotheses.org/1316>

KWAKEL 2018
KWAKEL, ERIC. *Books Before Print*. Amsterdam and Leeds: Amsterdam University Press and ARC Humanities Press, 2018.

OLTROGGE 2009
OLTROGGE, DORIS. "Illuminating the Print: the Use of Color in Fifteenth-Century Prints and Book Illumination". *Studies in the History of Art* 75: 298–315. 2009.

PETROSKI 1999
PETROSKI, HENRY. *The Book on the Bookshelf*. New York: Vintage Books, 1999.

SHERMAN 2008
SHERMAN, WILLIAM H. *Used Books: Marking Readers in Renaissance England*. Philadelphia: University of Pennsylvania Press, 2008.

WIKTENAUER
CHIDESTER, MICHAEL, ET AL. "Joachim Meyer". *Wiktenauer*.
<http://www.wiktenauer.com/wiki/Joachim_Meyer>

ABOUT THE AUTHOR

REBECCA L. R. GARBER received her Ph.D. in German Languages and Literatures from the University of Michigan in 1999, with a specialization in medieval studies. She taught for three years at Wayne State University and then at a private high school before turning to translation as a full-time occupation. After joining a stage combat troupe in Michigan in 2006, she began translating combat manuals with CHEMAS (the Cambridge Historical European Martial Arts Study group), where her expertise in Medieval German and Latin was more useful than in most aspects of modern life. This is her third published HEMA translation, the first being "Florius de Arte Luctandi" (FLP) in *The Flower of Battle of Master Fiore Furlano de'i Liberi* (with KENDRA BROWN; 2016), and the second being Hans Talhoffer's Københaven manuscript in *Alte Armature und Ringkunst: The Royal Danish Library Ms. Thott 290 2°* (2020).

ABOUT THE EDITOR

MICHAEL CHIDESTER has been studying historical European martial arts since 2001, and has been Editor-in-Chief of Wiktenauer since 2011. In 2019, he started a publishing company called HEMA Bookshelf to produce facsimiles of fencing manuals and publish translations and historical research. MICHAEL is a Research Scholar of the Meyer Freifechter Guild, a founding member of the Society for Historical European Martial Arts Studies, a member of the Western Martial Arts Coalition, and a Lifetime Member of the HEMA Alliance. He has lectured on historical martial arts across North America and Europe and has written several books, including *The Illustrated Meyer: A Visual Reference for the 1570 Treatise of Joachim Meyer* (2020), *The Flower of Battle: MS M.383* (2021), and *"The Foundation and Core of All the Arts of Fighting": The Long Sword Gloss of GNM Manuscript 3227a* (2021), and contributed or edited to many others. He currently trains at Athena School of Arms in Cambridge, MA.

329238Z6R00143

Made in the USA
Coppell, TX
29 May 2024